HAYAO MIYAZAKI

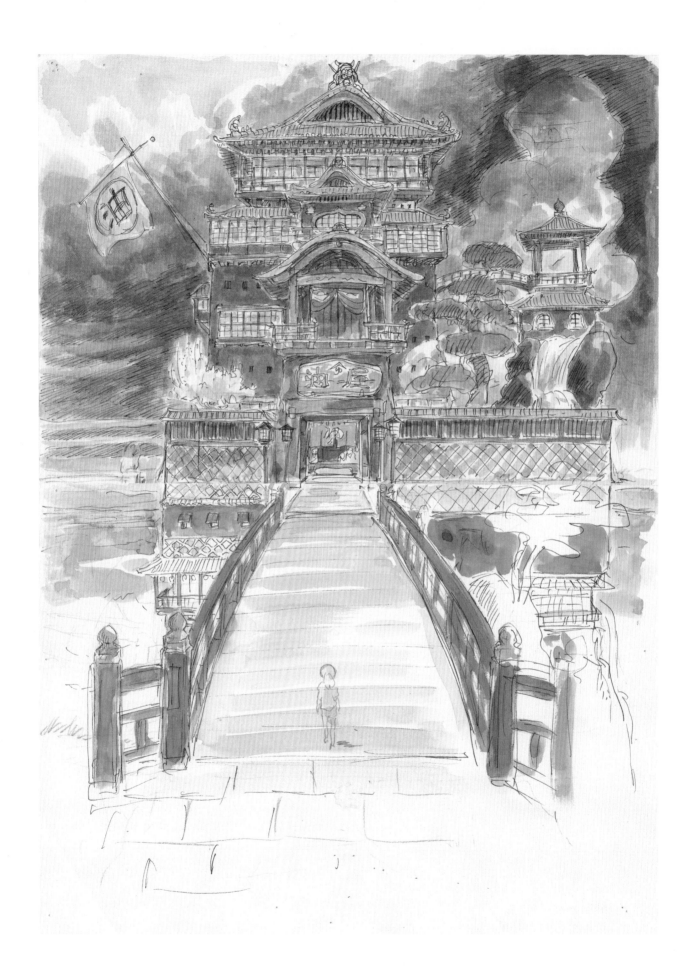

HAYAO MIYAZAKI

JESSICA NIEBEL

PETE DOCTER
DANIEL KOTHENSCHULTE

Foreword by TOSHIO SUZUKI

ACADEMY MUSEUM OF MOTION PICTURES
LOS ANGELES

DELMONICO BOOKS · D.A.P.
NEW YORK

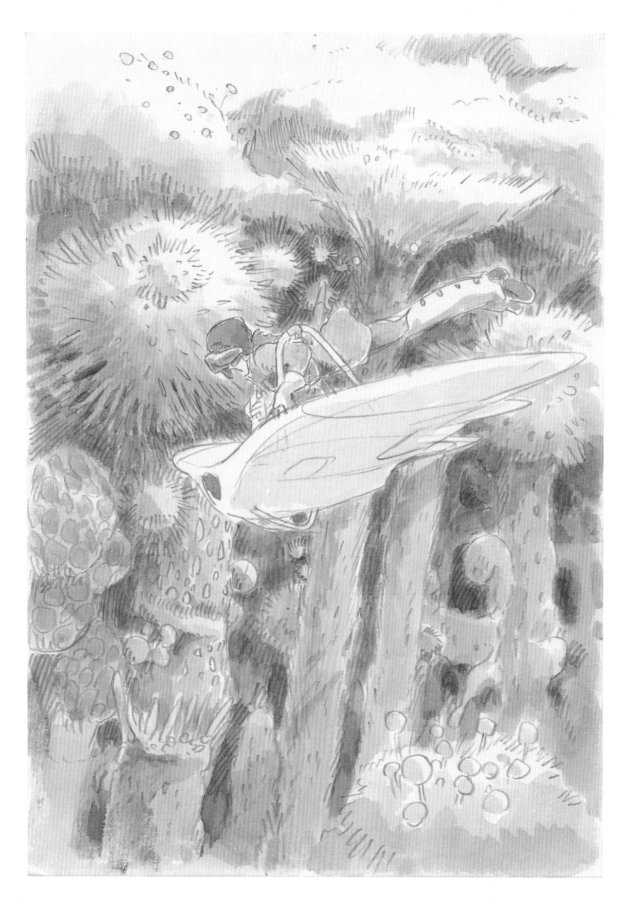

Hayao Miyazaki, Nausicaä of the Valley of the Wind imageboard (Nausicaä flies her mehve)

CONTENTS

DIRECTOR'S FOREWORD

FROM THEIR INCEPTION, MOVIES HAVE CAPTURED OUR COLLECTIVE IMAGINATION by showing us the reality of our world or by transporting us to another dimension. Movies allow us to experience other points of view and, by doing so, connect us through our shared humanity. The idea of founding a film museum—a space in which to champion cinema as a transformative art form—was first brought forward in Los Angeles shortly after the founding of the Academy of Motion Picture Arts and Sciences in 1927. An elusive dream for many decades, the Academy Museum of Motion Pictures has finally come to fruition thanks to the enthusiastic work of a global community of artists and supporters. We are indebted to them for their efforts, and we extend our deep appreciation for their ideas, guidance, and assistance over the years as we unveil this new global center for cinema.

It is a great honor for the Academy Museum to present **Hayao Miyazaki** as its inaugural temporary exhibition. This is the first North American retrospective of one of cinema's most treasured auteurs—an artist responsible for some of film history's most cherished animated movies, among them **My Neighbor Totoro** and **Spirited Away.** Miyazaki-san's extraordinary artistry, vision, and creativity have influenced and delighted filmmakers and film lovers around the world. Enchanting and deeply moving, his films have earned him global acclaim and continue to inspire endless wonder. With more than 350 works, large-scale projections, and immersive installations, **Hayao Miyazaki** is a joyful examination of Miyazaki-san's oeuvre that offers a glimpse into deeper truths about the human condition. It has been a privilege to collaborate with our friends at Studio Ghibli on this groundbreaking project.

We extend our profound gratitude to Hayao Miyazaki for his support and for so warmly welcoming members of our Academy Museum team to his studio. We are thankful to the staff at Studio Ghibli and the Ghibli Museum for their wonderful partnership and friendship. In particular, we wish to thank Toshio Suzuki for his generous assistance and for writing the poetic meditation on Miyazaki's work included in this catalogue. We also wish to express our appreciation to Koji Hoshino for his encouragement and steadfast help from the project's beginning.

Academy Museum Exhibitions Curator Jessica Niebel's thoughtful exploration of Miyazaki-san's vision and work as a filmmaker, draftsperson, and animator offers visitors a window onto his endless imagination. I extend my deep appreciation to Jessica for her leadership in forging a rewarding and treasured partnership with Studio Ghibli and for creating an exhibition that inspires such wonder and enchantment. I also thank Assistant

Curator J. Raúl Guzmán for his tireless dedication to the exhibition, which he has enhanced in insightful and creative ways.

This exhibition was made possible through the assistance of many generous partners—most notably Kathleen Kennedy, who provided pivotal support at the genesis of the project. We are grateful to Christie for their in-kind contribution. We are thankful to the Arthur and Gwen Hiller Memorial Fund, the Japan Foundation, and the Los Angeles County Department of Arts and Culture for their generous support and commitment to the exhibition. **Hayao Miyazaki** marks the beginning of the museum's slate of temporary exhibitions, which will be presented in the Marilyn and Jeffrey Katzenberg Gallery. We thank the Katzenbergs for their vital support in helping us develop this important space.

Finally, I want to thank the Trustees and staff of the Academy Museum and the Academy of Motion Picture Arts and Sciences—our parent organization. They have demonstrated an unwavering dedication to the development of the museum. Because of their efforts, Los Angeles has a new home for the movies. I am grateful for their vigorous work, passion, and commitment in laying the foundation for a world-class institution that will safeguard and celebrate our cinematic heritage for decades to come.

BILL KRAMER
Director and President, Academy Museum of Motion Pictures

HAYAO MIYAZAKI'S POWERS OF VISUAL MEMORY

FOR OVER FORTY YEARS, I have known Hayao Miyazaki. To sum up his talents: he doesn't forget what he has seen. This is true for still objects but also moving objects.

When Miya-san comes across a building or landscape that he likes, he gazes at it for a while, taking it in. It may be for five minutes, or ten minutes, or even several hours. Take Lady Eboshi's mansion in **Princess Mononoke.** I was astounded when I took a look at the building Miya-san had drawn. Some two or three years earlier, he and I had traveled to Otaru, in Hokkaido, to see what is called a "herring mansion," built by a fishing magnate who had earned his fortune from the herring industry. That lavish building had been transformed into Lady Eboshi's mansion. When I pointed that out, Miya-san said to me, mischievously and full of delight, "This one's three times the height."

In **Spirited Away,** the character Chihiro is modeled on a ten-year-old girl whose family visited Miyazaki at his atelier in Shinshu every summer from the time she was a small child. In the opening scene of the film, Chihiro runs through a strange town. Her way of running—lifting both arms slightly and pumping them from side to side—replicated that of this little girl. This isn't to say that he interacted with the girl. He just observed her mannerisms and demeanor, never becoming bored. He would watch how she acted when she was with other children, how she behaved when she was surrounded by adults. He would observe how she expressed her feelings for as long as time allowed.

Whether the object of his interest is buildings, landscapes, or people, he never picks up a camera to take a photograph. Neither does he make a sketch with pencil on paper. He just goes on gazing. Even when he finds something that catches his fancy, he doesn't draw it right away. It could be a year, at the earliest, or ten years later that he draws it.

I suspect that this is what goes on: On occasion, he opens a drawer inside his head and pulls out a memory to sketch. If he isn't satisfied with his drawing, he puts it back into the drawer. Then, as his memory of that scene fades, he opens the drawer again and makes another sketch. He replaces the elements he has forgotten using his imagination. As he repeats this process, characters, landscapes, and buildings full of originality take shape. Miya-san's daily routine is to dash up to the rooftop of Studio Ghibli to watch the tinted clouds and setting sun. The face of the sky is different each day. The world is moving.

I can't avoid mentioning here Hayao Miyazaki's forthcoming film. It will take a long while for it to be completed, so I can only say a little about it. The title has been announced: **How Will You Live?** A character modeled on a real person appears in this film as well, but who could it be? I was stunned when I first saw the storyboard. It is none other than I myself. Daily interactions between us had been re-created exactly as they occurred,

and the scene perfectly depicted friendship. I might add that I appear at first glance to be a bad guy. And I am not human. I was impressed as well as dumbfounded.

Let me take this opportunity to reveal this as well: Hayao Miyazaki's powers of visual memory are nothing short of genius, but in everyday matters, his forgetfulness is extreme. It is much worse than average. He is apt to forget even important things that we talked about just a few moments before. This isn't due to his age; he was this way when he was still young. It may be because he is always thinking about his current work, 24 hours a day. No exaggeration: even when he is asleep. Incidentally, Miya-san doesn't use a smartphone or a personal computer. He doesn't believe in information that can be easily obtained. He believes in people.

I have written about just one aspect of Hayao Miyazaki's creative process. I would be happy if it helps people to understand this exhibition. Hayao Miyazaki himself is very honored that his works are being presented at the Academy Museum of Motion Pictures. The exhibition is the result of the efforts of many people. We express our deep appreciation.

TOSHIO SUZUKI
Producer, Studio Ghibli

My Neighbor Totoro film still

HAYAO MIYAZAKI: AN INTRODUCTION

JESSICA NIEBEL

Films have the power not only to salve our discontent with the world but to make us realize the yearnings within our hearts.[1]

THERE IS NO DOUBT THAT HAYAO MIYAZAKI'S FILMS ARE EXCEPTIONAL. This is true not only of the quality of the animation—a huge team effort that requires the grueling work of the most talented and experienced craftspeople in Japan—but also of the filmmaker's approach and his intent. While Miyazaki is driven by the desire to create films that are entertaining, he believes they should, above all, have purpose and meaning. Touching something deep within our souls, his films elicit a powerful longing for another world—a world that may not be perfect but is nevertheless beautiful. We might even believe this place exists somewhere not too far from our own reality.

Perhaps his films feel so strangely familiar because they share their creator's understanding of the world, of humanity, and of the times we live in. Miyazaki is much more than an animator or a director of films. He is an auteur and a philosopher who seeks to express his insights, values, and vision through animated films. While never negating, simplifying, or downplaying the problems that we—and his protagonists—may face along our journey, he seeks to convey that there is still beauty in this world, something to be appreciated, something to give us hope. Says Miyazaki, "The question then becomes, what is hope? And the conclusion I'd have to venture is that hope involves working and struggling along with people who are important to you. In fact, I've gotten to the point where I think this is what it means to be alive."[2]

TO DATE, Miyazaki has created eleven feature films—the main focus of this retrospective exhibition—including nine with Studio Ghibli, Japan's most renowned animation studio, which he cofounded in 1985 with fellow filmmaker Isao Takahata and Toshio Suzuki. An editor at Tokuma Shoten at the time, Suzuki would become a producer at Ghibli, supporting both filmmakers in their creative processes. Miyazaki's extraordinary commitment as a visual artist began decades earlier when, as a shy child, he turned to drawing as a way to connect with and gain the admiration of his classmates. Dreaming of becoming a manga artist, he took to drafting exercises that trained his eye for keen observation of his surroundings. Insatiably curious, he began to wonder how the world would look from other points of view, for example, that of an insect or an airplane pilot.

This important aspect of Miyazaki's creativity—his impulse to imagine the world from another's perspective, or through a character's eyes—brings to mind my initial connection with his work, well before my involvement as a curator. During my own childhood in Germany, I regularly watched **Heidi, Girl of the Alps**, the 1970s television series—based on Swiss author Johanna Spyri's 19th-century children's book—which Miyazaki significantly shaped as a young animator working for director Takahata. Though my parents did not allow me to watch much TV, this show was a glorious exception. Heidi was an orphan, forced to deal with hardship at a young age and, even so, incredibly free and adventurous. How excited I was when the show came on and I could lose myself, for roughly 25 minutes, in Heidi's world. For hours after, I'd be outside on my swing, trying to fly high enough to jump onto a fluffy cloud, to see the world from above—just like Heidi in the title sequence. Little did I know that Takahata and Miyazaki had made the series in faraway Japan, or that the spirited girl's voice originally spoke in a language entirely incomprehensible to me.

My next encounter with a Miyazaki heroine didn't happen until the mid-2000s, when I was curating an exhibition of Japanese animation at the Deutsches Filmmuseum in Frankfurt. The title character in his **Nausicaä of the Valley of the Wind** is kindhearted, smart, and courageous, a burdened warrior princess. I had never seen anyone like her on the big screen. Even though—or maybe because—Nausicaä was an animated character, she felt more real to me than many live-action portrayals of femininity. I watched more Miyazaki films and was captivated by their artistry—the characteristic hand-drawn look, and the rhythm that resists the expectation for fast-moving sequences in favor of creating wonderful moments of stillness. Miyazaki is a master of cinematic expression who understands how to convey meaning in ways that transcend the characters' spoken words and actions. His outstanding films never rely on formulaic narrative devices: they are entertaining and thought-provoking in their elegant simplicity, with complex philosophical undercurrents. Unfortunately, all attempts to contact the studio to secure loans for that exhibition failed. It wasn't until ten years later, when the idea was raised that Miyazaki should be the subject of a major inaugural exhibition at the Academy Museum of Motion Pictures, that I reached out to them again. It took about a year, and the help of Academy members and others, to convince Studio Ghibli to collaborate with us on the first retrospective of Hayao Miyazaki's work to take place in North America, including lending us a rich selection of works, some of which have never before been publicly exhibited.

In July 2017, I went to Tokyo with Susan Jenkins, the museum's vice president of exhibition planning, to discuss our proposed exhibition with Studio Ghibli and—we hoped—to secure their agreement to participate as lenders and collaborators. Ghibli's staff welcomed us with great hospitality, taking us to tiny traditional restaurants as well as exhibitions at the Ghibli Museum and elsewhere in Japan. The trip ended in Beppu, a small town in the mountains with natural hot springs and relaxing onsen baths. As enjoyable as this tour was, I returned to Los Angeles puzzled that Studio Ghibli had not yet confirmed that we could move forward with our idea. Over the course of more visits to Tokyo, however, my nervousness abated and the importance of our various expeditions became clear: we would work together by observing, respecting, and taking part in the studio's way of doing things. Instead of explaining their philosophy, our partners would show it to us.

Learning through words is valuable, but learning through experience much more so. Though it can be challenging to look at the world from another's perspective, the process is enriching; such looking can facilitate a connection beyond words, and often it is the only way forward. My two closest partners in developing this exhibition, Assistant Curator Raúl Guzmán and Vice President of Exhibition Design and Production Shraddha Aryal, accompanied me on subsequent trips, and we continued to open ourselves up to understanding Miyazaki's way of thinking: Ghibli staff showed us more, and we learned more. Despite my not speaking Japanese, our friends at Ghibli became our teachers and Miyazaki our mentor. The exhibition and catalogue Hayao Miyazaki share what we, at the Academy Museum, have observed and taken in through the generosity of Studio Ghibli, but there is still much to be learned about this unique artist.

At eighty years of age—and presently working on his twelfth feature film—Miyazaki remains a reserved person; he does not like to appear or speak in public and agrees to give interviews only when a new film is released. Staff at Ghibli affectionately point out that when pressed for answers, he'll often simply respond that everything he has to say, he's saying through his films. Fortunately, our curatorial team was granted interviews with some of Studio Ghibli's main staff, which, along with Miyazaki's published statements, proposals, and notes over the years, provide rich insight into his creative process and philosophy.

○

MIYAZAKI CAREFULLY CHOOSES which films he wants to make, and he will work only on films he truly believes in.[3] Of course, most filmmakers, and especially those who work in the Japanese animation industry, cannot afford such luxury. Producing animated films is laborious, expensive, and time-intensive, and requires a well-trained and collaborative staff. Miyazaki started his professional career at the age of 22 as an animator at Toei Animation, where he worked on television episodes along with feature-length films. At Toei, he joined the workers' union, becoming its general secretary in 1964. There he met Isao Takahata—an encounter that would impact not only his future career but also his entire life. They would become friends, collaborators, and partners for 55 years until Takahata's passing in 2018. Together they left Toei to join A Production in 1971 and, in 1973, Zuiyo Enterprise; in 1975, they started working at the newly formed Nippon Animation along with a number of other former Zuiyo employees. After his first directing job, on the TV series Future Boy Conan, Miyazaki left Nippon Animation for Telecom Animation Film, where he directed his first feature film, Lupin the 3rd: The Castle of Cagliostro, produced by Tokyo Movie Shinsha and released in 1979.

In 1982, Miyazaki quit his job at Telecom. He began developing the film version of his popular manga Nausicaä of the Valley of the Wind, which would be realized at Top Craft animation studio, with Takahata acting as producer. As the first feature Miyazaki directed based on his own original story, Nausicaä was pivotal to his career. He expressed high hopes for the film before its release in 1984: "It's a model of one approach to film-making. If Nausicaä becomes a hit, it might be possible for me to make serious projects from a different point of view."[4] The critics' reactions proved Miyazaki right. Consequently, he and Takahata resolved to make the films they truly wanted to make, and to create the work environment that would allow them to do so: in 1985, they cofounded, along with Toshio Suzuki, Studio Ghibli.[5]

As a producer and promoter of Ghibli films, Suzuki has consistently respected both Miyazaki's and Takahata's visions as filmmakers and, despite their very different work styles, has done everything to support them over the years. As president of Studio Ghibli while it was still a division of Tokuma Shoten Publishing, Suzuki played a key role in the studio's long-term success by negotiating a distribution deal in 1996 with the Walt Disney Company. To this day, he is one of Miyazaki's closest confidants, and he never fails to back the policies that the auteur believes his staff should live by. Speaking on behalf of his fellow Ghibli staff members, Shinsuke Nonaka, vice president and head of business and legal affairs, explains that their creed is to make films that are worth making, that are entertaining, and that can earn money.[6]

Isao Takahata (left) and Hayao Miyazaki (standing, second from right) during the production of Castle in the Sky, ca. 1985

I think there is no set method or procedure for making a film. Those involved in the making of the film make a concerted effort, step by step, to create the film they want to make; the entire process is the creation of the film.[7]

FROM STUDIO GHIBLI'S VERY START, it was Miyazaki's goal to create an ideal work environment and offer working conditions that would foster new talent and make employees feel appreciated: "We need to hire new staff, train and nurture them, and we also need to improve the work conditions for our experienced staff."[8] While the animation industry standard in Japan is to treat films as individual projects, with staffers dismissed after the work is completed, Studio Ghibli recognized early on how advantageous it is to retain long-term staff, as Nonaka recalls: "We would hire young staff that were fresh out of college who would grow into becoming great animators."[9] Artists who wanted to work on non-Ghibli projects could request to be contracted. Offering above-average wages was a founding value because, says Miyazaki, "it's false to assume that just because animators love their work, we can keep their wages so low. That just isn't right."[10]

Today Studio Ghibli's facilities are quietly nestled between private homes and a flower shop, with no sign to announce them. The complex of buildings was opened in 1992 in Koganei, a residential part of Tokyo, according to specific designs by Miyazaki that allow the production team to work together in an intimate, comfortable environment. "Ghibli does everything essential in-house, because it facilitates a place where everyone can see each other and work together face to face," explains Nonaka.[11] The staff are surrounded by many windows, with views onto the pleasant neighborhood and its greenery. A peaceful atmosphere pervades, enabled by the fact that Ghibli does not allow visitors into the production area. At moments of pause, Miyazaki is known to retreat to the rooftop for a clear view of the sky above.

On our initial planning visit in July 2017, we had the honor of first meeting Miyazaki in his personal atelier, located not far from the studio buildings in a residential home. It felt almost like entering a sanctuary. Just as we sat down at the big wooden table to pitch our exhibition project, I noticed a gigantic tree outside the window, which made me think of the majestic trees so prominently depicted in many of his films. The image of the esteemed filmmaker with the impressive tree behind him has since turned into a treasured visual memory for me.

We conducted our interviews with key Ghibli staff in the studio's cozy library—about their work, what it's like to work with Miyazaki, and how things are done the Ghibli way. We learned that processes must be flexible and adaptive to the needs of each film. Prioritizing the film's individuality over the comfort of standard procedures requires, of course, tremendous effort. The staff's professed philosophy of "working together" was vividly apparent when they led us to the second floor of the Studio 1 building. Here, in a calm, unpretentious atmosphere, Miyazaki's films come to life. The animators' desks are grouped together in one portion of the room, with the background artists working in another; next to a window is Miyazaki's desk. Drawings are pinned up everywhere, and it feels like being inside the beating heart of Studio Ghibli.

At his desk, Miyazaki appeared before us for the second time, but he was so serenely focused on his drawing that he never even noticed us. On a later visit, we saw him at a young animator's desk, explaining something to her. Eventually, he sat down at the desk and started drawing—some things are best explained by doing. Indeed, by sharing his time with the members of his team, Miyazaki assures that everyone internalizes his vision until they have a deep understanding of what he's trying to accomplish: "The final product . . . must belong to everyone, as well as to each individual. For us, the ultimate dream is to create works this way and have as many people as possible view them."[12]

With Studio Ghibli, Miyazaki has fulfilled his dream. The staff couldn't be more appreciative of being able to work with the master so closely and over such long periods of time. Animator Akihiko Yamashita says of his experience: "Given how the studio includes not only animators but also an entire staff for art, ink and paint, compositing, as well as [computer-generated imagery], I found the close communication between each department really refreshing. . . . I found this form of 'communal work' exceptional and gratifying, as if we were all navigating one large ship together. . . . My most rewarding experience, however, was having the chance to really observe Miyazaki up close."[13] Yet at times it must be difficult to work for a genius like Miyazaki, a filmmaker whose expectations exceed those of most others and who demands absolute dedication from his team: "Nothing would make me happier than to be able to draw storyboards that would allow the Ghibli staff to go home after an eight-hour work day and to create films that everyone would want to go see. But I don't have the talent for that, so everyone here works themselves to the bone making films."[14]

○

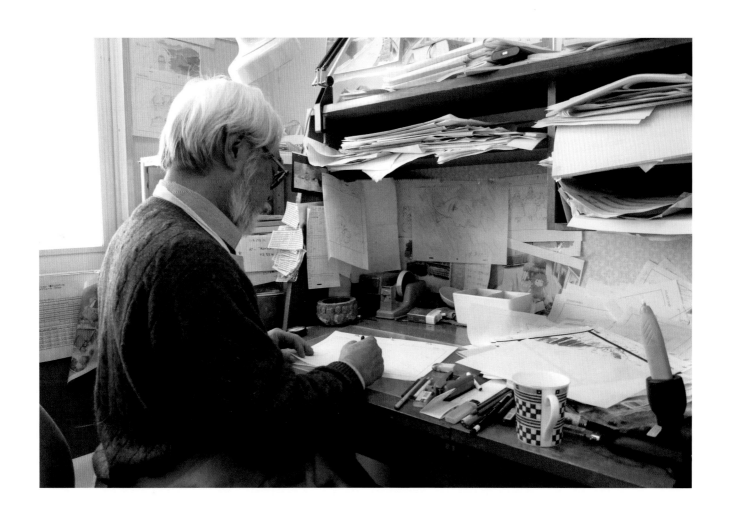

Hayao Miyazaki during the production of Ponyo, ca. 2008

AS A CORPORATION, Ghibli certainly expects its films to make enough money in revenue to be able to make another film; however, commercial success has never been a priority. Of the extent of his own interests, Miyazaki says, "I'm not limiting myself to the medium of film. There are a lot of beautiful things outside the world of film. That's what I believe."[15] Throughout a career that spans half a century, Miyazaki has always been determined to give children, the audience that most inspires him, hope in a world in which, he feels, they are often overwhelmed and overprotected. As a father himself, Miyazaki says his young sons "were both my motivation for work and my best audience."[16]

In 2001, the Ghibli Museum, Mitaka, was opened. Miyazaki designed the museum experience with children explicitly in mind: "All we need to do is create a space for them where they can be free, so that they can recover their original spirits. If they think the world is interesting, then they will become more curious."[17] Rather than following the concept of traditional museums, he invented a place that stimulates their sense of adventure and raises their curiosity through full-sensory activities: "It's important, in the process of experiencing things, to physically interact with the world and learn about it. Not just to see things, but to touch them, to smell them, and to taste them."[18] The museum is a series of environments where children are encouraged to run around and independently explore. The huge figure of the titular character from **My Neighbor Totoro** greets visitors at the entrance; inside, children can climb into a plush version of the Cat Bus from that film. True to its motto, **Maigo ni noroyo, issho ni,** meaning "Let's lose our way, together," the museum has winding staircases, narrow bridges, and displays concealed behind small doors inviting kids to open them.

Didactics and instructions are limited, following Miyazaki's focus on children. Just as children don't always fully understand every detail of their surroundings, he notes, "To understand this exhibit, people have to really think for themselves and stretch a bit. We're aiming a bit high here. We didn't want to aim too low by just pandering to the needs of the visitors. This is the way we've always created animation at Ghibli."[19] A part of the permanent exhibition is dedicated to the origins of animation and film. In the tradition of the three-dimensional viewing technology first invented by Étienne-Jules Marey in 1887, visitors can admire the astonishing effects of Ghibli's Bouncing Totoro Zoetrope.[20] The museum's theater screens short films Miyazaki makes exclusively for the venue, a highlight for all ages (although its low benches were specifically designed for young viewers).

A preschool designed by Miyazaki for the children of Ghibli staff, called Sanbiki no Kuma no ie, or "House of the Three Bears," is located within walking distance of the studio

and Miyazaki's atelier. The great filmmaker enjoys waving at the preschoolers walking by and welcomes their visits. The need to provide an environment in which the younger generation might thrive led to the preschool's founding in 2008. Like the Ghibli Museum, the preschool promotes concepts of experiential learning. For instance, it features a fireplace for cooking rice the old-fashioned way. Even though open fire and the heat of the rice pot may be dangerous, Miyazaki advises that children learn about traditional ways to prepare meals and taste the difference for themselves. Exposing children to the challenges of life is, from his point of view, necessary to facilitate their growth into stronger people: "We have to give children back the energy that they once used to have, to give them the energy that once gave them strength and allowed them to stand up to a little adversity."[21]

The Ghibli Museum and preschool are two major endeavors Miyazaki has undertaken beyond making films, yet he remains at work animating. When we first met at his atelier in the summer of 2017, he was deeply focused on his twelfth feature, *Kimitachi wa do ikiruka*. The translation of its title—"How will you live?"—sums up his oeuvre in a single question that hits at the core of his thinking and advocacy. In his own words: "I was the kind of boy who thought there must be something more important than my own happiness. . . . Even now, I still believe that there is something with greater meaning, beyond the individual." He continues, "I try not to think about things too far removed from me or too far off in the future. Instead, I try to do my best in a radius of five meters around me, for I feel ever more certain that what I discover there is real. It is better to make three children happy than to create a film for five million. It may not be good business, but to me this seems to be the real truth."[22]

NOTES

1 Miyazaki, "I Want to Fill the Space between Myself and the Audience," interview by Jun Watanabe, in Turning Point, 1997–2008, trans. Beth Cary and Frederik L. Schodt (San Francisco: VIZ Media, 2014), 78. Originally published in Hokkaido Shimbun, March 6, 1998.

2 Miyazaki, "On the Banks of the Sea of Decay: 'I'll still keep planting greenery and cleaning the rivers,'" in Starting Point, 1979–1996, trans. Beth Cary and Frederik L. Schodt (San Francisco: VIZ Media, 2009), 170. Originally published in Iki iki mizu bukku [Living Water, Loving Water], Kurashi to kankyo [Living and the Environment], published by Asahi Shinbunsha, July 20, 1994.

3 "I've always thought that, if given the chance, I might as well do what I really want." Miyazaki, "On the Banks of the Sea of Decay," 165.

4 Miyazaki, "Nature Is Both Generous, and Ferocious," in Starting Point, 338. Originally published in the roman album for Nausicaä of the Valley of the Wind (Tokyo: Tokuma Shoten, 1984).

5 Ghibli, referring to a hot wind of the Sahara Desert, was the familiar name for a type of Italian airplane flown during World War II. Toshio Suzuki, in an announcement at the Annecy International Animation Film Festival, Annecy, France, 1995.

6 Shinsuke Nonaka, interview by Jessica Niebel and Raúl Guzmán, Studio Ghibli, Tokyo, January 31, 2019.

7 Miyazaki, "What the Scenario Means to Me," in Starting Point, 58. Originally published in Koza Animation 3 "Image Design" (Tokyo: Bijutsu Shuppan-sha, 1989).

8 Miyazaki, "All I Want Is to Maintain a Workplace to Create Good Movies," in Starting Point, 89. Originally published in Animage, May 1991.

9 Nonaka, interview by Niebel and Guzmán.

10 Miyazaki, "All I Want Is to Maintain a Workplace to Create Good Movies," 89.

11 Nonaka, interview by Niebel and Guzmán.

12 Miyazaki, "Nostalgia for a Lost World," in Starting Point, 20. Originally published in Gekkan ehon bessatsu: Animeshon [Animation: Monthly Picture Book Special], March 1979.

13 Akihiko Yamashita (animator), in Miyazaki, The Art of Howl's Moving Castle (San Francisco: VIZ Media, 2005), 59. Yamashita has worked with Miyazaki since Spirited Away and was supervising animator for Howl's Moving Castle.

14 Miyazaki, "'Don't Worry, You'll Be All Right': What I'd Like to Convey to Children," in Turning Point, 222. Originally published in the roman album for Spirited Away (Tokyo: Tokuma Shoten, 2001).

15 Miyazaki, "I've Always Wanted to Create a Film about Which I Could Say, 'I'm Just Glad I Was Born, So I Could Make This,'" press conference at the 62nd Venice International Film Festival, September 8, 2005, in Turning Point, 327.

16 Miyazaki, "I Left Raising Our Children to My Wife," in Starting Point, 204. Originally published in Chunichi Shimbun, January 31, 1991.

17 Miyazaki, "Nothing Makes Me Happier Than Watching Children Enjoy Themselves: Three Months after the Opening of the Ghibli Museum," in Turning Point, 275. Originally published in Graph Mitaka 14 (March 2002).

18 Miyazaki, 273.

19 Miyazaki, "Children Have a Future That Transcends 'Imagination,'" in Turning Point, 264. Originally delivered as a talk and published by the Fuji Research Institute in Gekkan O Fai [Monthly O Phi], January 2002.

20 Ghibli's Bouncing Totoro Zoetrope inspired Pixar to create a Toy Story Zoetrope, which Pixar has gifted to the Academy Museum.

21 Miyazaki, "Children Have a Future That Transcends 'Imagination,'" 265.

22 Miyazaki, "Memories of Lost Landscapes: On Genzaburo Yoshino's Kimitachi wa do ikiruka (How Will You Live?)," in Turning Point, 399, 402. Originally published in Neppu, June 2006.

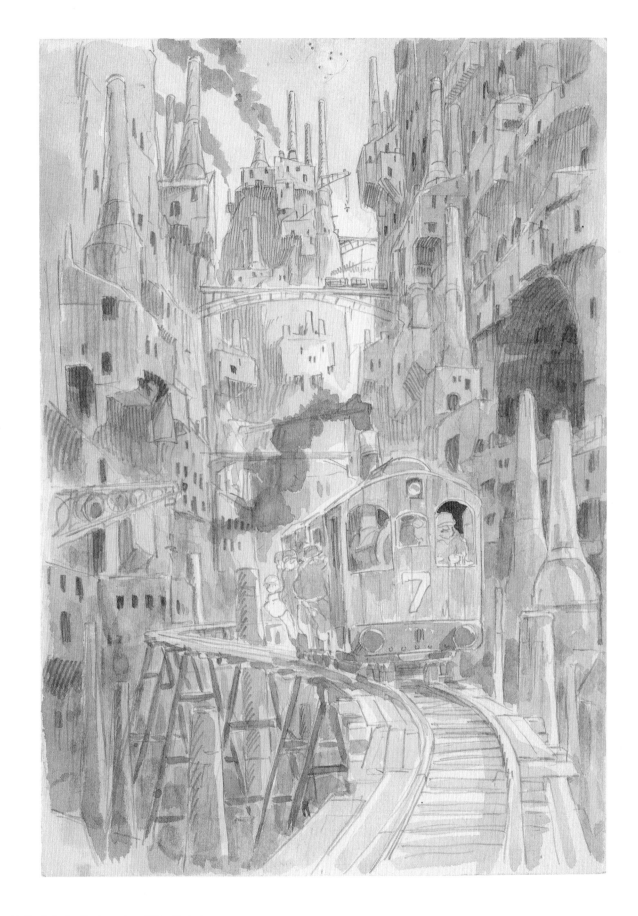

Hayao Miyazaki, Castle in the Sky imageboard (Slag Ravine)

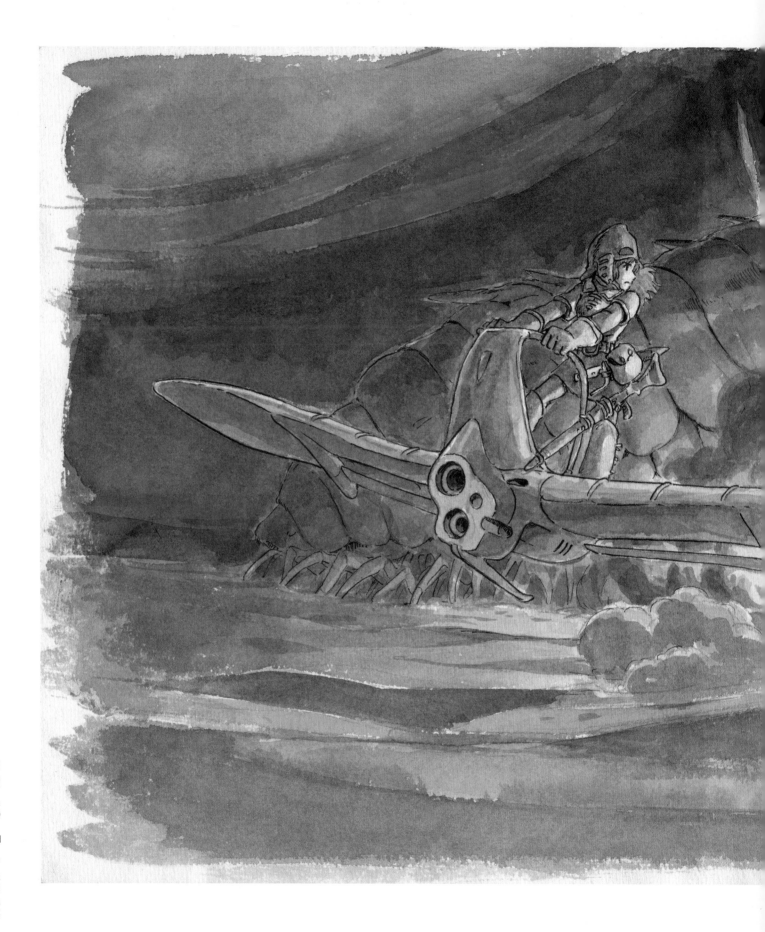

"HIDDEN AMONG THE MANY ILLUSTRATIONS DRAWN AT THE CONCEPTUAL STAGE, AMONG ALL THE MATERIALS ORIGINALLY USED IN DISCUSSING THE CHAOTIC AND DISPARATE IDEAS, LIES THE REAL STORY WE WANT TO CREATE."

Hayao Miyazaki, Nausicaä of the Valley of the Wind
initial imageboard

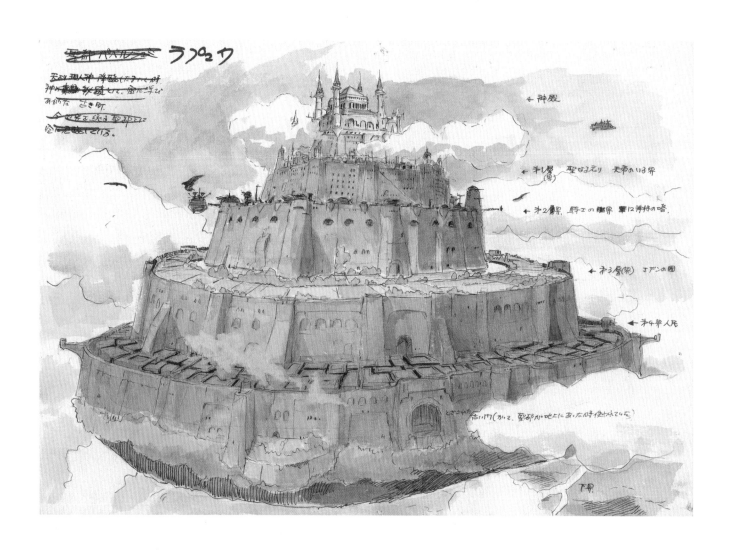

Hayao Miyazaki, Castle in the Sky
imageboard (initial concept for flying castle)

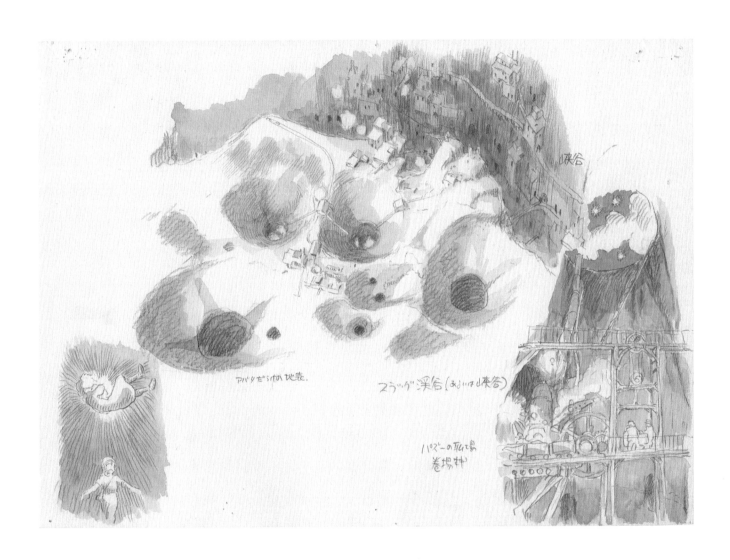

峡谷

アバタだらけの地表.

スラッグ渓谷 (あるいは峡谷)

パズーの私も島
巻場井

Hayao Miyazaki, Castle in the Sky imageboard
(Slag Ravine, Pazu catches Sheeta)

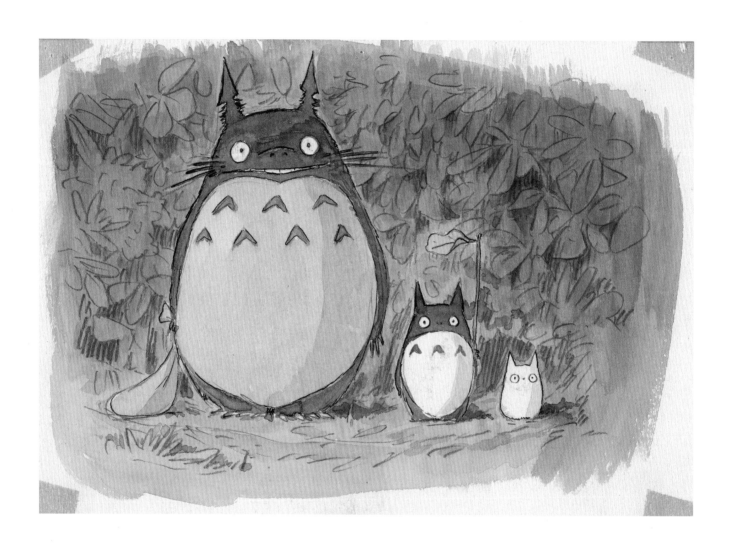

Hayao Miyazaki, My Neighbor Totoro
imageboard

The Totoros were initially named
Miminzuku, Zuku, and Min.

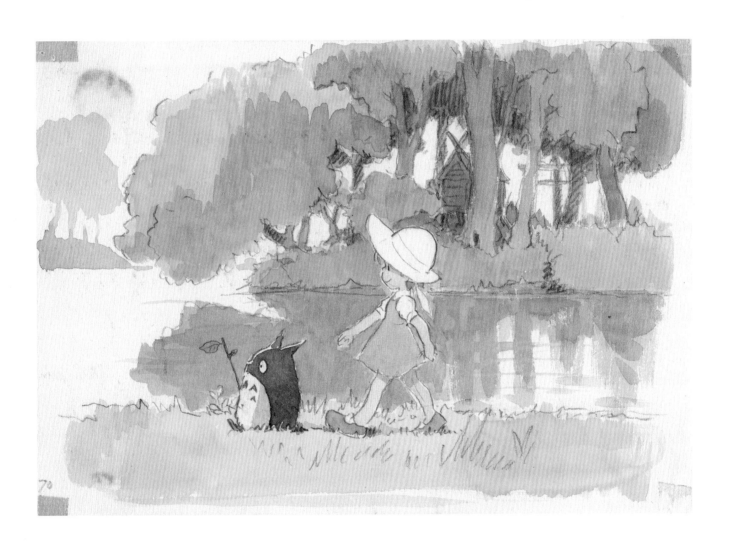

Hayao Miyazaki, *My Neighbor Totoro* initial imageboard
(Mei's first encounter with medium Totoro)

Kiki's Delivery Service imageboard
(Okino residence)

Kiki's Delivery Service imageboard
(Kiki on grassy knoll)

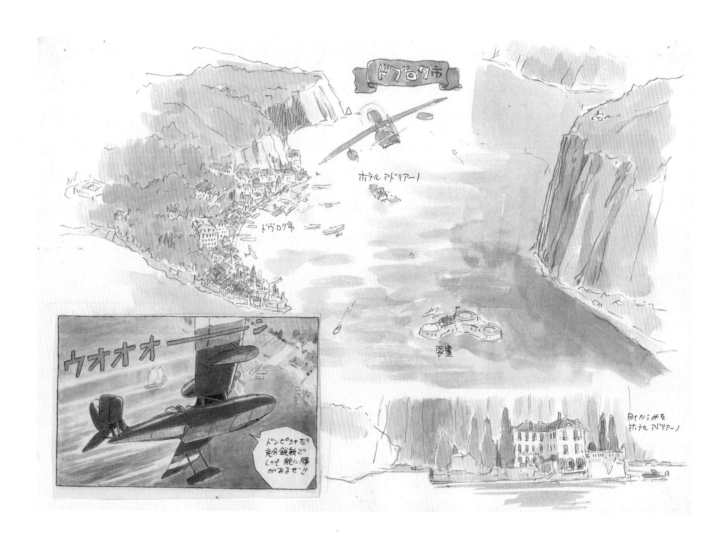

Hayao Miyazaki, *Porco Rosso*
initial imageboard (Doburoku City,
aerial map)

Hayao Miyazaki, *Porco Rosso*
initial imageboard (Porco's seaplane
approaches Hotel Adriano)

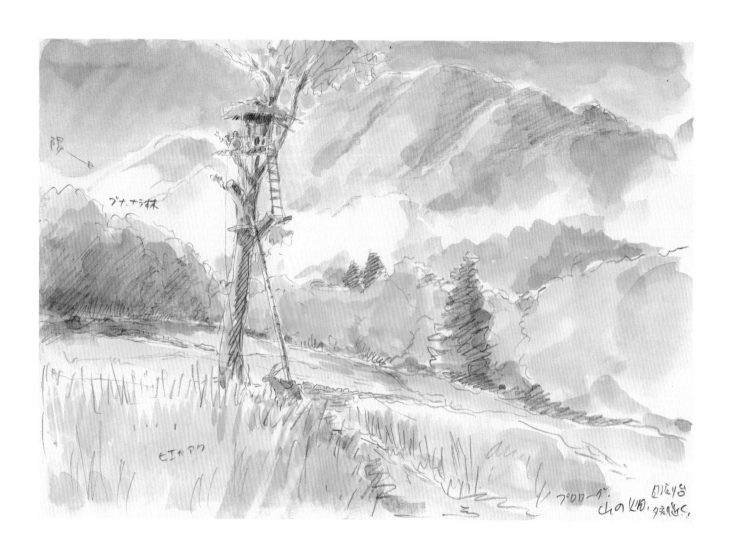

Hayao Miyazaki, *Princess Mononoke* imageboard
(Emishi Village, watchtower)

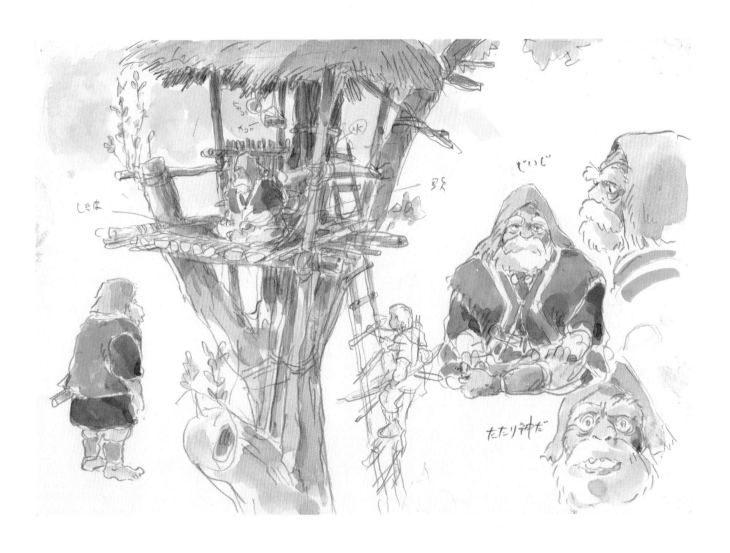

Hayao Miyazaki, Princess Mononoke imageboard
(Ji-san in watchtower with Ashitaka)

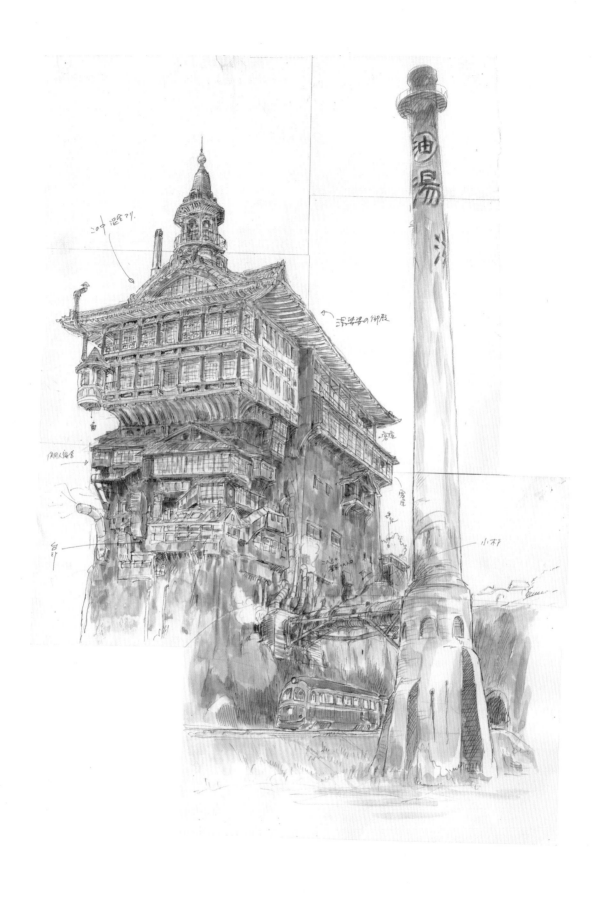

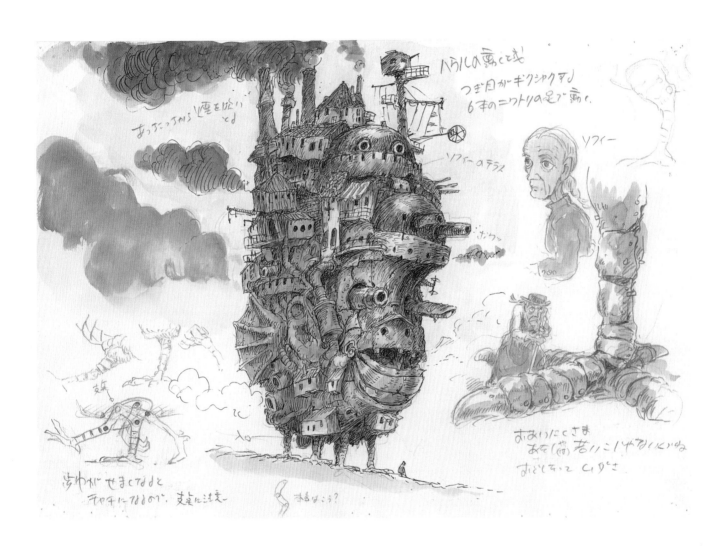

OPPOSITE: Hayao Miyazaki, *Spirited Away*
imageboard (bathhouse exterior)

ABOVE: Hayao Miyazaki, *Howl's Moving Castle*
initial imageboard (Howl's castle and Sophie)

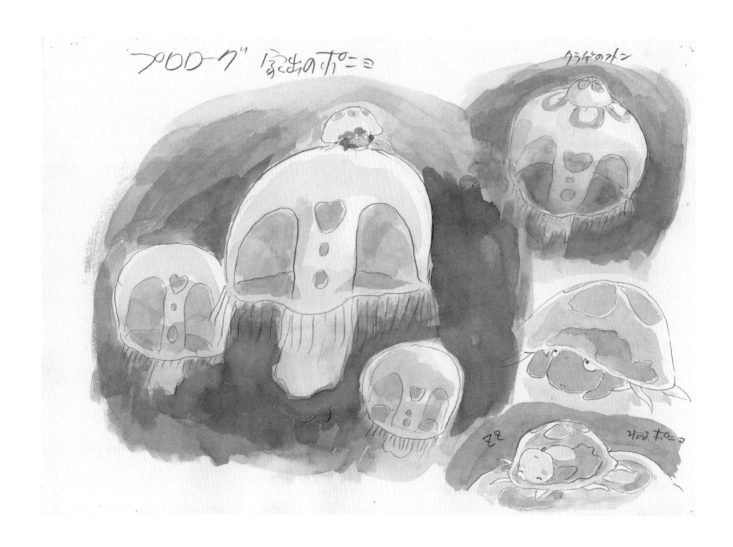

Hayao Miyazaki, Ponyo imageboard
(Ponyo on jellyfish)

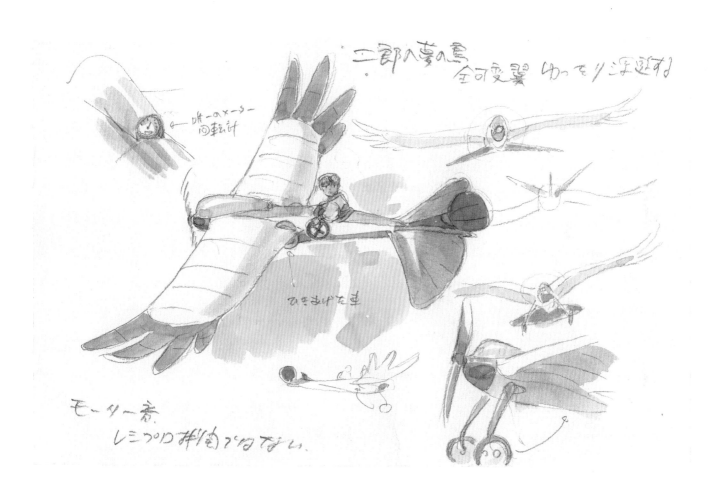

Hayao Miyazaki, *The Wind Rises* imageboard
(Jiro's bird-shaped airplane)

秒

株式会社 東京ムービー新社

"WE HAVE CONSISTENTLY TRIED TO MAKE 'FILMS,' NOT 'ANIME.'"

THE RISE OF THE MIYAZAKI MEDIUM

DANIEL KOTHENSCHULTE

HAYAO MIYAZAKI IS FREQUENTLY DESCRIBED IN SUPERLATIVE TERMS—formulations such as "the world's finest living animator" are common—and indeed his standing in the history of animation is uncontested. And yet such assessments do not truly do him justice because his importance as a filmmaker far transcends the realm of animation. Looking at the eleven feature-length films he has directed to date, each one of them a masterpiece in its own right, it is easy to explain their international success with hindsight: his films draw in their audiences right from the start by whisking them away to fully formed artistic worlds, as rich in detail as those in any of the style-forming classics of the fairy-tale genre, films like **Snow White and the Seven Dwarfs** (USA, 1937), **The Wizard of Oz** (USA, 1939), and Michael Powell and Ludwig Berger's version of **The Thief of Bagdad** (USA, 1940). In an almost symphonic way, Miyazaki's films orchestrate drama and calm and create an ideal emotional setting for the sensations stemming from his imagination. Similarly, his aesthetic finds a balance between traditional and modern visual languages, between the landscape painting of past centuries and surreal pictorial worlds, between the graphic stylization of traditional Japanese art and the radiant colorfulness of European impressionism. Whoever travels through forests, deserts, and deep-blue skies and seas with Miyazaki's protagonists simultaneously travels through time, which might be why these figures often choose modes of transport that appear antiquated and futuristic in equal measure. And if the realm of the fantastic happens to reflect the problems of our present reality, it is done unobtrusively but nonetheless persistently, much like Miyazaki's appeals for the preservation of nature and cultural traditions. What has, more than anything, contributed to Miyazaki's fame is this ability to create his own fully imagined universe through an unmistakable combination of storytelling and stunning visual language; in her biography of the same name, Susan Napier calls this "Miyazakiworld."[1] But as complete as this world is, as much as it entirely absorbs us as viewers, it nonetheless pursues a different kind of illusionism than that of Disney's classical feature animation.

PREVIOUS SPREAD: Lupin the 3rd: The Castle of Cagliostro layout drawing

When Western pop culture was only just beginning to discover manga and anime, Miyazaki distanced himself from these, the very mediums whose most important representative he was thought to be. "We have consistently tried to make 'films,' not 'anime,'" he told an interviewer in 1997, when his film **Princess Mononoke** had just broken box-office records in Japan.² Highly self-critical even then, at the height of his fame, he wondered whether he would be able to completely free himself from the influence of Osamu Tezuka (1928–1989), the extraordinarily prolific artist who initiated the golden age of manga in 1947 with **New Treasure Island (Shin Takarajima)** and went on to become the father of TV anime. With its large-eyed characters, Tezuka's seminal TV series **Astro Boy** (1963–66) (fig. 1), based on a manga that first appeared in 1952, came to epitomize the aesthetic of televised anime and Japanese animated films.

"Just as Tezuka-san couldn't escape Disney's spell while respecting Disney, I too am mired in the spell of Tezuka-san for drawing and director [Akira] Kurosawa for filmmaking," he said in the same 1997 interview. Indeed, as much as Miyazaki valued Tezuka's manga work, he harbored much criticism for his animation. In an essay published only three months after Tezuka's death, Miyazaki writes, "I appreciate him for being the person to pioneer story manga, and for having created the current of times in which we work today. . . . In terms of animation, however, I think I have the right and responsibility to say the following: Everything that Mr. Tezuka talked about or emphasized was wrong. . . . Tezuka's early works are almost all just imitations of Disney. To them he merely added his own narrative element. I say added, but his worlds continued to be created under huge influence from Disney. As a result, he always had an inferiority complex, a fear that he would never be able to surpass 'the great old man.'"³

While the influence of Tezuka can only barely be perceived in a film like **Princess Mononoke**, that of Kurosawa, conversely, is very present: the fast-paced tracking shots through the forest (fig. 2) are reminiscent of **Throne of Blood (Kumonosu-jō**, Japan, 1957), while the mass choreographies in the battle scenes betray the influence of **Ran** (Japan, 1985). For his part, Kurosawa, who included **My Neighbor Totoro** on a list of his 100 favorite films, considered Miyazaki a role model for Japanese film culture: "It's anime, but I was so moved. . . . I cried when I watched **Kiki's Delivery Service**. Really, all the talents I want for the movie industry have gone to the anime, so the movie industry has to really work hard. We have to make such movies that they make young people want to [see them]."⁴

fig. 1 Astro Boy (1963–66)

THOSE SEEKING TO UNDERSTAND Miyazaki's unique artistry cannot contemplate it only in the context of animation. In the early years of his career, Miyazaki—together with his teacher, mentor, and later colleague and artistic collaborator the anime director Isao Takahata (1935–2018) — carved out a niche within the anime industry, only to then oppose it with a counterproject and eventually an ideal in Studio Ghibli, which the two cofounded with producer Toshio Suzuki in 1985. In doing so, Miyazaki was able to create a fusion of auteur and studio cinema, a rare accomplishment in the history of film. Since the days of the visionaries of silent movies—Charlie Chaplin, Harold Lloyd, and Buster Keaton—few artists have been able to realize their visions as studio heads. Not even Walt Disney managed to do so, for he did not create drawings himself, nor did he execute his personal visions in the way that Miyazaki has. (It is ironic that while Disney was criticized for only rarely giving credit to individual animators, concept artists, color stylists, and art directors, we can nonetheless make out their contributions in all of his films; an entire branch of Disney research is dedicated to their careers.) Miyazaki's output, in contrast, has been viewed almost exclusively as the personal vision of a single artist. It is, in fact, he alone who determines every detail of his films, from storyboards and character designs to the animation of key scenes. What applies here is the principle of the master workshop, even though Miyazaki, who developed views critical of capitalism in his youth, aimed to provide an alternative to the alienated working conditions of the anime industry. Even with 200 to 300 employees working on his films, there has never been a feeling of anything resembling an "industry" at Studio Ghibli.

Apart from a handful of auteurs—among them Chaplin, Kurosawa, F. W. Murnau, Yasujiro Ozu, Mikio Naruse, Orson Welles, Jean Cocteau, Luis Buñuel, Michael Powell and Emeric Pressburger, Federico Fellini—very few filmmakers have ever realized their personal vision this comprehensively in studio cinema, which relies on the division of labor. At the same time, Miyazaki is no modernist; the innovations of the Japanese and European avant-gardes of the 1960s, which he encountered during his early working years whenever he went to the cinema, left him unimpressed. According to Takahata, he always aimed for an illusionist cinematic experience: "With Miyazaki you have to totally believe in the world of the film. He is demanding that the audience enter the world he has created completely. The audience is being asked to surrender." Takahata saw this as constituting a fundamental difference between them as collaborators and cofounders of Studio Ghibli. "I want the audience to have a little distance," he stated in 2005.[5]

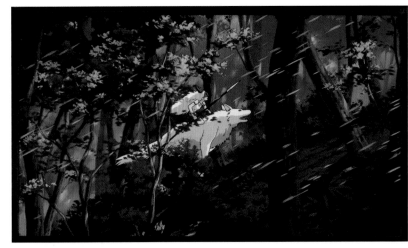

fig. 2 Princess Mononoke (1997)

ANIME BEFORE CINEMA

LONG BEFORE THERE WAS A GHIBLI MUSEUM, each of Miyazaki's films was a virtual museum, one that afforded refuge to all kinds of endangered and beautiful things, be they literary figures, mythological places, nature, or fantasy itself. At the same time, the fact that his medium, hand-drawn animation, has become virtually a dying art gives rise to a certain degree of nostalgia.

Anime was most likely born in the home theater. German magic-lantern projectors, which were able to play 35mm filmlets, were widespread in Japan at the beginning of the twentieth century. The earliest animated movie was created in Japan in 1907 for one of these home-use apparatuses; discovered in 2005, it consisted of a mere fifty hand-drawn images on a strip of 35mm film.[6] The history of anime created for the cinema would get underway in 1917, but Japan's national culture of animated movies would not get a name of its own for quite some time. According to the anime historian Nobuyuki Tsugata, the term anime did not appear in specialist magazines until after 1955, and daily newspapers did not start using it until the mid-1970s.[7]

Film historians have long considered animation a mere subcategory and, in doing so, have contributed to its marginalization. There are, however, many reasons why the exact opposite may be true. Animated images existed well before the invention of film. Nowhere is this better known than in Japan, which has a long tradition of narrative visual mediums such as emakimono, illustrated handscrolls that date as far back as the eighth century, and woodblock-printed picture books of the eighteenth and nineteenth centuries. Considering manga and anime to be direct descendants of these earlier Japanese art forms is controversial, though, especially when such claims are made by exoticizing Western art historians and critics; contemporary manga and anime artists are far more likely to be influenced by filmic narrative forms. The prehistory of cinema is nonetheless paramount for the self-concept of the directors at Studio Ghibli, who deliberately developed a history of their medium that did not begin with Disney and his admirer Tezuka.

In 1999, the studio published a book on the subject, written by Takahata, that conducts an in-depth analysis of several picture scrolls that have been classified as national cultural treasures, comparing them with modern animation techniques.[8] For Takahata, their aesthetic similarities can be explained by a continuity in their narrative function:

> Why does Japan generate so many manga and anime? And how are they able to captivate children and grownups alike? . . . It is that from the 12th century to today, a culture of using pictures to tell interesting stories—and to enjoy them as entertainment—has been part of Japan. While this may seem unusual, most of these narrative pictures were made for people who could read and write. Much like modern manga, the early art was easy to handle, and . . . put more emphasis upon the drawing than the writing to develop and convey exciting stories to visually appeal to the imagination of their audience. In that sense, the early drawings are quite like contemporary manga and anime in terms of visual and time expression.[9]

Among the twelfth-century picture scrolls highlighted by Takahata for their superior depiction of movement and expression of emotion are the **Choju-jinbutsu-giga** (Scrolls of Frolicking Animals). Their lively drawings of rabbits, monkeys, and frogs getting up to some mischief can be considered groundbreaking for all anthropomorphic figures in the history of art.

If there is a common thread that takes us from these earlier forms to the aesthetics of manga and anime, it is the positive relationship with two-dimensionality. To Miyazaki, "Japanese people like to recognize and perceive things in outline form—as lines. There are, in contrast, other peoples in the world who like to perceive things in terms of volumes or solid shapes. . . . As the popularity of narrative picture scrolls during the Heian and Kamakura periods shows, Japanese people have a long tradition in believing that they can represent all worldly phenomena with a combination of drawings and words. Politics, economics, religion, art, war, eroticism— there is nothing that narrative picture scrolls did not attempt to depict. We have inherited this tradition and continue it today."[10]

When cinema established itself in Japan at the start of the twentieth century, it was competing with two other forms of two-dimensional visual storytelling: magic-lantern shows and shadow plays. Due to their modest technical setups, these popular forms of entertainment were able to defy the more technologically advanced competition so remarkably well that for a long time they existed alongside one another. **Kamishibai** (paper plays), a type of street theater that employed illustrated boards and the spoken narration of a candy-selling **kamishibaiya**, started around 1910 and remained the most popular children's entertainment when Miyazaki was growing up in the years immediately following World War II (fig. 3). There were 10,000 **kamishibai** theaters in 1953, when the advent of Japanese television marked the beginning of their decline. (Ironically, a popular name for the new medium was "electric **kamishibai**.") In Tokyo alone, there were twenty companies that produced **kamishibai** boards, many of their illustrators later moving to manga.[11]

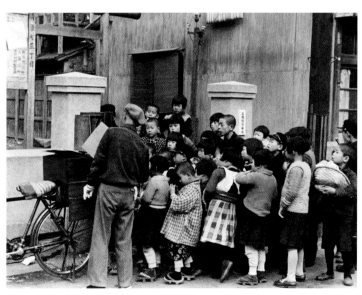

fig. 3 A kamishibai (paper theater) show in postwar Japan

Miyazaki (center) and Takahata (right) at A Production studios, ca. 1971

IN LOVE WITH AN ANIME PRINCESS: MIYAZAKI'S CALLING

IN 1963, WHEN MIYAZAKI DECIDED TO WORK IN THE FILM INDUSTRY after completing a degree in economics and politics, the classical era of postwar Japanese cinema was coming to an end: Ozu died that year, and Naruse shot his last film four years later. Younger directors associated with the Japanese New Wave, such as Nagisa Oshima and Kaneto Shindo, were countering studio cinema with a more experimental aesthetic. As a passionate cinemagoer, Miyazaki followed the selection of the progressive distributor Art Theatre Guild, which campaigned for modern cinema in the 1960s. Nonetheless, he felt closest to Chaplin's **Modern Times** (USA, 1936).

As he has repeatedly emphasized, it was love that brought Miyazaki to animation. Princess Bai-Niang (fig. 4), the heroine of the first Japanese feature-length animated film in color, **Panda and the Magic Serpent (Hakujaden,** 1958), captivated the teenager with a mixture of grace, girlishness, and self-confidence that makes her seem like an ancestor of the female protagonists who would eventually appear in Miyazaki's films. **Panda and the Magic Serpent** also includes a theme that recurs in almost all of Miyazaki's films: an innocent love that arises from a friendship between two children. The loss of magical powers and the price a heroine is prepared to pay for love are echoed, too, in Miyazaki's films **Kiki's Delivery Service** and **Ponyo.** Of his first encounter with **Panda and the Magic Serpent,** Miyazaki would later recall, "It was as if the scales fell from my eyes; I realized that I should depict the honesty and goodness of children in my work."[12]

From the very first frame, the playful panda that belongs to the male lead, Xu Xian, charms us as one of the most memorable cartoon stars in history—and anticipates the comical protagonist in Miyazaki and Takahata's early film **Panda! Go Panda!** The sequence of a dramatic storm at sea with its raging whale is reminiscent of Disney's **Pinocchio** (1940), which had come to Japanese screens in 1952 and had a tremendous impact; meanwhile, the Chinese motifs recall the cinematic style of the Wan brothers. Just as the great live-action directors such as Ozu, Naruse, Kenji Mizoguchi, and Heinosuke Gosho deliberately drew from both Japanese and Western traditions with regard to their stylistic devices, anime was now also demonstrating this kind of freedom. Miyazaki took note of this, and it would be a distinctive feature of the movies he would later make.

The seventeen-year-old Miyazaki watched **Panda and the Magic Serpent** three times, but once he found himself employed as an in-between animator, or in-betweener, at Toei Animation—the very studio that had produced the film—this magic paled in comparison with a new influence: "All I could remember of the work was how imperfect it had been. Had I not one day seen **Snezhnaya Koroleva** [The Snow Queen, 1957] during a film screening hosted by the company labor union, I honestly doubt that I would have continued working

fig. 4 Panda and the Magic Serpent (1958)

as an animator."[13] Numerous Miyazaki motifs originate in the Russian classic; for example, the relationship between the present and a timeless world of fairy tales, and the close rapport between children and their grandparents' generation. The exciting airplane piloted by Father Frost may have made as much of an impression as the suggestive backdrops of the ice palace, which resonate in the subterranean world that Miyazaki's heroine Nausicaä discovers.

It was Takahata, Miyazaki's senior by five years, who recognized Miyazaki's talent during his early days at Toei and mentored him. The young in-betweener also left a deep and immediate impression on one of the leading animators, Yasuo Otsuka, who would later become the animation director and character designer for two of Miyazaki's directorial projects, **Lupin the 3rd: The Castle of Cagliostro** and the television series **Future Boy Conan**. During their collaboration on the feature film **Gulliver's Travels beyond the Moon**, Miyazaki pushed through minor but pivotal changes to the story. At the conclusion of the space odyssey, an aging Gulliver, together with a small boy, saves a robot princess who has been carried off by evil robots inside a giant chess piece. In the closing sequence, they open the chess piece and the robot princess splits apart, revealing a beautiful human princess within. According to Otsuka: "The change was only a single cut but from the point of view of the work as a whole it was an enormous departure. . . . From that time on Miyazaki pursued the core of animation in terms of strongly advocating the evocation of human beings within the overall theme of the work."[14]

Miyazaki's years of apprenticeship took place during revolutionary times, when student protests and fundamental societal changes were shaking the strict hierarchies at Toei. In 1965–68, Takahata—who, like Miyazaki, was a union activist (fig. 5)—produced his first movie, **Little Norse Prince Valiant**, and as its sole director used a new kind of teamwork. Miyazaki, until then an in-betweener on the lowest rungs of the studio hierarchy, advanced to scene designer. He drew the majority of the detailed backdrops and animated a spectacular nature figure, the stone man at the start of the film, affording us a preview of his future creatures. Set in a deeply colored yet sparse and desolate Nordic landscape, **Little Norse Prince Valiant** depicts the lonely journey of a boy named Hols who pulls a sword out of the body of the stone creature. The medieval legend of King Arthur and motifs from Richard Wagner's **Ring of the Nibelung** are combined to form a simple story with moments when the fantastical enters the narrative—for example, when the boy's friend turns out to be a witch. The film feels immediately familiar to those who know Miyazaki's later work.

Takahata was a master of visual storytelling, but he did not create any of **Little Norse Prince Valiant**'s drawings himself. It was Miyazaki who took over on those tasks not related to directing. This hierarchical division of labor would continue for some years after they left Toei, in 1971, to work at the studios A Production and later Nippon Animation. This might have given

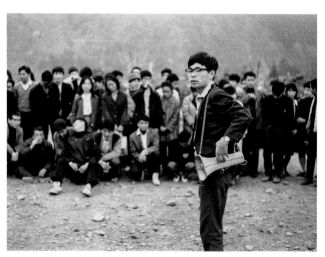

fig. 5 Hayao Miyazaki as a union activist, ca. 1964

rise to a subliminal rivalry between the two friends, which stayed with them even into their long partnership at Studio Ghibli.

One particularly successful example of the way they distributed their work at the time is the TV series Heidi, Girl of the Alps, which Takahata directed, with Miyazaki working on the scene design and animating the opening credits. For Miyazaki, Heidi has remained Takahata's "masterpiece," even as his other films, such as Grave of the Fireflies, have proved far more popular: "Given all the restrictions in animation then, he did everything he could. Not only that, he accomplished so much."[15] Their follow-up project was another TV adaptation of a children's book from the early twentieth century. Anne of Green Gables, a girl's coming-of-age story set against lush Canadian landscape backgrounds, enjoyed equal success but offered Miyazaki little in the way of new challenges. After fifteen episodes, he quit the collaboration with Takahata. "The days of making 'our' films and calling ourselves partners are over. We're at the next stage. I had to start directing."[16]

○

MIYAZAKI HAD IN FACT COMPLETED HIS FIRST EFFORT AS A DIRECTOR, the TV series Future Boy Conan, in 1978, while at Nippon Animation. The show set new standards for the medium and can be considered the foundation for his later masterpieces. Based loosely on The Incredible Tide (1970), a young-adult novel by the US science-fiction writer Alexander Key, the 26-episode series takes place in a postapocalyptic world that counts an eleven-year-old boy and his grandfather among its few survivors. After the death of the grandfather, the boy leaves the secluded island where they have been living in order to search for a girl who washed up on the beach only to be kidnapped straightaway by a stranger.

Miyazaki's interpretation is a far cry from the dystopian milieu of the novel. His version sees the largely depopulated world as an almost Edenic setting for a Robinsonade. "I didn't like the original story," he explained when interviewed about the series. "The author's views of an End Times or Armageddon come from his own latent insecurities and fears, so he brought an awful lot of pessimism with him."[17] In later years, Miyazaki would continue to defend his method of freely interpreting original novels without conforming to the wishes of the original authors, as would be the case with his adaptation of Eiko Kadono's story Kiki's Delivery Service.

As in Miyazaki's later manga and its film version, Nausicaä of the Valley of the Wind, nature has reclaimed a destroyed earth in Future Boy Conan, an optimistic take on the story's ecological message: "I have been told [that] the idea that nature can recover by itself may be a very Japanese one. . . . It's sort of like cutting down a tree: when you do, you later get an explosion of weeds and brush, right? But in the real world, there are lots of places where, after you cut down the trees, you wind up with nothing growing at all."[18]

For Miyazaki, a world largely liberated from the evidence of modern civilization afforded a kind of futurism devoid of the visual codes of science fiction since the days of Tezuka's first TV series, Astro Boy, one of anime's most favored genres. The spartan design of intergalactic settings and spaceships, and the limited movements of robots and androids, allowed for an extreme

economy in animation. When Miyazaki chose deserted or postapocalyptic settings in his later work, he took the opposite tack, showing a wealth of detail. He was critical of the low industry standards that Tezuka and his many imitators established: "Because he established this precedent, animation productions ever after have unfortunately suffered from low budgets."[19]

Even though Miyazaki was able to negotiate a delivery deadline of two weeks per episode with the network, Japan Broadcasting Corporation (NHK), the low budget and demanding pace of TV animation barely allowed for the high quality he had envisioned. Despite these restrictions, Future Boy Conan's adventures are dynamic and exceedingly entertaining. What makes the series unique, however, is the high level of emotion Miyazaki achieves using a limited number of animation drawings. In the second episode, for example, key animator Yoshifumi Kondo managed to combine expressions of anger and grief in Conan's face following the death of his grandfather (fig. 6). It is the most pronounced departure possible from any kind of naturalism—an almost abstract expression that appears profoundly human despite employing the simplest means. Miyazaki also made use of the reduced number of drawings per second to suspend the action and create moments of conscious pause, a technique that would carry over to his more expensively produced feature films. The film critic Roger Ebert once wrote: "I told Miyazaki I love the 'gratuitous motion' in his films; instead of every movement being dictated by the story, sometimes people will just sit for a moment, or they will sigh, or look in a running stream, or do something extra, not to advance the story but only to give the sense of time and place and who they are. 'We have a word for that in Japanese,' [Miyazaki] said. 'It's called ma. Emptiness. It's there intentionally.'"[20]

Anticipating Nausicaä, Future Boy Conan took television audiences to a future closer to the past than to the present. The resulting impression of timelessness corresponds to an impulse— a longing to flee from the here and now—that Miyazaki had attributed to teenagers, the core audience of anime: "It's a sense that although you may currently be living in a world of constraints, if you were free from these constraints, you would be able to do all sorts of things. The word nostalgia comes to mind. Adults, fondly recalling something from their childhood, often speak of nostalgia. But even three-, four-, and five-year-olds feel a similar sentiment. . . . Yet, we can still enjoy ourselves in different fantasy worlds. And this yearning for other, lost possibilities may also be a major motivator for those of us in the industry."[21]

This thought has numerous implications for the interpretation of Miyazaki's later work. On the one hand, it shows great understanding of the tendency toward escapism associated with anime fan culture. On the other, the ambiguous treatment of location and time provides an opportunity for enormous narrative freedom. And more than that, even if international distribution was not a consideration in Miyazaki's early work, his words suggest a cosmopolitan point of view that can be regarded as the basis for his subsequent worldwide success. By freely combining European, Japanese, and mythological settings, he would go on to create universal locations and places of longing.

fig. 6 Future Boy Conan (1978)

WALT DISNEY FOUND INSPIRATION for the mountain village in Pinocchio not just in author Carlo Collodi's Italy but also in the picture-postcard views of the Bavarian town of Rothenburg ob der Tauber. Miyazaki, for his artistic projects that would follow Future Boy Conan, drew inspiration from travels undertaken with Takahata for past projects. For 1974's Heidi, the two had visited the Swiss and German Alps, and for a planned adaptation of the children's book Pippi Longstocking (1945), they traveled to Stockholm. The setting for Miyazaki's feature-length directorial debut, Lupin the 3rd: The Castle of Cagliostro, is a patchwork of these Central European dream locations.

The film's hero, the charming thief Lupin, appears as familiar as the mountainscapes and Mediterranean flair of the fictitious duchy of Cagliostro. To be clear, Lupin himself is also stolen goods: Monkey Punch (Kazuhiko Kato), author of the original manga on which the story is based, modeled him on Arsène Lupin, the protagonist of a series of novels by the French author Maurice Leblanc, who between 1905 and 1935 produced 20 volumes, among them La Comtesse de Cagliostro (1924). Miyazaki is cowriter of the screenplay, storyboard designer, and director of this romantic adventure film, which is set in the posthippie era of its making. In this sense, the magical story offers yet another example of his concept of nostalgia: "At the end of the 1960s, young people were still humming antiwar songs. . . . Around 1970, however, this once-exhilarating mood dissipated, and some people began boasting about how apathetic they were. Apathy itself became a trend of the new era. . . . Unlike traditional heroes who would grin and bear whatever hardships they faced, Lupin took full advantage of a bountiful consumer society and was truly a creature of his era."[22]

For Miyazaki, the fashion for minicar racing, a modest and short-lived pleasure, was characteristic of this moment in an increasingly prosperous Japan. This affinity for subcompact cars provided the inspiration for the yellow Fiat 500 (fig. 7) Lupin drives during a wild car chase at the outset of the film. The director himself was a passionate fan of the Citroën 2CV: "Even animators like us, who had traditionally boasted of having the lowest incomes in society, were suddenly able to drive cars."[23] The comedy inherent in these scenes is reminiscent of European adventure comedies of the 1960s and 1970s such as those directed by Philippe de Broca and starring Jean-Paul Belmondo.

While the contemporary references reveal the era of the film's creation—a rarity in Miyazaki's work—the magical elements appear timeless: the atmospheric skid across the roof of the castle combines the sophisticated flair of Alfred Hitchcock's To Catch a Thief (USA, 1955) with the poetic surrealism of the French animator Paul

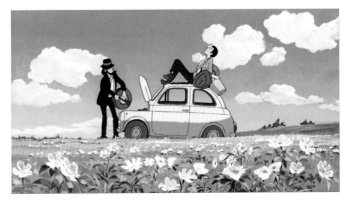

fig. 7 Lupin the 3rd: The Castle of Cagliostro (1979)

Grimault. Miyazaki is an admirer of Grimault's classic The King and the Mockingbird (Le roi et l'oiseau, France, original release [unfinished] 1952; completed 1980), and the architecture of that film's fantastical castle is instantly recognizable in the backdrops of The Castle of Cagliostro.

There is also a faint hint of Walt Disney, whose films Miyazaki saw in his youth but, as a filmmaker, looked upon with great detachment. During the rescue mission, Lupin and the runaway princess Clarisse find themselves standing on the hand of a large tower clock, recalling a well-known scene from Peter Pan (USA, 1953), and the setting inside the clock bears a likeness to Disney's classic Clock Cleaners (USA, 1937). The dangerous cogwheels are modeled not only on Chaplin's Modern Times, a Miyazaki favorite, but also on the Disney cartoon The Old Mill (1937), which, with its concept of animate nature and the humanized depiction of the derelict building, had already inspired the early Japanese anime classic Spider and Tulip (Kumo to Churippu, 1943).

Later, Miyazaki would rightly disagree with Western critics who consider him a "Japanese Disney," a patronizing compliment that ignores both his independent concept of art and his comprehensive creative functions. ("Walt Disney was a producer. I am a working animator and director, so I don't like to be compared to him," he said in 1998.[24]) By his own account, his distance from Disney also played a role with regard to his positioning within the Japanese anime industry: "The generation ten years older than my colleagues and me was influenced by Disney. The earlier Disney films like Snow White and the Seven Dwarfs, Fantasia, and Pinocchio were all wonderful in terms of technique. But their depiction of the inner thoughts of human beings was so simplistic that I didn't enjoy them very much."[25]

Miyazaki's relationship with individual Disney films, however, is rather differentiated. To an audience of animators in 1982, he recommended The Old Mill as a prime example of effects animation, "a pinnacle of achievement, something never surpassed by any subsequent Disney animation." For him, Snow White demonstrates "how animators can complete a work in a very healthy way, achieving a type of perfection in the process."[26] Elsewhere he adopted a critical stance toward Disney's veteran team of animators known as the Nine Old Men, for their ideal of an "illusion of life" in the animation of human figures: "Disney's Cinderella is living proof that modeling live-action images in the pursuit of realistic movement is a double-edged sword. In trying to achieve a sense of realism by using an average American young woman as model, they lost even more of the inherent symbolism of the original Cinderella story than they did with their version of Snow White."[27] This statement might explain why, to a certain degree, Miyazaki's character design remains faithful to the collective aesthetic of manga rather than getting close to photorealism. It is his films' fundamental distance from live action that allows him to fully appeal to the viewer's imagination, and figures that are so visually removed from reality are more open for projection.

Miyazaki's commentary in the illustrated books that accompany his films gives an idea of the close personal connection he has with his characters. His remarks on the portraits of his heroine Nausicaä, which he first drew for the cover of Animage magazine, read as if he knew her personally. "Nausicaä looking forward and smiling seemed extremely unlikely to me." Or: "I knew when I was drawing that Nausicaä would never pose like this."[28] Takahata described Miyazaki's close relationship with his creations: "He has to work with his characters for such a long time

Hayao Miyazaki during production of Lupin the 3rd: The Castle of Cagliostro, ca. 1978

during productions, and he can't stand the idea of creating any with whom he cannot identify emotionally."[29] What Miyazaki most clearly rejects when it comes to Disney films is the typical storylines, which he views as one-dimensional: "Films must also not be produced out of idle nervousness or boredom or be used to recognize, emphasize, or amplify true vulgarity. And in that context I must say that I hate Disney's works. The barrier to both the entry and exit of Disney films is too low and too wide. To me they show nothing but contempt for the audience."[30]

In his own films, Miyazaki would consistently avoid homogeneous happy endings. Likewise—apart from the classic villain character of the count in The Castle of Cagliostro—the scoundrels in his work certainly avoid the cliché. Miyazaki's films follow his personal design at every stage. In the history of feature-length animation, such uncompromising authorship has only rarely been achieved.

NOSTALGIA FOR A LOST WORLD: NAUSICAÄ AND A NEW STYLE OF VISUAL STORYTELLING

MIYAZAKI AND TAKAHATA STAYED with Telecom Animation Film for three years after the release of The Castle of Cagliostro at the end of 1979. "Animation is still a very new field," Miyazaki wrote at the beginning of that same year, "and there are only a few works in existence that we can really call classics."[31] He confessed, "Today I rarely watch any animation that amazes me or makes my heart pound with excitement." The essay in which this statement appears, "Nostalgia for a Lost World," reads almost like a manifesto. It is a key document to understanding his art. Right at its start, the 38-year-old provides a definition of his medium, almost like a promise for his future career. "I'm talking about building a truly unique imaginary world, tossing in characters I like, and then creating a complete drama using them. Simply put, this is what animation is to me."[32]

At the time he wrote the essay, nine months before his debut as a feature film director, Miyazaki could look back on sixteen years in the anime industry, during which he had performed almost every function, from in-betweener to key animator, layout artist, writer, and director. During the three fateful years that followed, he would develop the ideas and begin his storyboards for an entire string of films that would become classics of the medium. "I had about three years with lots of time to plan," he reminisced in 1996, "and I've been working off those plans ever since. I drew bits of Castle in the Sky and My Neighbor Totoro, and most of the motifs that became Nausicaä of the Valley of the Wind [fig. 8] originated during those years as well. I did a few quick jobs during those years, but for the most part, I spent them figuring out what it was I wanted to do."[33] What retrospectively may sound like renewed vigor and a sense of purpose was mixed

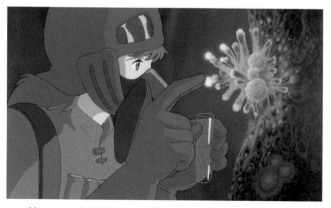
fig. 8 Nausicaä of the Valley of the Wind (1984)

with a critical view of the world rooted in his concern for the political and ecological situation. "I was extremely irritated at the time. I confess I was angry about the general state of the world, among other things. It was right around 1980. In addition to being upset by environmental problems, I was also concerned about where humanity was headed, and especially about the state of Japan. Most of all, I suspect, I was angered by the state of my own self."[34]

The Castle of Cagliostro, despite not being a major commercial success, brought Miyazaki increased recognition. In August 1981, Animage magazine made him the subject of an entire issue. The central article, written by Toshio Suzuki, bore the programmatic title "Hayao Miyazaki: World of Romance and Adventure." Miyazaki's budding friendship with the anime editor would become instrumental in the founding of Studio Ghibli, where Suzuki would serve as president for many years. In his role as an editor at Animage, Suzuki asked Miyazaki to realize his artistic ideas in a sophisticated serialized manga. Thus, Nausicaä of the Valley of the Wind was born, an epic centered on a young princess in an apocalyptic world who gets embroiled in a war between two kingdoms while humankind is on the brink of an ecological catastrophe. When the series, which ran from 1982 to 1994, finally came to an end, it had turned into an institution with 5.27 million anthologies sold; by 2005, this number had risen to 11 million.[35]

Perhaps the most successful manga in history, it is also the one with the most unusual appearance. Even the layout, with its small rectangular panels arranged in parallel, is more reminiscent of the European comic tradition of the likes of Hergé (Georges Prosper Remi), the Belgian creator of Tintin, than of the work of Miyazaki's Japanese contemporaries. The wealth of detail in the individual pictures corresponds to a complex structure of subplots and often altogether surprising plot points. Even so, the narrative is easy to follow; the alternation of expansive action sequences and emotional dialogue anticipates the engaging storytelling of Princess Mononoke. In drawing the Nausicaä manga, Miyazaki was already following the example of Kurosawa's adventure movies, with their indulgent elegance.

Nausicaä was the first in a series of Miyazaki heroines living in close touch with nature, and she was inspired by several sources. The filmmaker took motifs from the young heroine Yara, conceived for a planned film version of the US writer and illustrator Richard Corben's early 1970s comic Rowlf. He replaced Yara's faithful canine companion with a fictitious species of fox-squirrel early on in the creative process, creating a partnership that reminded Miyazaki of the eighteenth-century fairy tale "Beauty and the Beast." The name Nausicaä he borrowed from the daughter of the Phaeacian king in the sixth book of Homer's Odyssey, and her affinity for a barely domesticated insect world stemmed from the twelfth-century Japanese tale "The Lady Who Loved Insects" (Mushi-mezuru Himegimi). In light of a manga this sophisticated and elaborate, Miyazaki's self-assessment seems almost coquettish: "I started drawing the manga only because I was unemployed as an animator, so I'll stop drawing it as soon as I find animation work," he explained as late as 1993, one year before the release of the manga's final installment.[36]

Just as Miyazaki's films redefine the conventions of anime by expanding the artistic possibilities of the medium, his manga also far exceeded genre expectations. The complexity of the drawings and story—in fact, the entire world he created for Nausicaä—might be seen as the

artist's attempt at preventing the manga from ever being turned into a film. Suzuki, for his part, initiated the manga's publication in **Animage** to lay the foundation for funding an anime, as he recounts in a 1998 documentary.[37] One year later, this preventive measure would prove a significant challenge. Production for the film began in May 1983, with Takahata as producer, financial backing from **Animage** publisher Tokuma Shoten, and the staff and facilities of the minor anime studio Top Craft. The following March, the cinema version was released by Toei Animation, the same company where Miyazaki had started as an in-betweener two decades earlier.

Today, **Nausicaä** is considered to be the first film by Studio Ghibli, even though the studio was not founded until a year later, in June 1985, when Miyazaki and Takahata took over Top Craft, which had gone into liquidation. The visual aesthetics and themes of **Nausicaä**, as much as its emotional appeal, would prove characteristic of Miyazaki's later films, each a richly orchestrated score of excitement and inwardness. Their musical equivalent was provided by composer Joe Hisaishi, whose minimalist album **Information** had been released by Tokuma Japan Communications in 1982 but who was then inexperienced in writing music for film. Over the course of his decades-long collaboration with Miyazaki, which to date includes all of the latter's feature-length films, Hisaishi has developed a highly melodic, varied style in which epic symphonic passages are often interrupted by minimalist solos. Both are virtuosos with an expressive spectrum ranging from opulence to restraint.

Nausicaä chronicles its heroine's fight for the habitat of seemingly the only vicious species still extant, the majestic, giant **ohm** insects. The appeal to the healing powers inherent in the devastated postapocalyptic landscapes appears onscreen with unpretentious pathos. While the film's 1984 release coincided with the growth of an international environmental movement, Miyazaki's inspiration originated in a catastrophe decades past: the mid-1950s mercury contamination of Minamata Bay in Japan. About two thousand people in the region died after eating poisoned fish.[38] What particularly struck Miyazaki was how the fish population increased after commercial fishing had come to a standstill in the region, and the animals' ability to absorb the poison.[39] Yet, Miyazaki did not want viewers to consider the story primarily an expression of his ecopolitical commitment: "I didn't start out writing and drawing **Nausicaä** because I specifically wanted to talk about ecosystems or the need to protect the environment. . . . I wrote it thinking that maybe I should go into this and that direction, and then just followed my whim."[40]

Where **Nausicaä** positions its political message almost as an unexpected additional benefit, the feature-length documentary **The Story of Yanagawa's Canals (Yanagawa horiwari monogatari,** Japan, 1987), written and directed by Takahata, is dedicated almost entirely to an abundance of art. This comes in the form of lyrical landscape photography and short animation sequences. The film documents the restoration of the sixteenth-century canal system of a southern Japanese city. The idea came from Miyazaki, who had visited Yanagawa; the location struck him as an ideal subject for a documentary. Nearly three hours in length, the film shows how culture and nature can be preserved by returning to traditional methods and engaging every inhabitant. Takahata finds his hero in the section chief of the Yanagawa city office, Tsutae Hiromatsu, who manages to move mountains with his patience.

A bottleneck in funding for Takahata's expansive production resulted in the founding of Studio Ghibli, which would open in 1985 and release the documentary in 1987. Suzuki, who had provided a loan for the production, joined Miyazaki and Takahata in founding this new studio, which put Miyazaki in the position to create his next feature-length animated movie.

A WORKPLACE TO CREATE GOOD MOVIES: THE RISE OF STUDIO GHIBLI

IN 2010, WHEN MIYAZAKI PUBLISHED A LIST OF HIS 50 FAVORITE CHILDREN'S BOOKS, it was the selection of a passionate reader who stressed Western classics by Daniel Defoe, Antoine de Saint-Exupéry, Robert Louis Stevenson, Mark Twain, and Jules Verne while also placing some lesser-known writers in their company.[41] To the filmmaker, concepts that were richly explored in earlier centuries had retained their appeal: realistic settings as a foil for the fantastic and the adventurous, a fulfillment of childhood utopias. "One of the essential elements of most classical children's literature is that the children in the stories actually fend for themselves," the filmmaker has noted.[42]

Miyazaki's first film after the founding of Studio Ghibli, Castle in the Sky (fig. 9), opened in theaters in 1986 and can be seen as an anthology of motifs from classical children's literature. The miner boy Pazu and the mysterious girl Sheeta, who literally falls from the sky, start out on a journey together that takes them through the clouds to a lost civilization. Set in a fictive nineteenth century, the film melds Verne's futurism with Charles Dickens's social criticism, while the childrens' odyssey seems to set its course for Stevenson's Treasure Island (1883). They cleverly form a strategic alliance with pirates. The quest's mysterious goal, reaching the flying treasure island of Laputa, has a forerunner from a previous century, namely part three of Jonathan Swift's Gulliver's Travels (1726).

As in The Castle of Cagliostro, memories are awakened of 1970s European adventure cinema, with breathtaking chase scenes that shift between railways, automobiles, and nostalgic yet futuristic flying machines. The calmer moments are animated spectacularly too. Within a few seconds, an English landscape becomes charged with the pathos of early Technicolor dramas.

The backgrounds and effects animation demonstrate how consciously Miyazaki composes for the large screen. The director and film critic René Clair spoke of cinéma pur, in which the allure of the filmic medium imparts an intensity that for a few moments brings the plot to a stop. When Pazu and Sheeta gaze longingly at the play of clouds and want to explore the land behind the horizon, the sumptuous animation takes on just this autonomous power.

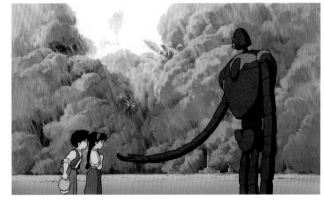

fig. 9 Castle in the Sky (1986)

Hayao Miyazaki during production of Castle in the Sky, ca. 1985

In the mid-1980s, postmodernism was at its height; it was in vogue to quote styles from different eras and combine them liberally. It was also the beginning of steampunk in pop culture, which embraced a steam-powered retro-futurism that was aligned with the moment. What separated Miyazaki from this postmodern zeitgeist was the absence of irony and any code of coolness. In Castle in the Sky, he accompanies his young heroes at their eye level and with emotional sympathy as they undertake their journey. As fairy-tale-like as a castle in the clouds may be—this mini-Neuschwanstein flying island is half fortress, half layer cake—the window onto reality remains open. The film's mining context mirrors the structural transformations that European industrial nations were experiencing in the 1980s and that cast a shadow on the Japanese economy, with economic growth taking place at the expense of ecological resources.

Miyazaki traveled to the United Kingdom to do research for Studio Ghibli's first official release while Suzuki put the finishing touches on the studio's offices. He brought back his historical impressions from the island nation's numerous mining museums, but this onetime union activist was also stimulated by the social aftermath of the mine closures. "I was in Wales just after the miners' strike," Miyazaki remembered in 1999. "I really admired the way the miners' unions fought to the very end for their jobs and communities, and I wanted to reflect the strength of these communities in my film. . . . I thought what a pity it was that the industry was dead, but on the other hand there's nothing that could be done about it."[43] Like the painters at the turn of the twentieth century, Miyazaki, in Castle in the Sky, depicts industry as a powerful, fire-breathing devil. At the end of the odyssey, however, in an oasis of hostility to progress, a flying island, like the last offshoot of a lost planet, floats above the clouds so as to take root in a better world.

There were only thirteen months between the opening of the studio and the film's premiere on July 23, 1986. Work on the main animation hadn't even begun until early November 1985, an enormous effort for a 124-minute film with 75,000 hand-painted cels. In Japan, Miyazaki's critical gaze on industrialization, a mismatch to the hedonistic zeitgeist of economic booms, may be one reason Castle in the Sky's reception fell short of expectations. In the following years, Miyazaki remained true to his critique of capitalism. In a 1989 interview, he very bluntly stated that he hated the Japanese economy, adding, "Surely there can be no more superficial people than the Japanese. They were not able to transcend the demon of rapid economic development. And as a result, [we have] the corruption of the world, the loss of ideals, and the worship of material things."[44] Despite this despair, or perhaps precisely because of it, Miyazaki for the first time decided to set a film in his home country. But it would be a different Japan, one still uncorrupted by the destructive force of progress.

○

WITH MY NEIGHBOR TOTORO, **MIYAZAKI RELEASED HIS MOST PERSONAL** and, to this day, most popular film, set in a rural milieu inspired by his own neighborhood in the town of Tokorozawa. "I wanted My Neighbor Totoro to be a heartwarming feature film that would not only entertain and touch its viewers but stay with them long after they left the theatres," he said. "I wanted the spirit of the film to endear lovers to each other, inspire parents to fondly recall their childhood, and encourage kids to roam around temple grounds or climb trees."[45]

Set in the mid-1950s, the film greets its spectators with a warmth and cordiality that never end. Along with his own memories, it seems as if Miyazaki took as his models the most significant chroniclers of domestic life in Japan's postwar cinema, Ozu and Naruse. In his youth, Miyazaki had witnessed this defining time for Japanese cinema, accompanying his father to the moviehouse.[46] A frequent theme of the two directors was the contrast of urban and rural life. In Naruse's The Approach of Autumn (Aki tachinu, Japan, 1960) (fig. 10), for instance, a country mother gives her young son away to relatives in Tokyo. Suddenly self-sufficient, the boy makes friends with the girl next door and together they explore the city. In My Neighbor Totoro, two city kids, who must also get along without their mother, are confronted with the reverse shock of rural life. In order to stay near the hospital where their mother is a patient, sisters Satsuki and Mei, with their father, move to a smaller town. Worry about their mother is a quiet keynote of Miyazaki's playful comedy.

The girls pass their first test of courage in their encounter with small, flake-like creatures that have made themselves at home in an abandoned house. The main theme of this pastorale, however, is a sonorous bass tone—the warm murmur of the potbellied creature Totoro, Miyazaki's most famous figure, whose voice is a bit like an owl's, a bit like a bear's. Born as early as the mid-1970s in sketches for a planned children's book, Totoro is one of the most unusual stars that animated cinema has spawned. Rarer still for the genre, his ever-growing popularity is based on a single film. Miyazaki has rejected the notion of a franchise, an approach most studio heads would have embraced.[47] Totoro's magic is not only in the universal charm of his design. It is the film's mise-en-scènes that give the title character a supernatural aura. His first scene is artfully conceived. Two smaller Totoros have put Mei on their trail, and this leads to their first meeting with the giant. As the film's composer, Hisaishi paired the short search with a sprightly main theme that is as minimalist and uplifting as the figures it accompanies: a sequence of six tones and simple variations.

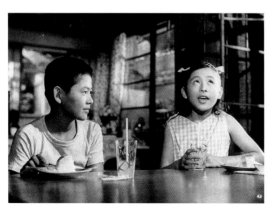

fig. 10 The Approach of Autumn (1960)

Hisaishi's composition has since taken on a life of its own as the anthem of Studio Ghibli and its fans, but its clever original dramaturgic function should not be overlooked. On the one hand, the melodic line serves as an analogy to the movement in the animation. On the other, the optimistic quality of the scene cancels out any potential fear the youngest spectators might experience when faced with a gigantic Totoro and his mighty teeth. Miyazaki says, "He's only an animal. I believe he lives on acorns. He's supposedly the forest keeper, but that's only a half-baked idea, a rough approximation."[48]

What is admittedly crucial for the narrative is the question of Totoro's actual existence within the plot. Even if the creature appears at a moment in Mei's life when she may have fantasized him as an imaginary friend, no one within the story doubts his existence. (How frustrating children's stories can be when the fantasy turns out to be "merely a dream" simply because a false realism demands that it be so.) My Neighbor Totoro allows a realistic reading, in which the film matter-of-factly portrays the fantastical the way it appears to a child. Suzuki remembers Miyazaki's rejection of the original tagline for the film poster, which read: "This kind of strange creature does not live in Japan anymore. Probably." The director's correction: "This kind of strange creature is still living in Japan. Probably."[49]

Totoro's second appearance, in a long, rainy scene, is iconic: the motif of the giant furry creature waiting at a bus stop, a girl alongside him (fig. 11). It appeared on posters for the film and can be found in early sketches. Miyazaki's outline goes on to say, "The bus never comes and darkness falls. Then something emerges from the dark. The creature is not wearing any shoes, its nails are long, and it isn't underneath an umbrella. They stand together for a while, then the girl slowly offers her other umbrella to the creature and demonstrates how to use it. As they wait for the bus, one arrives, but it is a whimsical 'Cat Bus.'"[50]

As magical as any encounter with a Totoro and a Cat Bus would be, it is the effect of the rain that creates the poetry of the scene. Art director Kazuo Oga was responsible for the special magical realism of the backgrounds and played a decisive role in further honing Miyazaki's characteristic approach: amplification by means of subtle reduction to the essential. As Oga explained, "We're following everyday life without much artifice, so the backgrounds have to be 'as is'. . . . The essential thing is drawing things 'as is' in the simplest way possible. If the backgrounds appear natural, then we increase the chance of more comic images of Totoro and the Cat Bus blending naturally . . . as if they might really exist. At least that's what I'm hoping for."[51]

If it is the credible depiction of everyday reality that highlights the magic of My Neighbor Totoro, this may even be heightened in the movie with which it was simultaneously released. Takahata's animated Grave of the Fireflies, with its humanist realism, tells of two children and their fight for survival in bombed-out Kobe. It may be the saddest animated film in history and one of the most moving statements against war in any medium. Unsparing but magnified by a kind of modern neorealism, the film pushes the boundaries of the medium. Both films, in their own ways, warn against forgetting—a concern rooted in the suffering from war that Miyazaki and Takahata lived through as children, as much as it is in the fleeting bliss of childhood fantasy.

○

fig. 11 My Neighbor Totoro (1988)

THIS WAS A HISTORIC MOMENT IN JAPANESE FILM HISTORY. Studio Ghibli had taken anime to heights that are rare for any film category. My Neighbor Totoro and Grave of the Fireflies are both now considered classics but, as a demanding double feature, they took in disappointing box-office receipts in their first release. When Miyazaki was deciding on his next project, no one could guess that the reticent forest creature would single-handedly ensure Studio Ghibli's financial independence through enormous merchandising revenues. Thus, a day after My Neighbor Totoro's completion, work began on Miyazaki's next film, Kiki's Delivery Service.

By the end of the 1980s, Miyazaki saw himself in full possession of his artistic powers. In the years that followed, he presented the film world with a string of masterpieces, each one only increasing his fame: Princess Mononoke, Spirited Away, Howl's Moving Castle, and Ponyo on the Cliff by the Sea. During these decades, the world of animation saw its most radical innovations since Snow White and the Seven Dwarfs. As international audiences enjoyed a "Disney renaissance" of hand-drawn animation, the founding of numerous important animation studios, and Pixar's groundbreaking computer animation, the Miyazaki medium upheld its unique aesthetic standards as well as its highly personal approach. Pixar artist Pete Docter, now that studio's chief creative officer, supervised the English-language version of Howl's Moving Castle in 2005; the flying house in his own Academy Award–winning feature Up (USA, 2009) can be seen as a tribute to Miyazaki's work.

At the time of this writing, hand-drawn animation has become an almost obsolete technology in US feature animation, making Miyazaki's work even more unique. There are no scenes in his films that Miyazaki hasn't conceived and designed, but it requires an industry to fulfill these personal visions and make his authorship a reality. Today, Miyazaki runs the last renaissance workshop. As a socialist, he was instrumental in improving the working conditions in the anime industry. But how rare that an industry is not corrupted by commercialism. In The Kingdom of Dreams and Madness (Yume to kyoki no okoku, Japan, 2013), directed by Mami Sunada, a documentary film on the making of The Wind Rises, Miyazaki takes the words of the film's tragic hero, the airplane builder Caproni, for his own credo: "You know, people who design airplanes and machines, no matter how much they believe that what they do is good, the winds of time eventually turn them into tools of industrial civilization. It's never unscathed. They're cursed dreams. Animation, too. Today, all of humanity's dreams are cursed somehow. Beautiful yet cursed dreams. . . . What I mean is, how do we know movies are even worthwhile? If you really think about it, is this not just some grand hobby?" In 1979, when he laid the foundation stone of the Miyazaki medium with his essay "Nostalgia for a Lost World," he gave the answer: "If I were asked to give my view, in a nutshell, of what animation is, I would say it is 'whatever I want to create.' . . . But no matter what others may say, if it isn't something I really want to work on, it's not animation to me."[52]

NOTES

1 See Susan Napier, Miyazakiworld: A Life in Art (New Haven, CT: Yale University Press, 2018).

2 Miyazaki, "On Japan's Animation Culture," interview, in Turning Point, 1997–2008, trans. Beth Cary and Frederik L. Schodt (San Francisco: VIZ Media, 2014), 71. Originally published in Yomiuri Shimbun, August 8, 1997.

3 Miyazaki, "I Parted Ways with Osamu Tezuka When I Saw the 'Hand of God' in Him," in Starting Point, 1979–1996, trans. Beth Cary and Frederik L. Schodt (San Francisco: VIZ Media, 2009), 193. Originally published in Fusion Product's Comic Box, May 1989.

4 Quoted in Helen McCarthy, Hayao Miyazaki: Master of Japanese Animation: Films, Themes, Artistry (Berkeley, CA: Stone Bridge Press, 1999), 132–33.

5 Quoted in Margaret Talbot, "The Auteur of Anime," Asia-Pacific Journal 4, no. 3 (March 29, 2006), https://apjjf.org/-Margaret-Talbot/1900/article.html.

6 Frederick S. Litten, Animated Film in Japan until 1919 (Norderstedt: Books on Demand, 2017), 22. The film shows a young boy in a sailor suit. The only thing he does—in a self-referential act— is write katsudo shashin (animated images) on a blackboard.

7 Nobuyuki Tsugata, Nihonhatsu no animeshon sakka Kitayama Seitaro [Seitaro Kitayama, Japan's First Animation Artist] (Kyoto: Rinsen Shoten, 2007).

8 Isao Takahata, Jyu-ni Seiki no Animation [12th-Century Animation: Film and Animation Techniques as Seen in Kokuho Emaki Scrolls] (Tokyo: Tokuma Shoten, 1999).

9 Isao Takahata, "12th Century Animation," Japan Quarterly, July–September 2001, 31.

10 Miyazaki, "My Theories on the Popularity of Manga," acceptance speech upon receiving the Japan Cartoonists Association's Prize, June 20, 1994, in Starting Point, 161.

11 Frederik L. Schodt, Manga! Manga! The World of Japanese Comics (New York: Kodansha International, 1983), 62.

12 Miyazaki, "My Point of Origin," lecture, Joint Animation Studies Groups at Waseda University, Tokyo, June 5, 1982, in Starting Point, 50.

13 Miyazaki, "Thoughts on Japanese Animation," in Starting Point, 71. Lecture originally published in Nippon eiga no genzai [The State of Japanese Film] (Tokyo: Iwanami Shoten, 1988).

14 Yasuo Otsuka, Sakuga Asemamire (Tokyo: Tokuma Shoten, 2001), 117. Cited in Napier, Miyazakiworld, 37.

15 Miyazaki, in the documentary The Kingdom of Dreams and Madness (Yume to kyoki no okoku, Japan, 2013).

16 Miyazaki.

17 Miyazaki, "Speaking of Conan," interview by Yoko Tomizawa, in Starting Point, 289. Originally published in Mata aeta, ne! [We Meet Again!], ed. Yoko Tomizawa, Animage Bunko series (Tokyo: Tokuma Shoten, 1983).

18 Miyazaki, 290.

19 Miyazaki, "I Parted Ways with Osamu Tezuka When I Saw the 'Hand of God' in Him," in Starting Point, 196.

20 Roger Ebert, Hayao Miyazaki interview, rogerebert.com, September 12, 2002, https://www.rogerebert.com/interviews/hayao-miyazaki-interview.

21 Miyazaki, "Nostalgia for a Lost World," in Starting Point, 18. Originally published in Gekkan ehon bessatsu: Animeshon [Animation: Monthly Picture Book Special], March 1979.

22 Miyazaki, "Lupin Was Truly a Creature of His Era," in Starting Point, 278–79. Originally published in Animage, October 1980.

23 Miyazaki, 278.

24 Miyazaki, "Forty-four Questions on Princess Mononoke for Director Hayao Miyazaki from International Journalists at the Berlin International Film Festival," in Turning Point, 91. Originally published in the roman album Animage Special: Hayao Miyazaki to Hideaki Anno (Tokyo: Tokuma Shoten, 1998).

25 Miyazaki, 92.

26 Miyazaki, "On Animation and Cartoon Movies," Second Anniversary Lecture delivered at Osaka Animepolispero, July 27, 1982, Toei Kaikan, Sonezaki-Shinchi, Osaka, in Starting Point, 124.

27 Miyazaki, "Thoughts on Japanese Animation," 75.

28 Miyazaki, The Art of Nausicaä of the Valley of the Wind Watercolor Impressions (San Francisco: VIZ Media, 2007), 26, 86.

29 Isao Takahata, "The Fireworks of Eros," afterword to Starting Point, 456.

30 Miyazaki, "Thoughts on Japanese Animation," 72.

31 Miyazaki, "Nostalgia for a Lost World," 23.

32 Miyazaki, 17.

33 Miyazaki, "Trial and Error Leading Up to the Birth of Nausicaä," in The Art of Nausicaä, 152.

34 Miyazaki, "On Completing Nausicaä of the Valley of the Wind: The Story Continues," in Starting Point, 392. Interview originally published in Yomu [To Read], June 1994.

35 Miyazaki, "Now, after Nausicaä of the Valley of the Wind Has Finished: Interview: 'The Story Won't End,'" Yom Magazine (June 1994).

36 Quoted in McCarthy, Hayao Miyazaki, 72.

37 The Birth of Studio Ghibli, bonus section of Blu-ray, Nausicaä of the Valley of the Wind, Buena Vista, 2017.

38 Many in the West learned about Minamata disease only decades later, in W. Eugene Smith and Aileen Mioko Smith's book Minamata (New York: Holt, Rinehart & Winston, 1975).

39 See McCarthy, Hayao Miyazaki, 74.

40 Miyazaki, "On Completing Nausicaä of the Valley of the Wind," 391.

41 "Hayao Miyazaki Picks His 50 Favorite Children's Books," Open Culture, http://www.openculture.com/2017/05/hayao-miyazaki-picks-his-50-favorite-childrens-books.html.

42 Miyazaki, "Personally, I Think There Is a Continuity from Nausicaä," in Starting Point, 341. Originally published in the roman album for Castle in the Sky (Tokyo: Tokuma Shoten, 1986).

43 Quoted in McCarthy, Hayao Miyazaki, 96.

44 Miyazaki interview, quoted in Hikaru Hosoe, "Meisaku Kansho Tonari no totoro Haha naru shizen to innosensu," in Konan Women's University Research 42 (2005): 86. Cited in Napier, Miyazakiworld, 103.

45 Miyazaki, The Art of My Neighbor Totoro (San Francisco: VIZ Media, 2005), 5.

46 See Robbie Collin, "Hayao Miyazaki Interview: 'I think the peaceful time that we are living in is coming to an end,'" Daily Telegraph, May 9, 2014, https://www.telegraph.co.uk/culture/film/10816014/Hayao-Miyazaki-interview-I-think-the-peaceful-time-that-we-are-living-in-is-coming-to-an-end.html.

47 Nonetheless, he has allowed merchandising licenses, and the immense returns turned his personal reservations regarding consumer industries almost into an absurdity. This bonanza has exceeded the film's budget many times over. The opening of a Ghibli theme park in Aichi Prefecture on the former world's fair grounds has been announced for 2022; a replica of the house from My Neighbor Totoro has stood there since 2005.

48 Miyazaki, The Art of My Neighbor Totoro, 102. As with Godzilla, the colossal ancestor of the fantastic beings of Japanese film history, Totoro's gender is never defined.

49 Sumiko Kajiyama, Jiburi Majikku: Suzuki Toshio no somoryoku (Tokyo: Kodansha, 2004), 55. Cited in Napier, Miyazakiworld, 110.

50 Miyazaki, The Art of My Neighbor Totoro, 20.

51 Quoted in Miyazaki, The Art of My Neighbor Totoro, 166.

52 Miyazaki, "Nostalgia for a Lost World," 17.

戦場をとぶ ハラル

67

"THE ANIMATOR MUST
FABRICATE A LIE
THAT SEEMS SO REAL
VIEWERS WILL THINK
THE WORLD DEPICTED
MIGHT POSSIBLY EXIST."

FANTASY IN THE FAMILIAR

PETE DOCTER

HAYAO MIYAZAKI IS ONE OF THE GREAT FILMMAKERS OF OUR TIME. And I don't mean just within the medium of animation—he is a great filmmaker, period. His movies are beloved by people around the world, so rabidly in his home country of Japan that several of his films broke box-office records, outselling Hollywood blockbusters like Titanic and the Lord of the Rings series. Miyazaki's films are small miracles, full of insight and imagination. His stories teem with strange characters and inexplicable events yet somehow make perfect sense. They take us to the most far-out fantasy worlds imaginable but are also beautifully observed slices of real life. And when you consider that he is quite literally creating everything you see on screen with his pencil, it's clear why many of us in animation have a sort of love/hate relationship with this man.

What is it that makes Miyazaki's work so admired? His films are amazing mental vacations, full of fantastic creatures, huge machines, and wondrous places. His technical artistry, layout, and design are all worthy of study. I believe what speaks so profoundly to people is something much more subtle: his incredible powers of observation.

We animators like to say that when we first sit down at our desks, there is nothing but a piece of white paper staring back at us. At most studios, this is not quite true. There has likely been considerable story and design work done by other artists, from which the animator takes concepts, poses, or expressions and uses them to build his or her scene of animation. But Miyazaki actually does start on his own, designing and storyboarding his films himself. He is essentially the casting director, actor, set designer, and director of photography rolled into one.

He does collaborate closely with a talented team of designers and animators who bring forward many aspects of a film, but their work follows Miyazaki's own storyboard drawings. To start with nothing may seem like a daunting task, but for a person with an active imagination, the problem is in fact the opposite: everything is possible. So, what to choose, with the universe at your fingertips? Though his films take us into fanciful environments full of incredible characters, Miyazaki seems to begin with intimate details pulled from the everyday world around him.

PREVIOUS SPREAD: Hayao Miyazaki, Howl's Moving Castle imageboard (Bird Howl flies over battlefield)

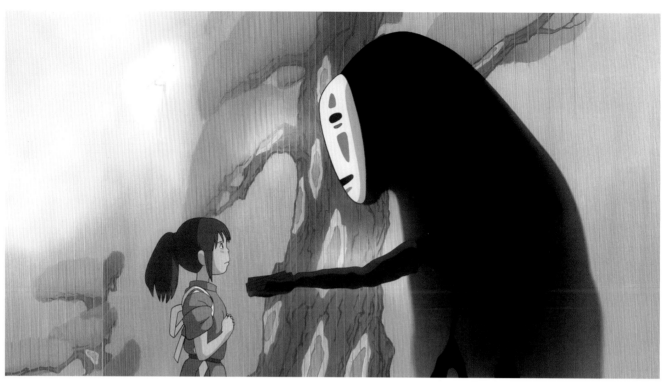

Spirited Away film still (Chihiro and No Face)

My Neighbor Totoro is about two little girls who befriend mysterious nature spirits. But before we meet these mystical characters, Miyazaki grounds the film in our own world. The charming house in the country is old, so when Dad goes to open a window, he struggles with it. When the two girls arrive, they're too excited to take off their shoes before entering, so they run around inside on their knees. These familiar details ground us, so that when the strange creatures begin to appear, we believe in them all the more. It is the truthful elements that lure us into believing in a world that doesn't actually exist.

Miyazaki's characters are genuine and memorable because, while they may be charming and heroic, they are never perfect. Chihiro in Spirited Away is downright spoiled as the film begins; she pouts and complains in the back seat of the family car. She screams in fright when her parents turn into pigs. She cries in desperation at being stuck alone in a strange bathhouse with weird creatures. Well, who wouldn't? Rather than put us off, this behavior draws us in and helps us connect with Chihiro. She exhibits the same fears and vulnerabilities any of us would experience in her situation. Miyazaki gives the character room to mature and grow, allowing us to discover that she also has strength, courage, and the ability to love.

Miyazaki's films are full of characters that are appealing and cute. But well before things get too saccharine, that "cute" character may eat someone, vomit, or start leaking fluid. True, Totoro is fuzzy and soft, but he also has a very large mouth full of huge teeth. No-Face in Spirited Away is mysterious but also by turns violent, gruesome, and lonely. Miyazaki finds a perfect balance between appealing and gross, charming and creepy.

Even the "bad" characters have their charm. Those who are initially portrayed in a negative light, such as the title character in Howl's Moving Castle, are shown to be capable of change. All of his characters have their flaws and—no matter how fantastic—their humanity. As Miyazaki reminds an animator in Kaku Arakawa's documentary Never-Ending Man (2016), "You're drawing people, not just characters." For someone with the freedom and ability to draw whatever he wants, Miyazaki has the self-discipline to present only that which speaks to us.

His practice of closely observing the real world is also clear in his settings and certain recurring themes. Most of Miyazaki's films are set in fictitious towns or locations, but each one feels specific and real. The architectural and textural details in Howl's Moving Castle or Kiki's Delivery Service come only from a deep study of source material. And Miyazaki's love of aircraft is evident in many of his films, for example Porco Rosso, where aviation is a central theme.

I've been fortunate to meet Miyazaki several times at his studio and to spend time talking with him. On one visit, I asked him to list his favorite Western animators and films. I mentioned my own favorites, Chuck Jones and Friz Freleng, and was surprised to discover that he'd never heard of them. Or maybe their names just got lost in translation. Regardless, it made perfect sense that Pinocchio and Snow White top Miyazaki's list of favorites, considering the lush richness and level of believability of his own films.

Walking among the rows of silent animators working elbow to elbow, I was struck by the sound of paper flipping and the scritch-scratch of pencils. Studio Ghibli is not unique here; most animated films made in Japan are hand-drawn. Why? I suspect it's due to sociological and economic factors as much as artistic choice. Ghibli is not stuck in time—there are plenty of artists using computers to do their work. But for Miyazaki himself, I imagine there is something about drawing that taps most directly into his subconscious.

Like all forms of art, filmmaking is an emotional communication. Yes, audiences prefer stories that make logical sense, but unless they make us feel something, we find no reason to watch. The more filmmakers can step around their own cerebral cortex and tap into their emotional core, the more powerfully their films will speak. For Miyazaki, his pencil is an extension of his arm. He's drawn for so many hours, for so many years, it's as natural to him as walking. I've watched experienced artists conjure thoughts and feelings by drawing that they would never have been able to communicate using language. In fact, I suspect this is why Miyazaki needs to storyboard his films himself. I remember that when he visited Pixar in 2007, he seemed surprised and somewhat envious to find that we engage small teams of artists to storyboard our films. When asked why he doesn't employ other story artists as well, he sighed and said his own method was imperfect, but he didn't want to ask someone else to do work that he might have to cut. He felt it was more efficient to just do it himself. This efficiency probably has more to do with the fact that he doesn't always know logically what he wants until he draws it, and he likely has exacting thoughts on how it should be done.

I have spoken with stop-motion animators for whom the same thing is true: they have worked with the medium for so long that they're only able to fully express what they're feeling by moving that puppet one frame at a time. Many computer animators feel this symbiosis with their computers. Musicians, painters, dancers too: their skill in the medium gives them a freedom from logic, allowing them to tap into their deeper selves and release feelings perhaps they didn't even know they had.

"How much of your stories do you know before you start drawing?" I asked Miyazaki. "'Knowing the story' and 'knowing what happens in the story' are two different things," he answered. "When I started to

storyboard Spirited Away, all I knew was that a girl gets separated from her parents and some weird things happen to her. That was all. I discovered everything else while drawing it."

It may be a stretch to say that the pacing of Miyazaki's films mirrors real life, but they certainly seem more closely related to a quiet walk in the woods than to other animated films. In a world where most of us can't sit for longer than a few seconds without pulling out our phones, Miyazaki's films invite us to feel the breeze as it blows through a field, dream along with a young girl as she watches the clouds drift by, or wait at a bus stop with two sisters on a rainy evening. Many moments in his films are about nothing other than the charm of watching a kid eat soup or a tired old woman walking. It is rare to find a director who uses quiet and serenity so effectively.

Perhaps Miyazaki's work is so unique because he claims not to watch many other films. If they're bad, he told me, he feels he wasted his time; if they're good, he gets jealous. Miyazaki even dislikes home video of his own films, telling kids to watch them once, then—rather than watch them again and again—go outside and play. Such advice isn't good for business, but it shows that Miyazaki has bigger ideas about how he'd like to affect the world.

If it feels as if details from his movies are pulled from his own childhood, it's because they are. When I asked him about this, he said he'd revisited his childhood so often that he's now more nostalgic for a road he walked down last week. He's sold his childhood for his movies, he laughingly added.

Miyazaki is a uniquely gifted storyteller and artist who takes advantage of what animation does best: building fantastic worlds and characters that wouldn't be possible in any other medium. But it is his childlike capacity for observation that gives his fantasy its firm grounding in the familiar, and his ability to capture the familiar that gives his work its believability. Hayao Miyazaki's films take us into lush, invented worlds that ultimately serve to wake us up and inspire us to look more closely at our own.

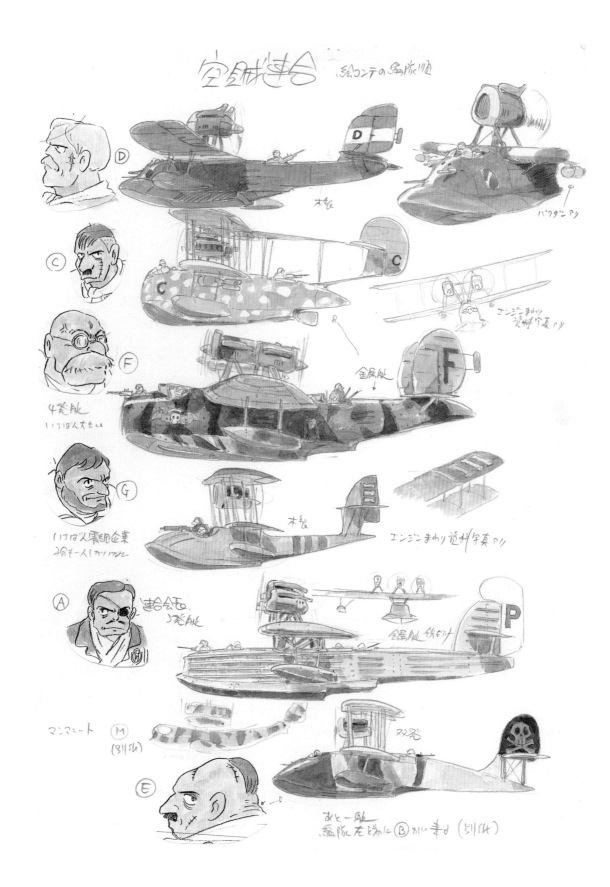

Hayao Miyazaki, Porco Rosso imageboard (Air Pirate Coalition seaplanes)

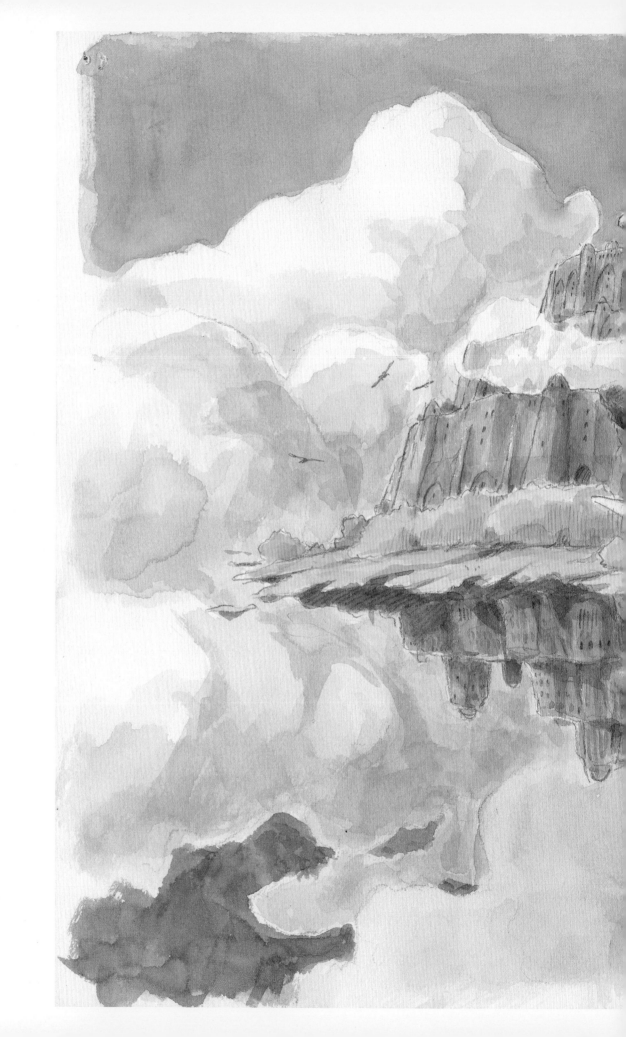

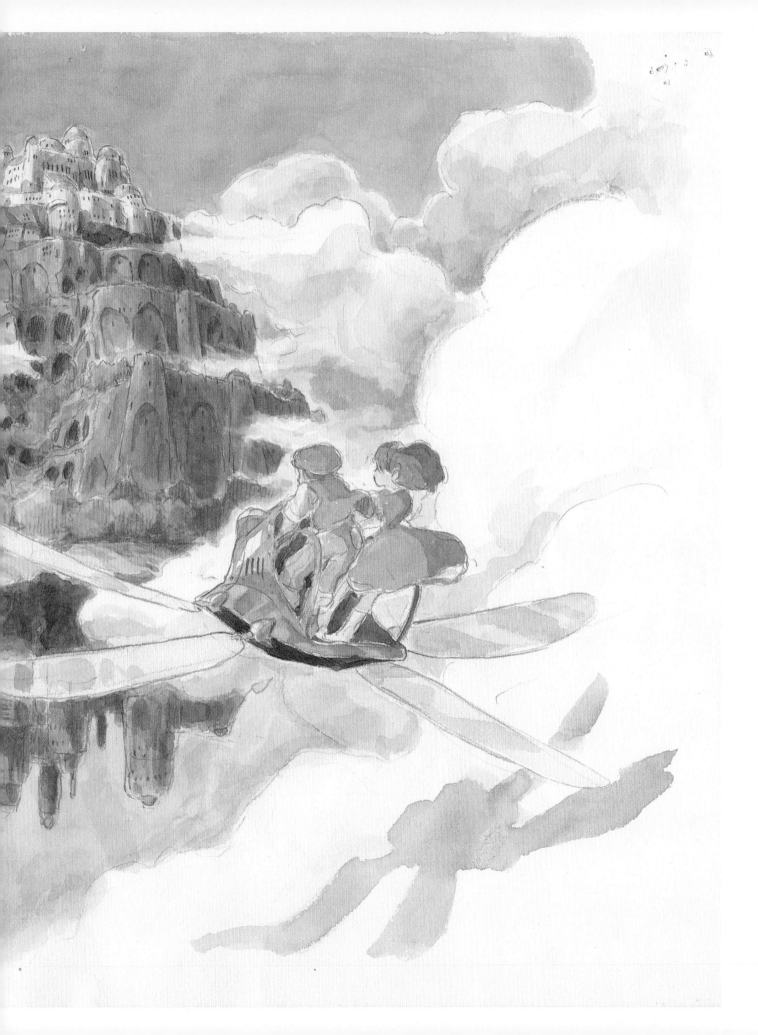

"THE RELATIONSHIP
IS NOT ONE OF
ME CREATING THE FILM,
BUT RATHER OF
THE FILM FORCING ME
TO CREATE IT."

HAYAO MIYAZAKI: CREATOR

JESSICA NIEBEL

ALWAYS, HAYAO MIYAZAKI WONDERS WHAT IT MEANS TO BE ALIVE. He traces this complex question by assessing, on a theoretical level, how humans exist—what is the human condition?—as well as by asking practical questions—how do individuals experience specific situations? As a filmmaker, Miyazaki combines the micro with the macro, recognizing humans and their environments as inseparable. While focusing on the everyday lives of individuals, he also pursues contextual knowledge, and his insistence that it is "essential to be interested in subjects that have traditions going back hundreds of years, and to broaden your own knowledge"[1] leads him to pursue philosophical connections—intellectual, spiritual, cultural, environmental, and archaic. He stresses the interconnectedness of individuals not only within human communities but also, significantly, within nature, in a universe that is not human-centered. That these relationships, and their limitations, inevitably lead to conflict is the central dilemma of Miyazaki's oeuvre.

His particular sensitivity to the human condition helps viewers realize something about themselves, how they relate to the world, and the fundamental difficulties of life. To watch a Miyazaki film is to go on a journey, experiencing the world through his characters' perceptions. Typically, his protagonists leave home and are forced to fend for themselves; they confront loneliness, frustration, and loss, but they also encounter beautiful things in enriching moments. In the end, they find balance through reconnection with their original state of being and the understanding that humankind is an integral part of the universe. In Miyazaki's view, children are closer to such an existence than adults, perhaps because they rely less on rational thinking. "Our brains seem at first glance to be logical, but the structure of our brains is not. That is why I believe that the most important thing is our intuition."[2] This same philosophy applies to Miyazaki's process in creating a film from start to finish.

PREVIOUS SPREAD: Hayao Miyazaki, Castle in the Sky imageboard (Sheeta and Pazu approach Laputa on Flaptor)

Each of his films, he says, already existed somewhere and it was his job to realize it. He believes, too, that a film should evolve as it is being made. Rather than writing a screenplay, he draws imageboard after imageboard from his imagination, inspired by all kinds of things—memories, literature, history, or simply an appearance.[3] He will eventually share with the Studio Ghibli team a written proposal outlining certain themes. Next, he starts developing the film's storyboard, including notes on framing, camera movement, editing, and dialogue. The storyboard allows the production team to schedule and distribute tasks among the animation team, the background artists, the ink and paint department, and other crucial players leading up to postproduction. Throughout, Miyazaki oversees every aspect of the filmmaking process and will inevitably change his mind about certain decisions.

Once completed, each film presents its own identity, distinct from any previous Miyazaki creation, though with certain intriguing factors in common: complex protagonists, often female; villains who are never entirely bad; fantastical worlds depicted in realistic ways; a fascination with flying; and meaningful encounters with elders, magical creatures, and trees. Consistently, his films build cross-generational bridges, even though each is initiated with a specific age group in mind. Porco Rosso, for instance, "was designed to be a work that businessmen exhausted from international flights can enjoy even if their minds have been dulled from lack of oxygen. It must also be a work that boys and girls, as well as aunties, can enjoy."[4] In making Spirited Away, Miyazaki "tried to create something about which I could honestly tell my ten-year-old friends, 'I made this for you.'"[5] About staying in touch with the younger generation, he says, "Reality changes depending on the era we're in, so as a creator I feel as though I should always be aware of the condition in which contemporary children find themselves."[6]

It should be stressed that Miyazaki has pursued his ideal—to make movies that matter—with children in mind as his most important audience: "Animation should above all belong to children . . . truly honest works for children will also succeed with adults."[7] He claims not to have too many memories of his own childhood but does recall that he didn't feel he had an identity of his own: "As a child . . . I was trying to follow my parents' will without any self-reflection. I wasn't conscious of this, which is scary in itself. As I developed into a youth and young adult, I came to realize that I shouldn't be just a good kid, that I should look at things with my own eyes and have independent ideas."[8] Miyazaki has made it his greatest aspiration not only to understand how today's youth feel and how they perceive the world but also to help them feel liberated, self-reliant, and independent. In his own words, nothing gives him more pleasure than "to create films that help children feel glad that they've been born."[9]

While his films often feature young protagonists and narratives that unfold from their viewpoints, Miyazaki doesn't feel that children have to fully understand every detail of his films. As he puts it, "Children are adventuresome on their own as they try to comprehend the wonders of this world, and that's best for them. This means there should be many more strange things around children that they can't understand."[10] It is Miyazaki's conviction, too, that young people move through the world with innate knowledge: "Their souls consist of far more than just purity and innocence and gentleness. These aspects of children are of course important, but I'm talking

about something much more basic. Children are filled with . . . things so ancient that only their DNA remembers."[11]

Evoking a spiritual longing for something ancestral that now seems distant and lost, Miyazaki's films are timeless. If, as his oeuvre conveys, life is full of struggle, one must not give up. His protagonists face setbacks and come to realize they must claim responsibility for their lives: they will decide how they want to live, realizing that while they are part of the world and have impact on its present and future, they are not able to control it. "Embracing contradiction"—that is, not shying away from life's complexities—offers a way forward. "If we understand that there has never been a fundamental solution," Miyazaki notes, "we can deal with it."[12] It is precisely this resolution that makes his films so appealing to audiences everywhere. On his own commitment to carrying on as a filmmaker, he says, "When you are faced with real hardship, convinced that your plans are no good, your subconscious mind thinks for you and lo and behold an answer comes. When the answer comes in that form, I really feel like I'm creating a film. That's when I know I have the right answer."[13]

"WHEN DEPICTING CHARACTERS, REMEMBER WE ARE ONLY SHOWING THE TIP OF THE ICEBERG."

CREATING CHARACTERS

MIYAZAKI IS FAMOUS FOR DEPICTING CHARACTERS WITH FULLY DEVELOPED PERSONALITIES, portrayed in nuanced ways that reflect complex, almost tangible inner lives. It usually takes years for Miyazaki to truly know his protagonists, to figure out what they are thinking or how they might react in certain situations. "You have to start asking the characters who they really are and what they're doing," he explains.[14] There is no doubt that these characters are fully alive in his imagination, with personalities that far exceed what viewers see in the film. They have a past, a future, and traits known only to the filmmaker and perhaps a handful of others at Studio Ghibli who collaborate in bringing them to life.

Sometimes Miyazaki is still poring over character development during production. Animator Kitaro Kosaka remembers his surprise when Miyazaki, asked during production what the character Nahoko is thinking in an important scene of **The Wind Rises**, didn't know how to respond.[15] His reaction could have been due to his belief that his characters have wills of their own—that his role is to help them express themselves. In this sense, Miyazaki wouldn't **define** what Nahoko has on her mind so much as wonder about it. He respects her thoughts, as he does those of all of his characters, and lets her have her say.

Something of the enigmatic realness of his characters is captured in Miyazaki's remarks to an interviewer in 1997: "I . . . threw away the perspective that humans were good. In each person there is stupidity just as there is wisdom. That is what humans are made of."[16] Villains aren't evil, they've just made bad choices. Likewise, heroes aren't all good, and they will certainly make mistakes. Each protagonist is created from scratch yet rendered in extraordinary detail, based on the filmmaker's far-ranging imagination and richly philosophical approach, followed by intensive research and production at Studio Ghibli. Through their humane and deeply considered portrayal, Miyazaki's characters become believable and relatable.

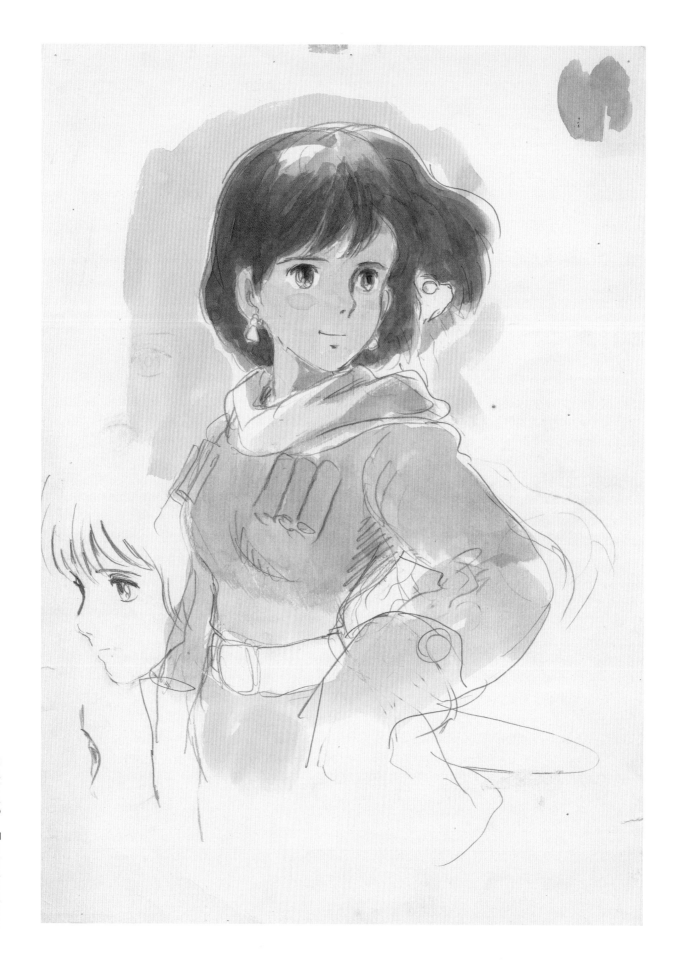

NAUSICAÄ

Nausicaä of the Valley of the Wind is set on Earth during humanity's twilight era. The story features a girl who, while being drawn into battles between human beings, comes to look far beyond the human state.[17]

THE HEROINE NAUSICAÄ is a princess from the Valley of the Wind who lives in a time when the very existence of humanity is imperiled. She loves her people, all living creatures, and flying—Nausicaä is a wind-rider who freely glides through the sky. But she has burdens to carry and tremendous responsibility weighs on her. She is devastated after the murder of her father and the discovery that humans have poisoned their environment past the point of habitability. "The center of my story was always the strong-willed girl shouldering the fate of her country," Miyazaki says.[18]

Though she fights her enemies when necessary, Nausicaä never loses her compassion for beings of all kinds. At the film's climax, as fantastical **ohm** creatures—giant insects from the Sea of Decay—attack her village, she endangers her own life to save that of a baby **ohm**. In Miyazaki's understanding: "She acted for her own sake, not for the sakes of those in the Valley of the Wind, but because she could endure no more. Rather than considering the risk to her own life, Nausicaä felt that unless she returned the baby **ohm** to the pack, the hole in her heart would never be filled. That's the kind of person I think she is."[19]

Miyazaki spent many years developing Nausicaä, initially for her portrayal in his manga series, first published in 1982, two years prior to the film's release. Her name is borrowed from Greek mythology, yet more dominant among the broad sources that inspire her personality is Japanese folklore, from the ancient concept of "wind masters" to an eleventh-century Japanese story about "a princess who loved insects and apparently ran about in nature even after coming of age, delighting in watching such things as caterpillars metamorphosing into butterflies. As a result she was viewed as quite eccentric."[20] Yet, Miyazaki shaped Nausicaä to be her own person. In his take: "She's a strange girl. She seems to regard the lives of insects and humans in the same way."[21]

Early imageboards show Nausicaä in a more fairy-tale-like accoutrement, and another approach includes studies of heavy armor; she then develops into a warrior princess with lighter weaponry and, most importantly, a wind glider. She is also a curious scientist, an engineer, and a pilot, and she has ancient wisdom, though she displays youthful frustrations. Despite her young age, she has a tremendous amount of responsibility. "Nausicaä has," in Miyazaki's description, "a touch of this grimness to her," because "I think the gloomier people are inside the more they think about others."[22]

OPPOSITE: Hayao Miyazaki, Nausicaä of the Valley of the Wind imageboard (Nausicaä character design)

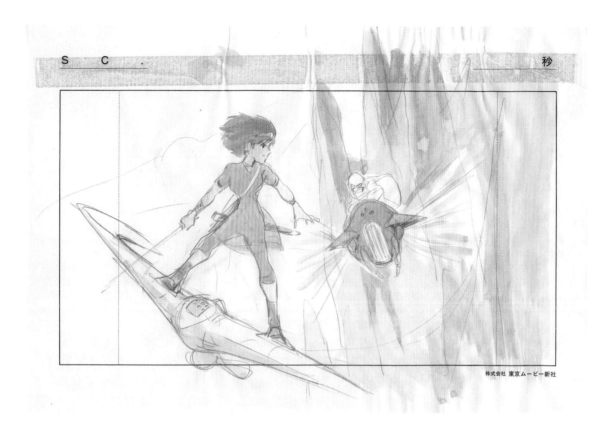

株式会社 東京ムービー新社

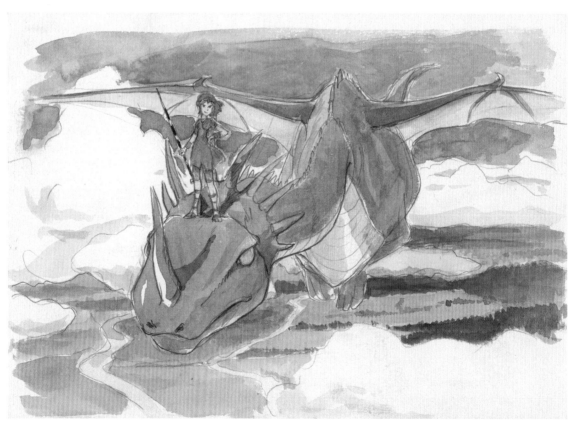

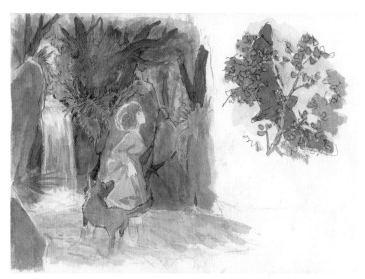

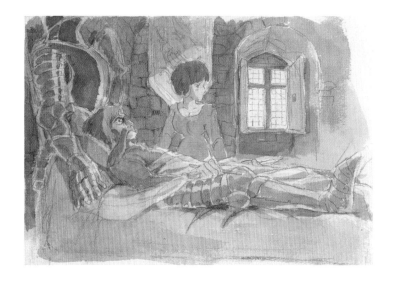

OPPOSITE, TOP: Hayao Miyazaki,
Nausicaä of the Valley of the Wind
initial imageboard (Sengoku Majo)

OPPOSITE, BOTTOM: Hayao Miyazaki,
Nausicaä of the Valley of the Wind
initial imageboard (Kushana and
the Earth Dragon)

THIS PAGE: Hayao Miyazaki, Nausicaä
of the Valley of the Wind initial
imageboards

The story of Nausicaä evolved from these
fairy tale–inspired imageboards.

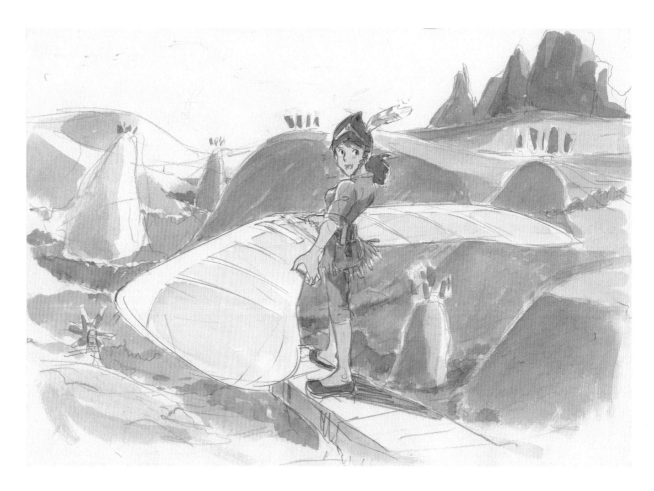

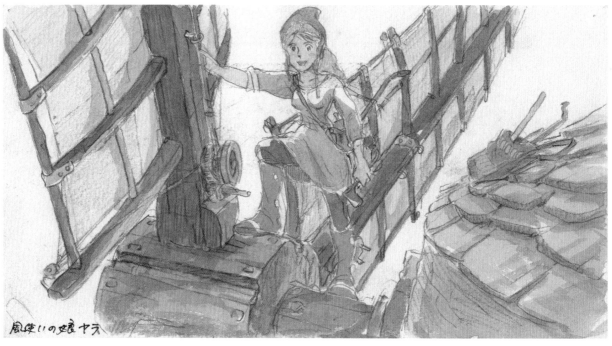

風使いの娘ヤラ

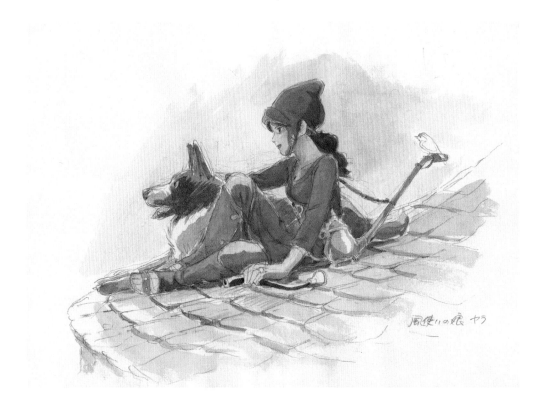

風使いの娘 ヤラ

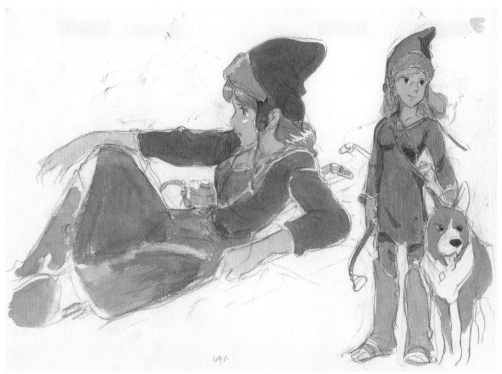

Hayao Miyazaki, Nausicaä of the Valley of the Wind
initial imageboards (Yara, the Wind Master)

The princess evolves into Yara, who
reads patterns in the wind and takes
flight on her glider.

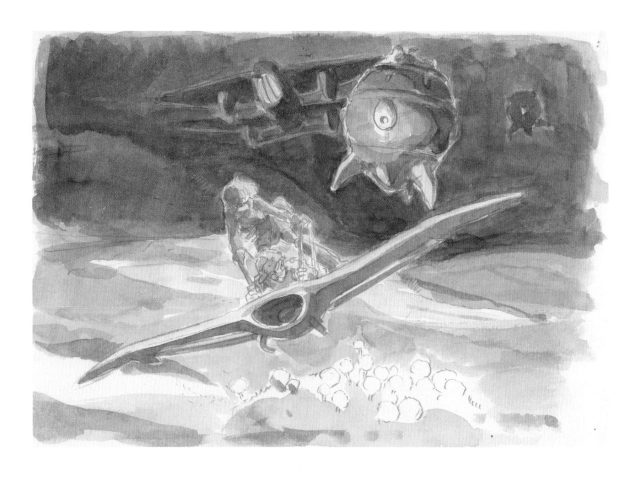

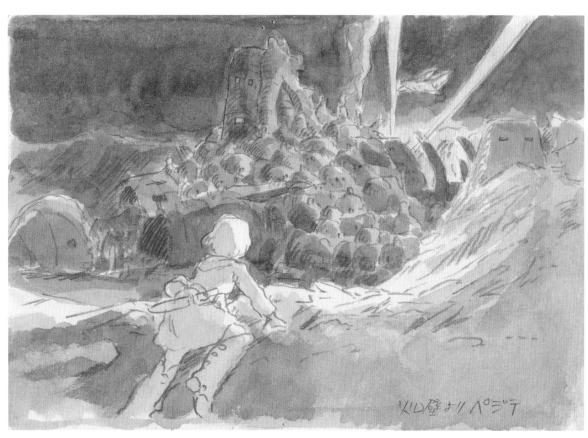

火口壁よりペジテ

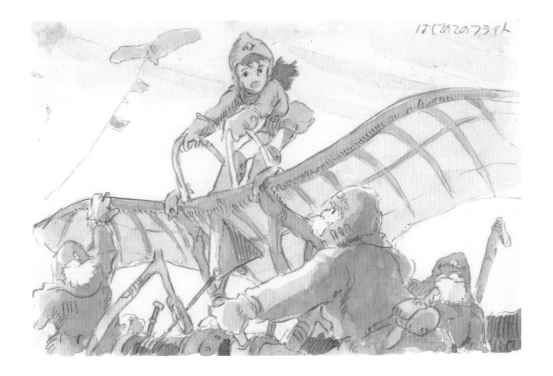

はじめてのフライト

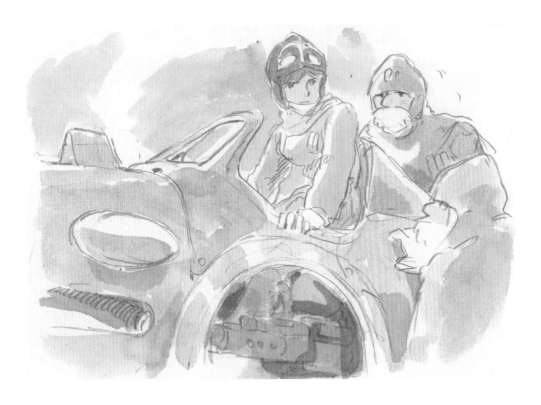

OPPOSITE, TOP: Hayao Miyazaki,
Nausicaä of the Valley of the Wind
imageboard (Nausicaä and Asbel
fly across the Sea of Decay)

OPPOSITE, BOTTOM: Hayao Miyazaki,
Nausicaä of the Valley of the Wind
imageboard (Nausicaä looks onto
Pejite from the crater wall)

TOP: Hayao Miyazaki, Nausicaä of
the Valley of the Wind imageboard
(Nausicaä's maiden flight)

BOTTOM: Hayao Miyazaki, Nausicaä
of the Valley of the Wind
imageboard (Nausicaä on gunship)

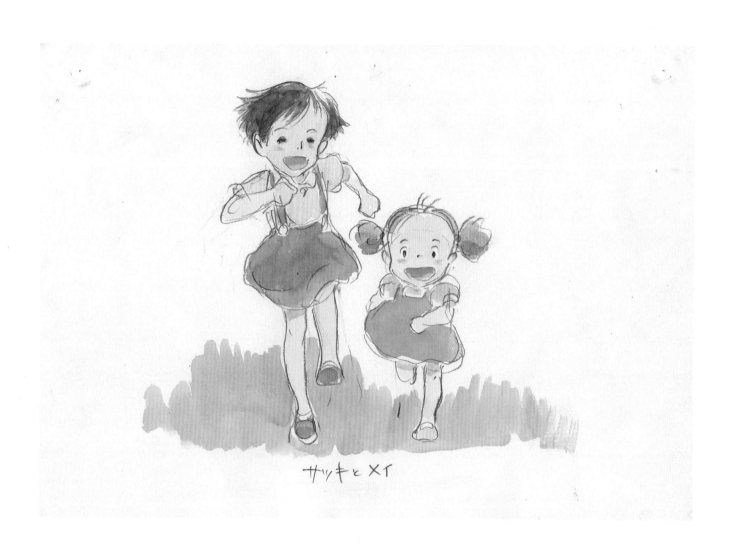

サツキとメイ

Hayao Miyazaki, *My Neighbor Totoro*
imageboard (Satsuki and Mei)

MY NEIGHBOR TOTORO
SATSUKI AND MEI

MIYAZAKI ORIGINALLY CONCEIVED OF JUST ONE YOUNG GIRL as the protagonist of My Neighbor Totoro, but it turned out she had two incompatible sides: "One side of her proved to be too immature, so we split this dichotomy into two characters."[23] Thus, young Satsuki was given an even younger sister, Mei.

The film is set in postwar Japan, and it starts with Satsuki and Mei's move with their father to a house in the countryside while their mother is hospitalized due to a prolonged illness. The adventurous pair run about, exploring their new surroundings, taking in every detail like "the blueness of the sky, the acorns on the ground, the little flowers blooming at the roadside."[24] The sisters' perspectives are also divergent: while Satsuki is at school, Mei enjoys the carefree pleasures of childhood on her own, soon encountering the local spirits, including the forest spirit she calls Totoro. As the days pass, Satsuki experiences the pains of growing up as she quickly takes on extra household duties in the absence of her mother, and an acute sadness affects her usual vivaciousness.

Miyazaki recounts developing the storyboard of My Neighbor Totoro to follow the characters' emotional responses to their changing circumstances past, present, and anticipated: "Initially, I didn't intend to have [Satsuki] cry so much. I thought of Satsuki as a girl who could keep her emotions under control. After completing part B, I looked at the relationship between Satsuki and Mei. Mei is guileless and doesn't think deeply about things, so she's not gloomy. But Satsuki gets depressed. Why? Because she is trying too hard to be good. If she could recognize that she is trying too hard, Satsuki would be able to feel better. If she fails to do this, she will turn into a delinquent. It was only after the storyboards had been done for part B that I realized I had to let this girl's emotions explode somewhere. I was already starting part C."[25]

Miyazaki drew partially from his own childhood for the development of Satsuki, especially her ability to keep her composure. His mother was hospitalized for long stretches of time, and he was asked to grow up fast, tasked with household chores, and left to be introspective. When he visited his mother, he was too shy to embrace her. In My Neighbor Totoro, while Mei is exuberant upon seeing her mother during a hospital visit, and "still young enough to hug her," Satsuki is reluctant to show affection.[26] Having her hair brushed lovingly by her mother, then, becomes a precious experience for Satsuki, and her mother says to her, "You and I are a lot alike, Satsuki." Such moments of interpersonal connection, here spoken out loud and poignantly visualized in Satsuki's interactions with her family, make the interior lives of Miyazaki's characters real to audiences.

SATSUKI: MAIN CHARACTER; FOURTH GRADER[×]

A girl bursting with vitality, seemingly growing up basking in sunshine. Limber and flexible body, stretching to its fullest. Vivacious and distinct expressions with eyes that dart about, unflinchingly looking at reality. Strong and reliable. In a family whose mother is absent, she is fulfilling the role of homemaker. Of course, she is not just full of cheer. She does have some sadness inside, but for now she is full of life, her legs wanting to run, and she is eagerly impressionable.

She doesn't like the typical girlish things. She loves to run, jump, laugh. She doesn't shy away from fighting boys. The normal boys her age are staggered by her vitality.

She has no trouble changing schools and makes friends right away. But because she has to look after her father—who is deficient in his ability to master the realities of daily life—and her little sister, she has been forced to exercise forbearance. This necessitates her having to be mature. Yet, this girl has a talent for enjoyment even in hard times.

As she grows up, Satsuki will encounter several turning points, no doubt becoming a woman of depth. In this film, however, she must be depicted as a charming girl full of vitality.

MEI: SATSUKI'S YOUNGER SISTER; FOUR YEARS OLD[×]

In contrast to Satsuki, who is reliable and quick-witted, Mei is a single-minded, persevering child. Stubborn yet cheerful, she is like her older sister in that she is persistent and not timid. But with her initial shyness and tendency to few words, she seems to be even more observant than Satsuki.

For some reason she doesn't fear goblins, and the goblins open up to her because her child's world has not yet been tainted by the common sense of adults—but this may also be due to her loneliness. Even Satsuki must bear up, but not having her mother around is an even greater hardship for a four-year-old. Yet, Mei is a bold happy girl without any dark shadows in her personality. She runs after her older sister and imitates her. But if she comes across something interesting, she becomes obsessed with it and forgets the way home or the time, upsetting her older sister.

[×] Miyazaki, "My Neighbor Totoro—Directorial Memo: Characters," 1987, in **Starting Point, 1979–1996**, trans. Beth Cary and Frederik L. Schodt (San Francisco: VIZ Media, 2009), 259–60. In the film, Satsuki is a sixth grader.

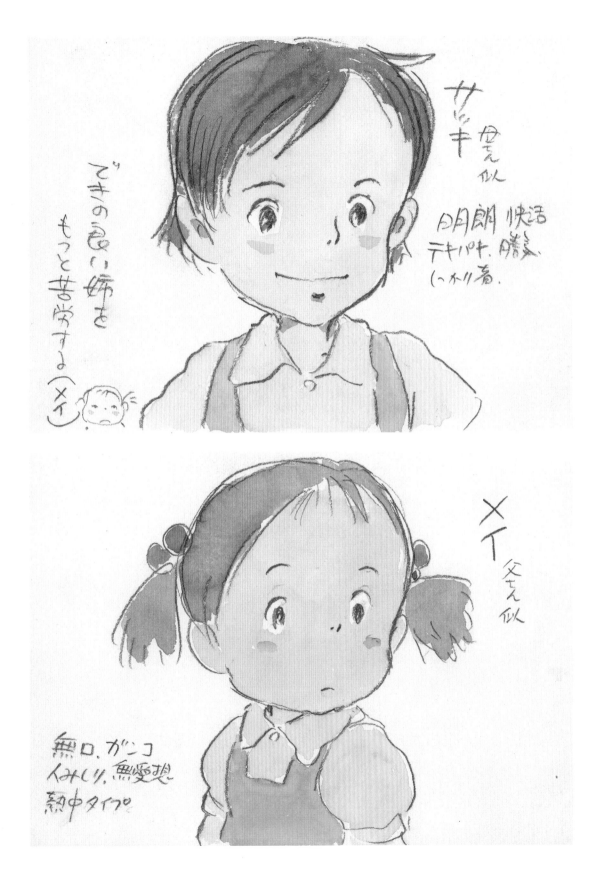

TOP: Hayao Miyazaki,
My Neighbor Totoro imageboard
(Satsuki character design)

BOTTOM: Hayao Miyazaki,
My Neighbor Totoro imageboard
(Mei character design)

Notes read: "Satsuki, takes after her mother. Bright and cheerful,
lively, brisk, strong-willed person of strong character" and
"Mei, takes after her father. Untalkative, stubborn, shy, unsociable,
the type that gets absorbed in things."

メイ（三月）→サツキ

ーすたきすぎ

OPPOSITE, TOP: Hayao Miyazaki,
My Neighbor Totoro imageboard
(character design for Satsuki, Mei,
and father)

OPPOSITE, BOTTOM: Hayao Miyazaki,
My Neighbor Totoro imageboard
(initial concept for Mei)

ABOVE: Hayao Miyazaki,
My Neighbor Totoro imageboard
(Satsuki and Mei scare away ghosts
at their new house)

My Neighbor Totoro production cel
(Satsuki and Mei)

A60

My Neighbor Totoro production cel
(Mei meets Totoro)

Kiki's Delivery Service imageboard
(Kiki and Jiji take flight)

KIKI'S DELIVERY SERVICE
KIKI

FOR HIS FIFTH FEATURE FILM, Kiki's Delivery Service, released in 1989, Miyazaki adapted a recently published novel of the same name by Eiko Kadono. He also based it on his own observations of the young working women around him, especially at Studio Ghibli, in their pursuit of economic and spiritual independence. His animated version of Kadono's hugely popular children's book is a reflection on "the spirit and the hopes of contemporary girls": "The true 'independence' girls must now confront involves the far more difficult task of discovering and expressing their own talents."[27]

The story centers on Kiki, a thirteen-year-old witch in training whose particular talent, or magical ability, is flying through the air on her broom. She leaves her parents to find a new home in the city, where she must fend for herself and struggles to gain acceptance. Kiki becomes an entrepreneur, starting a flying delivery service, but she encounters loneliness and self-doubt and loses her ability to fly. Ultimately, she must rediscover her talents in order to revive her business and grow into her own identity.

Kiki's magic is "something that all real girls possess": talents that require development and perseverance.[28] Kiki must drop her naïve ideas about work and the ease of an independent lifestyle to accept the inevitability of life's frustrations and disappointments. The key to more fully enjoying life, she comes to realize, is to be aware and use her skills consciously, "to make that power [her] own"—and this is what adolescence is all about.[29]

Miyazaki's empathetic portrayal of Kiki as she learns to handle her insecurities is "an expression of solidarity to young viewers who find themselves torn between dependence and independence."[30] He explains that Kiki's maturation is also conveyed visually: "My thought was that one characteristic of adolescence is learning to understand the appropriate use of these various facial expressions." In his own estimation, "the hallmark of this film is the expression of the many faces of a person. In the presence of her parents, Kiki is childish, but on her own she thinks things over with a more serious expression. She may speak roughly and bluntly to a boy her own age, but to her seniors, especially to people important to her, she acts politely."[31]

Kiki's emotional reactions are relatable to individuals at all stages of life, as are her crises of confidence: "Kiki will be depressed about other things in the future as well. She may become sad, but she will climb out of that feeling. That's how I wanted to end the film. I didn't want it to have a happy ending with her business becoming a success or her becoming the town's sweetheart. I wanted to give the sense that she will repeatedly become dejected and then regain her cheery vitality."[32]

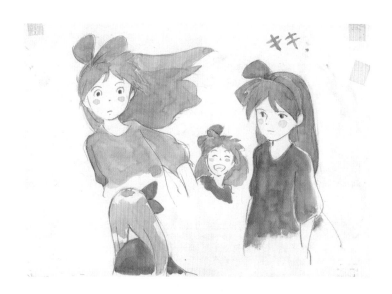

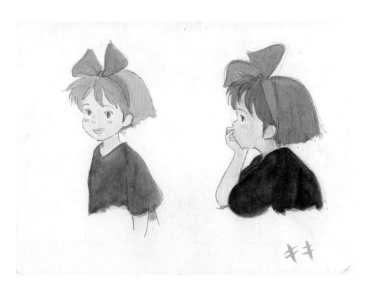

TOP AND MIDDLE: **Kiki's Delivery Service** imageboards (initial concepts for Kiki)

BOTTOM: **Kiki's Delivery Service** imageboard (character design for Kiki)

OPPOSITE: **Kiki's Delivery Service** initial imageboard (Kiki with Jiji)

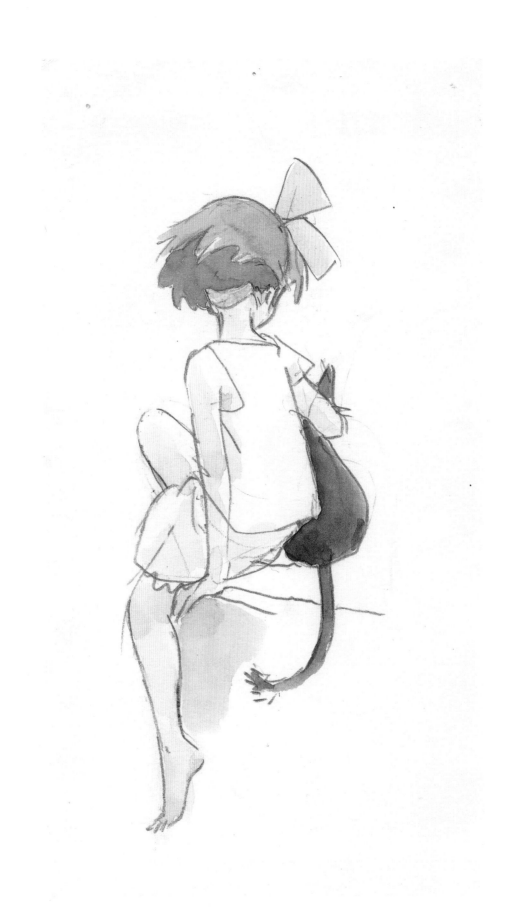

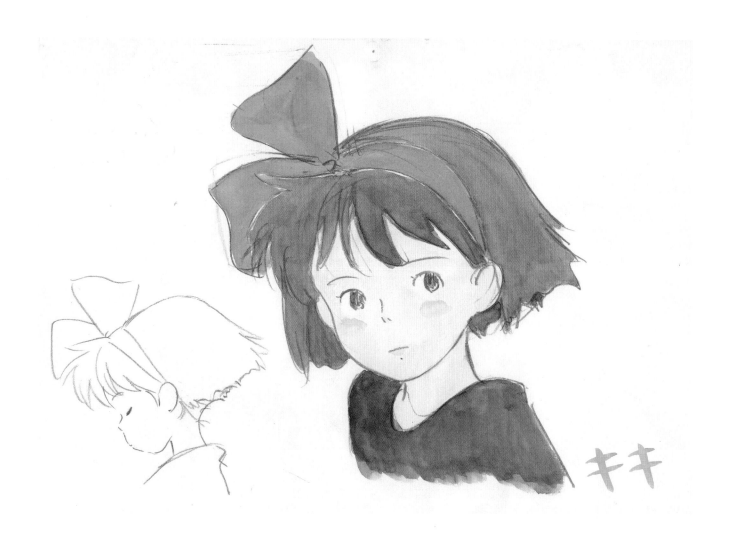

Kiki's Delivery Service imageboard
(Kiki character design)

5299 B-56

Kiki's Delivery Service production cel
(Kiki and Jiji)

Hayao Miyazaki, *Princess Mononoke* layout drawing (San and Ashitaka, scene 1625)

Note reads: "No background, entire frame is transmitted light."

PRINCESS MONONOKE
ASHITAKA AND SAN

ORIGINALLY, MIYAZAKI PLANNED to name Princess Mononoke after the hero Ashitaka, a boy who has a death curse placed upon him after he kills a boar-god transformed by hatred into a demon. A mark on Ashitaka's arm grows as the curse feeds off his anger, threatening to devour him from the inside. It was Studio Ghibli producer Toshio Suzuki who convinced Miyazaki to use Mononoke, or "vengeful specter," in the title to spotlight the film's other, female protagonist, a skilled fighter named San who was raised by wolves.[33] San despises humans for encroaching upon the forest and destroying all life within it. Defending the Forest of the Gods, San and her allies regularly attack nearby Iron Town and its inhabitants. With each side seeking to annihilate the other, Ashitaka finds himself in the midst of this conflict: he wants everyone to survive but knows that there is no easy way out.

The two lead characters play equally important parts in the film's narrative, set in medieval Japan in the Muromachi period. "This is a vivid period action-adventure drama woven from two threads—a vertical thread of the struggle between humans and spirits . . . and a horizontal thread of the meeting between a girl . . . and a boy." Both protagonists must deal with their anger, and, Miyazaki adds, "this meeting is the key to their liberation."[34] Ashitaka understands San's rage but also accepts the people of Iron Town; San, in turn, opens her heart to Ashitaka and even saves his life, but isn't able to forgive humankind. "I believe that violence and aggression are essential parts of us as human beings. I think it is impossible to eliminate that impulse from ourselves. The issue that we confront as human beings is how to control that impulse," Miyazaki says.[35]

While San and Ashitaka don't entirely overcome their anger, they fight together to restore life and subsequently resolve to live in peaceful coexistence, no longer acting to destroy others. Certainly, they will face more societal and spiritual hardship ahead, but instead of being judgmental or giving up in despair, Ashitaka tells San "to live."[36] Indeed, what has happened in the past cannot be erased, and few conflicts are easily resolved. "Princess Mononoke does not purport to solve the problems of the entire world. The battle between rampaging forest gods and humanity cannot end well; there can be no happy ending. Yet," Miyazaki continues, "even amid the hatred and slaughter, there are things worthy of life. It is possible for wonderful encounters to occur and for beautiful things to exist."[37]

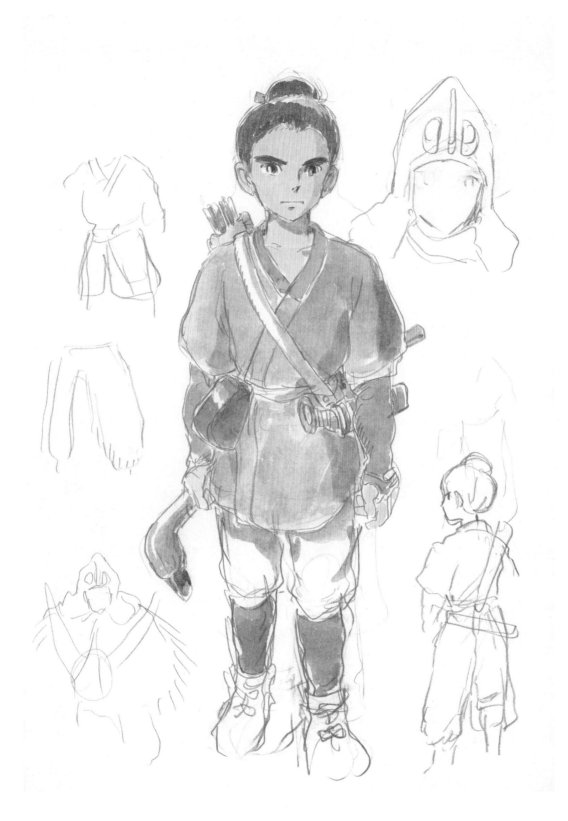

Hayao Miyazaki, Princess Mononoke
imageboard (Ashitaka character design)

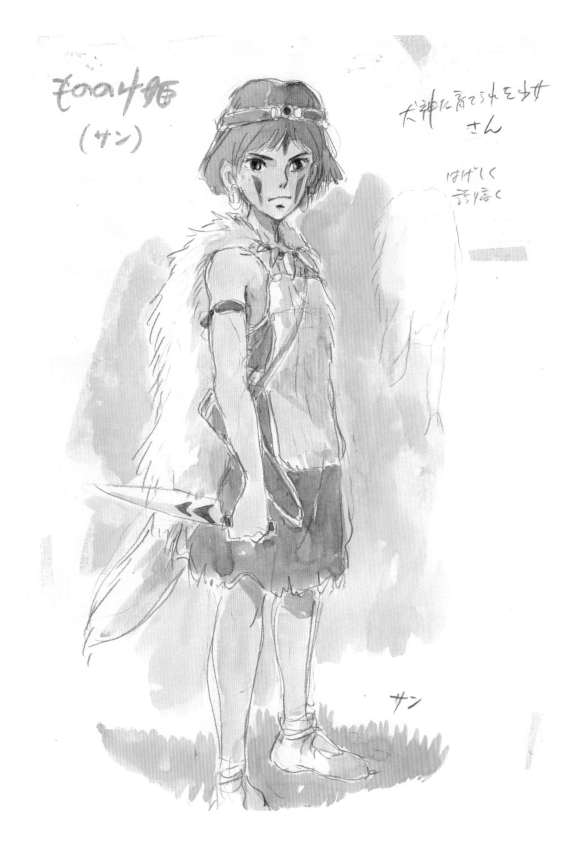

もののけ姫
（サン）

犬神に育てられた少女
さん

はげしく
きりりく

サン

Hayao Miyazaki, *Princess Mononoke*
imageboard (San character design)

Note reads: "Princess Mononoke.
A girl raised by divine wolves.
San. Fierce and proud."

犬神に育てられた少女
サン
(3oそい位)

OPPOSITE: Hayao Miyazaki, Princess Mononoke imageboard (initial concept for San)

ABOVE: Hayao Miyazaki, Princess Mononoke imageboard (initial concept for San with divine wolf and Ashitaka)

マシタカ

Hayao Miyazaki, Princess Mononoke
imageboard (Ashitaka and Yakul
character design)

Hayao Miyazaki, Princess Mononoke
imageboard (Ashitaka and Yakul
character design)

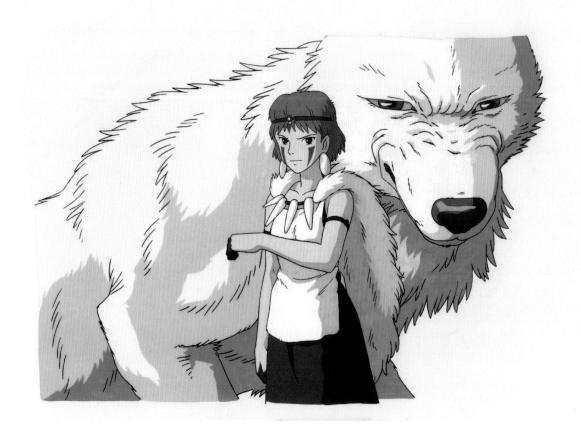

Princess Mononoke production cel
(San and Moro)

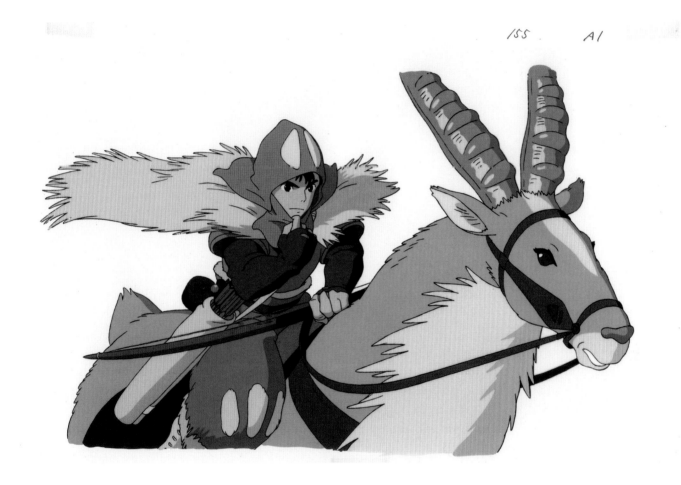

155 A1

Princess Mononoke production cel
(Ashitaka and Yakul)

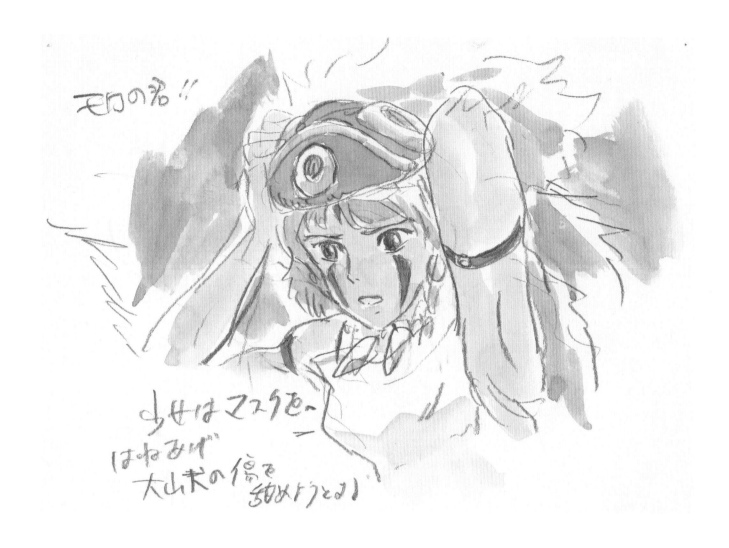

その名!!

あせはマスクを
はねみず
大山犬の傷を
なめようとし

Hayao Miyazaki, Princess Mononoke
imageboard (San character design)

Note reads: "The girl flips up her mask and
tries to lick the wound of the giant wolf."

THE PROCESS: CHARACTERS

YOU WILL FIND YOURSELF IDENTIFYING WITH THE VARIOUS CHARACTERS' EMOTIONS: WITH THEIR ANGER, JOY, AND GENTLENESS. THEIR EMOTIONS WILL BECOME YOURS. AND, AS IS OFTEN SAID, YOU WILL BECOME BOTH AN ANIMATOR AND AN ACTOR.[38]

THE PERSONALITIES OF MIYAZAKI'S CHARACTERS BECOME APPARENT not just through behaviors and actions but also in the way the characters look. In animation, every detail has to be designed in advance: bodies, facial expressions, movements, colors, clothes, words, voices. To define all of these, it is essential to know the basics—how old the characters are, where they are from, at what time they are living. Just as important is establishing their motivation or emotional state at any single point in the film.[39]

The general look of the characters evolves through Miyazaki's hand-drawn imageboards. Based on these, he and the supervising animator start drawing character designs. In-depth research is conducted into time periods, locations, and lifestyles. How would specific individuals interact with one another and move through the world? What would they wear and how would they talk? Extensive effort goes into the design phase, and the complications can multiply when a character's age changes during the film. (Jiro, the protagonist of The Wind Rises, is a good example of a character whose maturation is closely observed, and Sophie from Howl's Moving Castle transitions back and forth between her young and old self.) The finished character designs outline how every character looks from multiple angles; how motions such as running, flying, or sitting should be depicted; and how feelings such as joy, anger, and sadness are expressed.

The drawings are then shared with the animation department, whose task it is to bring the characters to life. The animators also work from Miyazaki's written character descriptions and the storyboard, which functions as a blueprint or visual screenplay for the entire film. More detailed information is provided in the layouts, uncolored drawings that focus on scene composition. They include Miyazaki's instructions for the animators, and, in comparison with the storyboard and character designs, they specify more detailed information on timing; character expressions;

CREATING CHARACTERS

perspective; movement of characters, settings, and the camera; and spatial relations (see also "The Process: Worlds," p. 141).

Next, the animators begin working on the key animation (called **genga** in Japanese), which illustrates key phases of each movement for each scene in the film. One specialty of Miyazaki's films is the studied depiction of flight, and it requires highly skilled animators to depict such complex movement fluidly and precisely. As is true for the layouts, the key animation usually undergoes several revisions before Miyazaki gives it the go-ahead. The team then proceeds with the in-between animation (**doga**), completing the movements that have been defined by the key animation drawings. After that, clean-up animation drawings provide a seamless look.

Color design is crucial to the planning of a film, and Studio Ghibli is famous for taking great care in selecting the overall palette of each project. In chart form, the color designer designates the hues to be applied throughout the film, with each character assigned an individual selection, including variations intended to convey their changing emotional states.

For Miyazaki's early films, the animation drawings were transferred onto transparent acetate sheets, called production cels, that the ink and paint department colored by hand. The cels were then layered, combined with backgrounds, and photographed frame by frame. This changed with **Princess Mononoke**, released in 1997, the last Miyazaki production to be shot on film and the last to use production cels. Now, though the animation of all of Miyazaki's feature films continues to be drawn by hand, the animation drawings are scanned and colorized digitally.

The way characters speak—how they sound—is as important as their look. Once the visuals are finished, the voice recording begins, with actors selected through a casting process that starts about six months prior. Explains Tamaki Kojo, Studio Ghibli's postproduction coordinator: "Ordinarily, auditions are difficult to do. For children, we do auditions. But for the more famous actors, it is logistically difficult to have auditions for their roles. So, what we normally do is, we'll take samples of work that they're currently doing, whether it be from television or film, and have the director listen to it." Kojo adds this process can be challenging: "Miyazaki doesn't like the way professional voice actors are trained to speak today. . . . The way they speak isn't concise." He observes that Miyazaki prefers a more traditional way of speaking, with clear intonation and direct expression.[40]

Most of Miyazaki's films have been distributed internationally and dubbed in other languages. Viewers who don't speak Japanese have the choice of watching the re-voiced version in a language they understand or the subtitled version of the Japanese-language release. Which version to opt for can be a difficult decision, but considering how much effort goes into creating the characters in Miyazaki's films, if the opportunity arises, it is well worth hearing the characters speak in their original voices.

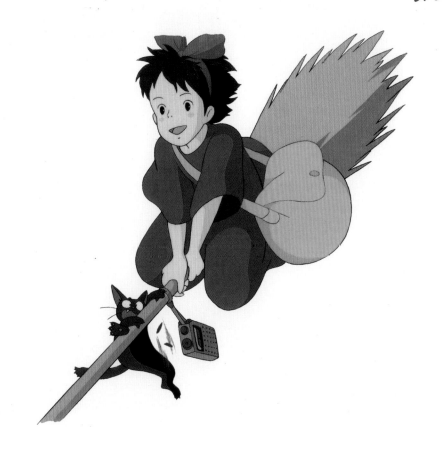

D155

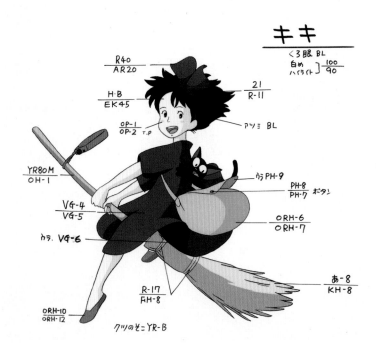

キキ

	くろ眼 BL
R40 / AR20	白め ハイライト] 100/90
	21 / R-11
H·B / EK45	
OP-1 / OP-2 T·P	アツミ BL
YR80M / OH-1	うら PH-9
	PH-8 / PH-7 ボタン
VG-4 / VG-5	ORH-6 / ORH-7
から VG-6	
	あ-8 / KH-8
R-17 / FH-8	
ORH-10 / ORH-12	

クツのそこ=YR-B

ABOVE: Kiki's Delivery Service production cel (Kiki and Jiji)

LEFT: A color design chart indicates the hues of each element to be painted in the production cels. The color designer's note reads "Kiki, Iris: BL (black), Whites of eyes: 100. Highlight: 90."

No. _____

【株式会社　トップクラフト　312-7166 315-0920】

カット	画　　面	内　　容	秒
1538		ナウシカの傷ついた足から光の粉が無数に生れて流れている	3.5
1539		ナウシカの扇の傷にあてられた飛毛から――と光の粉がふき出ている	4.0
1540	実色スケール	ナウシカのカゲにフランカール 人々の見守る中ナウシカのあたりブラシの光がOLでも変化しつつ次々に光がつよくなりついたナウシカまったく見えなくなる（トーカ光）	6.0
1541	光 トーカ光	光の中でゆっくり目をひらくナウシカ	
		ほほずりするテトに、手をやり　テト……	
つづく↓			13.5

TOPCRAFT CO.,LTD. BG/原図

BG 角触毛のカゲを
で借りる中心にグラデーテ'..Tい (2/5) A
S. C. 1539 TIME(+)

OPPOSITE: Hayao Miyazaki, Nausicaä of the Valley of the Wind storyboard

The storyboard's columns chart the scene number, frame image, story content, and duration. For scene 1540, Miyazaki notes, "As the people look on, the area around Nausicaä with the brushed light changes, and gradually the light becomes stronger, and finally Nausicaä can't be seen at all (transmitted light)."

ABOVE: Hayao Miyazaki, Nausicaä of the Valley of the Wind layout drawing

A layout drawing is made for each frame in the storyboard. For scene 1539, as the ohm's tentacles reach for Nausicaä, Miyazaki's note indicates: "BG (background) for tentacles' shadow color, please make the gradation with the wound as the center."

"THE CREATION OF A SINGLE WORLD COMES FROM A HUGE NUMBER OF FRAGMENTS AND CHAOS."

CREATING WORLDS

MIYAZAKI'S WORLDS ARE CREATED NOT JUST FOR THE EYES BUT FOR ALL THE SENSES. His sceneries are immersive and experiential, realized through a passion for detail paired with an observational perceptiveness that "allows us to experience the meaning of the landscape or the climate on a much deeper level."[41] Although his environments don't document real places, there seems to be something recognizable in them: they evoke feelings of familiarity. Through this uncanny effect, he establishes a sense of connection between his worlds and the viewer's own experience, reaching audiences of all ages and origins.

To build each "thoroughly believable fake world," Miyazaki takes inspiration from a multitude of sources, from his own childhood memories to places he has visited or read about in books.[42] He slowly forms a foundation of collected motifs and themes, assembling and rearranging them into new and evolving environments. Ultimately, the challenge is to unify these elements in a way that transcends the original fragments to form a holistic world. For Miyazaki, it is crucial that a film's imagined world be depicted with realism: if the audience cannot comprehend it, or if it lacks coherence, the fictional place will not be relatable. Art director Yoji Takeshige points out that in addition to conducting extensive research, Studio Ghibli's creative team works with Miyazaki by imagining what it would be like "to be there."[43] "I often tell our staff that they're not just creating drawings," Miyazaki explains. "They have to draw believing there's a world out there; if they just try to make drawings, they'll never get beyond that point."[44]

His team spares no effort in capturing atmospheric nuance, and they pay meticulous attention, for example, to the subtlest changes in natural light. Light is an indispensable tool in Miyazaki's portrayal of beauty—just as a real sunset can feel unforgettable, so, too, should an animated sunset make a lasting impression. "Our 'art' has consisted of being

passionate about bringing the light of the sun to the screen," he says of working with Studio Ghibli. "This world continues to exist, far, far behind the screen, in a place invisible to the eye, way beyond the left and right edges of the screen, where the sun is shining, and animals, plants, and humans are alive."[45] It is the lived presence in Miyazaki's films that makes his worlds resonate so strongly.

THE NATURAL WORLD AND HUMAN INDUSTRY

THERE ARE MOMENTS IN MIYAZAKI'S FILMS WHEN EVERYTHING QUIETS DOWN. In these moments of tranquility and contemplation, the protagonists find themselves immersed in nature, and the audience sees the world through their eyes: the soft radiance of flowers on a meadow, the peacefulness of clouds passing by, the shimmering of leaves in the breeze. Such precious moments embody an essential aspect of Miyazaki's films: the ways in which characters relate to one another and how they relate to the world are of equal importance. "We don't subordinate the natural settings to the characters," Miyazaki says. "Our way of thinking is that nature exists, and human beings exist within it. That is because we feel that the world is beautiful."[46] These scenes of nature often feel outside of time, and they prompt an experience of longing in viewers that has led Miyazaki to "indulge in the wild speculation that a sense of nostalgia is not simply something we acquire as adults, that it indeed may be a fundamental part of our existence from the very beginning."[47]

Crucially for Miyazaki, nature exists independent of human pleasure and enjoyment: "Although humans are part of nature and nature gives us life, there is a definite break between us and nature."[48] Indeed, nature as a force can be terrifying, and its capacity to devastate without provocation is illustrated throughout his body of work, and particularly impressively through wind, water, or fire, or through the shifting of tectonic plates, as in the historic example of the Great Kanto Earthquake of 1923, which destroys the city of Tokyo in The Wind Rises. In Miyazaki's words: "Nature is essentially savage. It negates culture and civilization. Despite humans' efforts to improve things for themselves, nature contains elements flatly opposed to our efforts."[49]

Arising within the natural world against the odds, human industry can be observed in Miyazaki's worlds as resulting in generative technologies that attest to the filmmaker's firm belief in the value of work—"To want to work is to want to live."[50] Hand-assembled machineries and contraptions appear in his films as wonders of the human imagination. But, Miyazaki warns, technological triumph poses a risk: "Dreams possess an element of madness, and such poison must not be concealed. Yearning for something too beautiful can ruin you."[51] This difficult fate is movingly conveyed in The Wind Rises, in which a brilliant and ambitious aircraft designer, Jiro, is overcome with remorse after developing a Zero fighter used by the Japanese Empire in World War II. Miyazaki's particular fascination with airplanes as ingenious but dangerous feats of engineering began during his wartime childhood, when his father, Katsuji Miyazaki, directed a manufacturing plant for military plane parts. In The Wind Rises, and in the earlier aviation-based film Porco Rosso, Miyazaki contrasts the elegance of certain planes in flight— their lightness and speed—with their power as war machines that bring suffering and death.

Rather than entirely romanticizing nature and condemning the human appetite for progress, Miyazaki pursues the ramifications of these forces' potential conflict uniquely in many of his films. In Castle in the Sky, the orphaned Pazu lives in Slag Ravine, where he and other miners—salvagers of the earth's resources—labor together to build an infrastructure for themselves, including housing and railways. They are shaping the surrounding landscape, Miyazaki notes, "in an era when machines are still exciting and enjoyable, and science does not necessarily make people unhappy."[52] The tension between civilization and nature as potentially violent is the central dynamic of Princess Mononoke, in which a society of pariahs lives in Iron Town, erected amid a mountainous wilderness. Iron Town's ruler, Lady Eboshi, believes her subjects will live well, and even thrive, if they expand their industry and the town's borders; in response to this insatiable desire for growth, the wild creatures of the surrounding forest see no way forward other than to attack. In Miyazaki's summation, "human beings are part of nature, are the ones who have destroyed nature, and are the ones who live within the nature they have destroyed."[53] Howl's Moving Castle begins in the idyllic hometown of a young hatmaker named Sophie who must leave to seek a remedy for an age-curse placed on her by the Witch of the Waste; when she later returns, Sophie is heartbroken to witness raging, uncontainable fires, brought on by senseless war, destroying the town's pretty shops and half-timber buildings.

Miyazaki is clearly critical of harmful human behaviors and openly disapproves of war and pollution, but it would be too simple to label him a pacifist or environmentalist. After all, he asks, "Isn't it the height of arrogance to keep showing nature as needing protection to keep from disappearing?"[54] In Nausicaä of the Valley of the Wind, while human activity has damaged the environment to the point where gas masks are required to breathe, nature itself is also actively poisoning them.[55] Ponyo's once pristine underwater world is increasingly sickened by carelessly discarded trash when Sosuke's home on a cliff is flooded by a powerful storm. "I think it's important to remember that we can't control the world," he advises, "that we need a sense of respect for it, even some humility."[56]

PONYO
THE SEA

WITH YOUNG VIEWERS IN MIND for his 2008 film **Ponyo**, Miyazaki set out to "make a well-rounded film using a few simple lines."[57] Yet, **Ponyo**, as a story of transformations, is remarkably complex. At the start of the film, the underwater home of the goldfish-girl Ponyo seems to be separate from the earthen cliff where a five-year-old boy named Sosuke resides. As Sosuke's affection for Ponyo grows, the two worlds come to overlap, mirroring the relationship that unfolds between the protagonists.[58] "The sea below, like our subconscious mind, intersects with the wave-tossed surface above. By distorting normal space and contorting normal shapes, the sea is animated not as a backdrop to the story, but as one of its principal characters."[59]

Having used CGI in his previous three feature films, Miyazaki decided, with **Ponyo**, to return to hand-drawn animation and once more push its potential by rendering the shapes and movements of a fluid world "where magic and alchemy are accepted as part of the ordinary."[60] Among the many technical challenges of this approach, in Studio Ghibli art director Noboru Yoshida's estimation, "The first is the waves. How do we render the water? The second is the wind. How does the grass look when it's blowing in the wind? Since we were trying to do everything that we would normally do with [CGI] by hand this time, I wanted to see how much we could achieve with 2D animation."[61] In the end, the studio landed upon a style that shifts between the naturalism Miyazaki usually deploys and more abstract scenes that consciously emphasize a hand-drawn quality. Miyazaki instructed Ghibli's creative team to "get rid of straight lines. Use gently warped lines that allow the possibility of magic to exist liberating us from the curse of perspective drawing."[62] The singularity of **Ponyo** lies in its flowing organic lines, which express a world dynamic defined by the living presence of the sea, "where even the horizon swells, dips, and sways."[63]

Ponyo is distinct among Miyazaki's works for the dominance of the color blue. Its many shades define the film's mood. Michiyo Yasuda, longtime chief color designer at Ghibli, had the rare opportunity to work with a storyboard to which Miyazaki had already applied color, but the assignment was nonetheless hugely demanding. In addition to determining the various hues appropriate for each scene, she had to take water's shifting transparency into account as she developed her color charts. About working out the film's detailed scheme, Yasuda recalls, "The color intensity and hues were different with every shot, from the look of the water spray to the underwater shots—everything."[64] The multiplicity of blues manifests a world that matches the constant transformation of the sea itself, a wondrous, multifaceted, powerfully dynamic world that remains unpredictable to humankind.

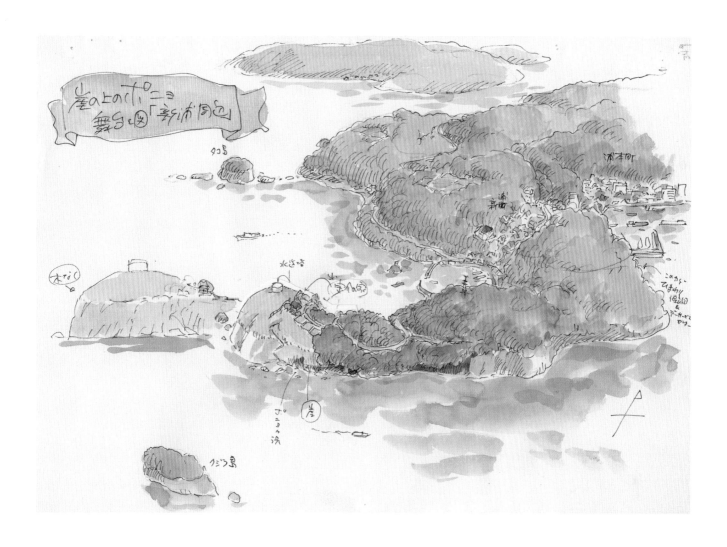

Hayao Miyazaki, Ponyo imageboard (aerial map, Uramoto Town, the Sunflower Nursery School, Ponyo Beach, Octopus and Whale Island, and Sosuke's house)

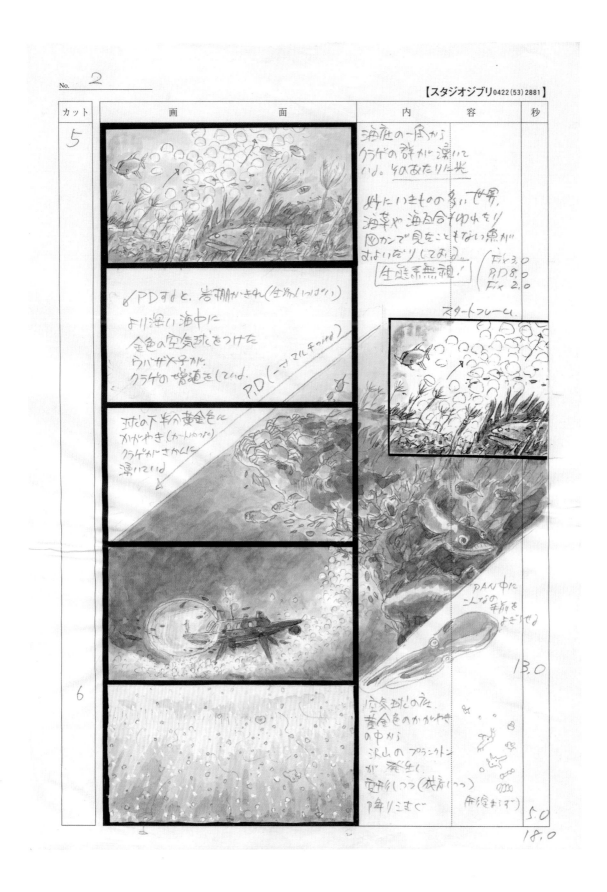

ABOVE: Hayao Miyazaki,
Ponyo storyboard

Miyazaki painted this storyboard outside the confines of the frames.
He indicates a downward pan and multi-plane camera work to capture
the complexity of the underwater ecosystem.

OPPOSITE: Ponyo production
imageboards (Basking Shark)

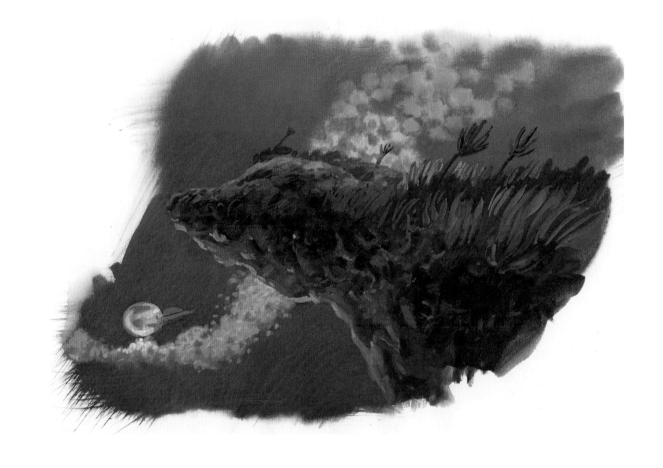

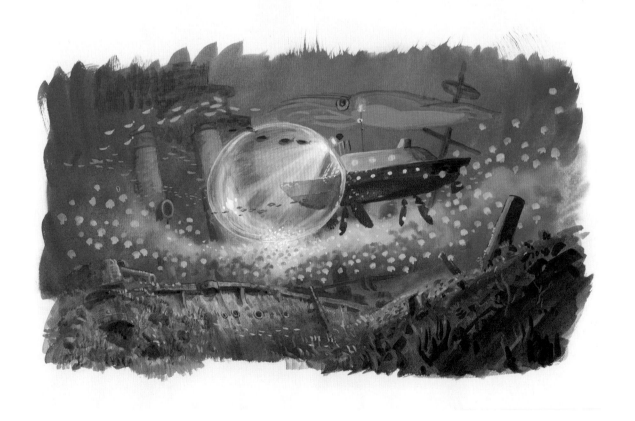

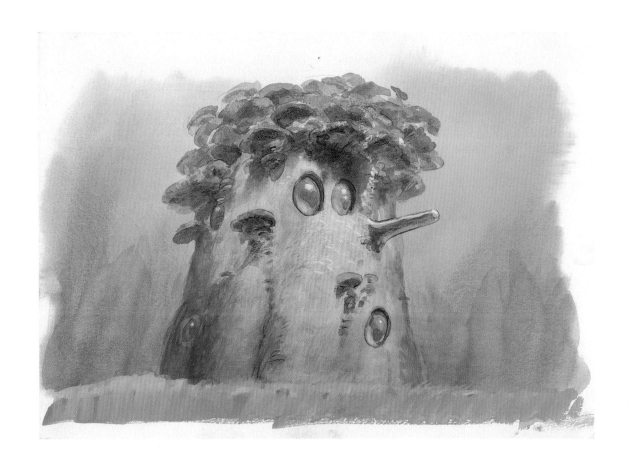

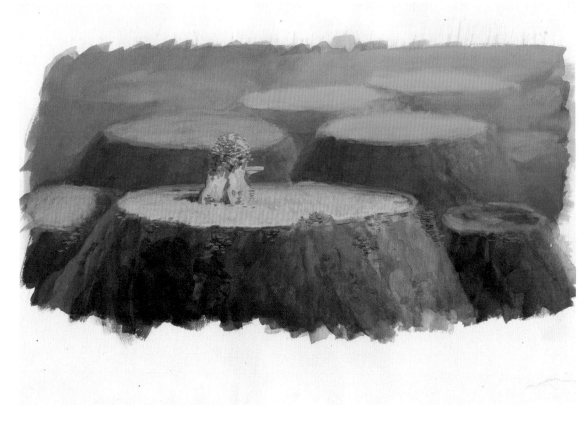

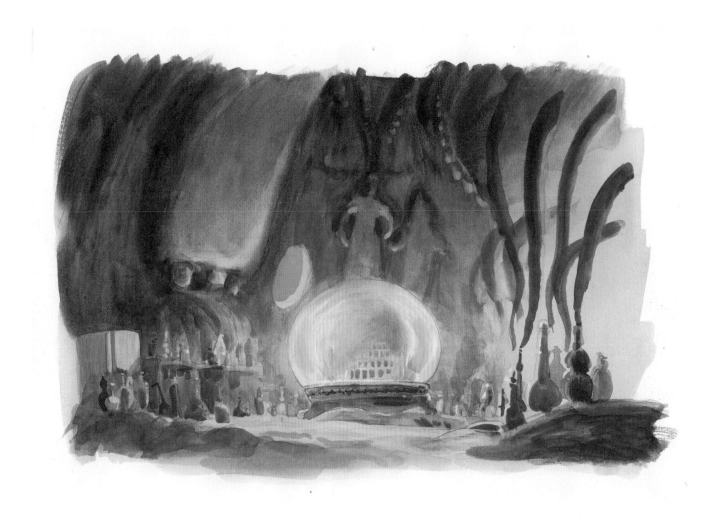

OPPOSITE: Ponyo production
imageboards (Coral Tower)

ABOVE: Ponyo production
imageboard (Fujimoto's laboratory)

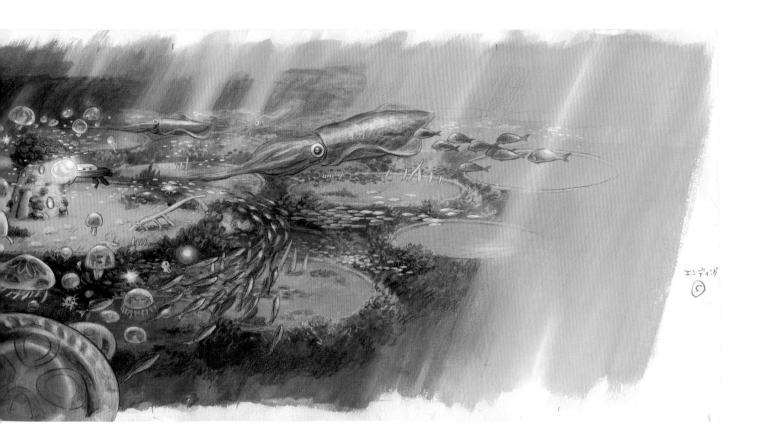

Ponyo backgrounds for end credits
(underwater worlds)

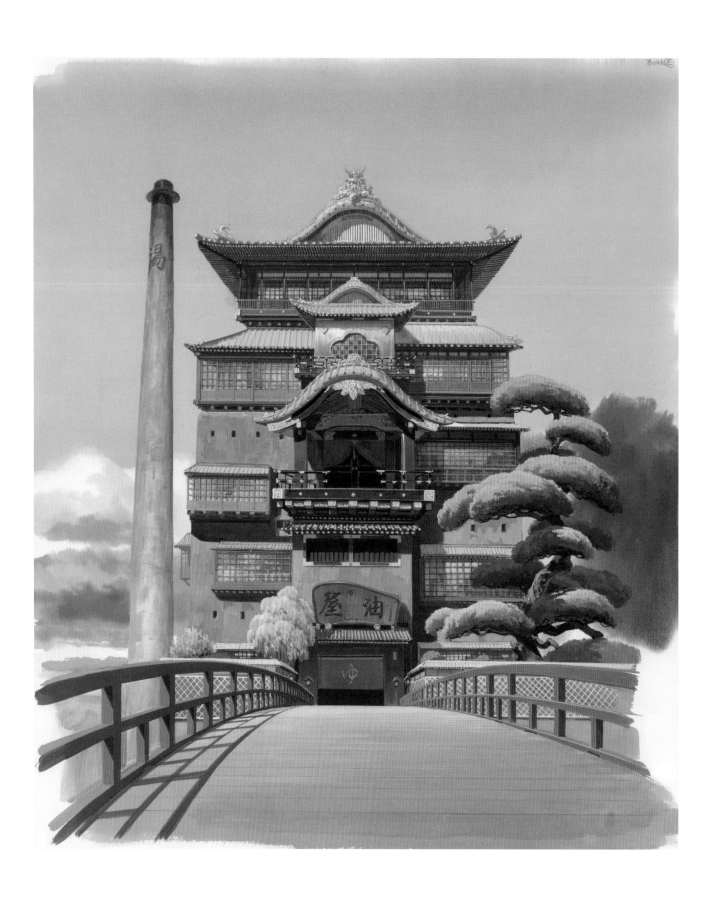

THE BATHHOUSE

SPIRITED AWAY IS THE TALE OF TEN-YEAR-OLD CHIHIRO as she navigates an alternate world—a spirit realm—into which she has unwittingly entered with her parents, who have since been turned into pigs. The film follows Chihiro's strange encounters as she seeks to restore her parents to their human forms and to return to normal life. For Miyazaki, creating the magical environment of Spirited Away involved noticing sundry details and aspects of Japan, past and present, so that an otherworldly experience might be evoked. "What we're ultimately depicting," he says of the film, "is the real Japan."[65]

The spirits' bathhouse where Chihiro finds work combines aspects of traditional Japanese culture—activities, decor, materials, and colors—with touches of modern Western convenience. By his own account, Miyazaki's intention was to build on specificities of his own cultural roots in order to shape an escapist fantasy realm that would strike a chord with audiences internationally: "a mishmash of a traditional-style palace, a grand Western-style (or quasi-Western-style) mansion, and something like the Palace of the Dragon King." The bathhouse, he adds, "is really like one of today's leisure land theme parks, but it's something that could also have existed in the Muromachi and Edo periods."[66]

Miyazaki chose red as the thematic color of Spirited Away to riff on its traditional association with sacred Japanese temples and shrines. The bathhouse is a commercial operation where spirits come for relaxation and purification, and Miyazaki instructed the art department to make it "more gaudy with the red, almost blinding."[67] At night, when the building emits an inviting glow from within, lights illuminate the bridge leading to its entrance. Inside, as art director Yoji Takeshige points out, the details of the interiors include "incandescent light bulbs, so the lighting has a reddish tinge."[68] During the day, the time of rest, the building shines even brighter red in contrast with the clear blue sky.

The bathhouse's "exaggerated design" ranges from its wildly vertical structure to the labyrinthine layout of its rooms.[69] An elevator—a strikingly modern convenience amid centuries-old decorative accents such as wooden beams and shoji, Japanese paper walls and sliding doors—runs from the basement boiler room all the way to the topmost rooms occupied by the building's overseer, the witch Yubaba. The young heroine Chihiro, along with the viewer, finds herself disoriented by the multitude of floors and portal-like hallways, where a door might open onto an even longer corridor. Slowly she starts to find her way in this perplexing business complex, scrubbing the baths and tending to somewhat scary or downright disgusting guests. Eventually, Chihiro releases herself from Yubaba's control—not by destroying her but by finding a way to live in this challenging world.

OPPOSITE: Spirited Away
background (the bathhouse)

Spirited Away foreground on
background (the boiler room)

Spirited Away background
(the boiler room)

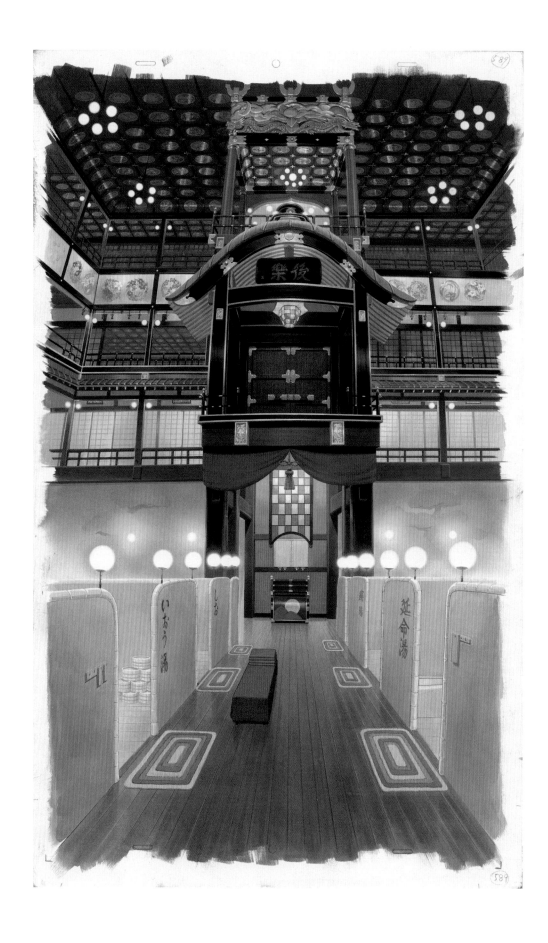

OPPOSITE: Spirited Away
background (bathing quarters)

The spirits can select "sulfur, salt,
or a life-lengthening bath."

ABOVE: Spirited Away background
(bathhouse elevator)

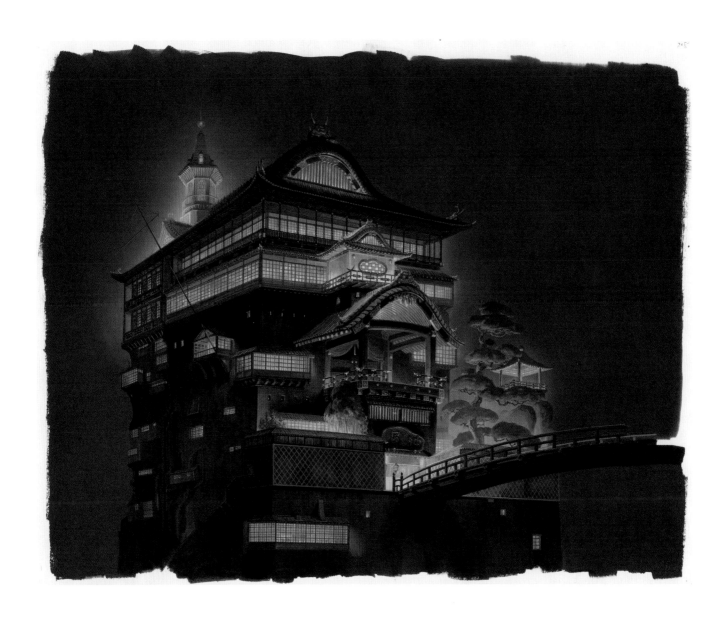

OPPOSITE: Spirited Away background
(bathhouse atrium)

ABOVE: Spirited Away foreground on
background (bathhouse at night)

At nightfall, the bathhouse comes to life
with spirits seeking healing and respite.

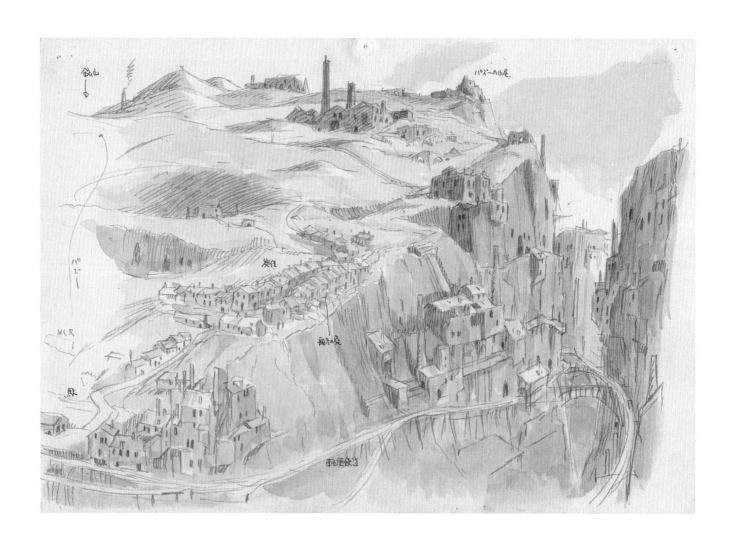

Hayao Miyazaki, Castle in the Sky
imageboard (Slag Ravine, aerial view)

THE PROCESS: WORLDS

WHAT RUSHES FORTH FROM INSIDE YOU IS THE WORLD YOU HAVE ALREADY DRAWN INSIDE YOURSELF, THE MANY LANDSCAPES YOU HAVE STORED UP, THE THOUGHTS AND FEELINGS THAT SEEK EXPRESSION.[70]

SIMILAR TO THE DEVELOPMENT OF CHARACTERS, THE PROCESS OF CREATING WORLDS starts with Miyazaki's drawings. He consolidates the ideas in his mind over many imageboards, which are typically drawn in pencil and then colored with watercolor. Studio Ghibli's staff research the fragments he is collecting, pursuing threads such as how a world's landscape and architecture might look and what seasonal changes might occur there. "Eventually, the basic form of your fictional world takes shape," says Miyazaki. "It becomes a shared world for the entire project staff. It becomes a world that actually exists! This is the 'imageboard' stage of the animation production process, the period when people become most excited in anticipation."[71] The imageboards, along with Miyazaki's storyboards, form the foundation of the art department's work at Studio Ghibli. The layouts are another source, providing additional information to the background artists of the art department as well as to the animation department (see "The Process: Characters," p. 115).

An essential part of an animated film's production is the creation of backgrounds. These depict the settings and thus determine the look and feel of each scene. They are hand-painted on paper, with particular attention paid to perspective, depth, light, and color. In a realistic interior scene, the time of day or the season is often indicated by the temperature and angle of the light falling through a window, while for an otherworldly scenario, imaginative leaps from the world we know are necessary: "When depicting a world with three suns, you have to construct a world that will seem to the viewers like it could have three suns."[72]

The foremost challenge for background artists is capturing the intensity and complexity of Miyazaki's ideas in their paintings: "Each shot should express the film's world in its entirety."[73] According to art director Yoji Takeshige, Miyazaki gives his artists many instructions and frequently tells them to "draw something familiar looking."[74] Even though the artists at Ghibli work in close coordination and their work is overseen by the art director, small differences between backgrounds are inevitable. In fact, Miyazaki encourages the infusion of personal style. "By drawing with our

own style, it ends up enriching the world that much more," continues Takeshige. "We all use the same materials, so the texture is the same."[75]

For any single setting within a film's world, numerous backgrounds will be completed to show different angles of perspective, including point-of-view shots, or to move between close-ups and long-distance views. While the dimensions of the painted backgrounds are usually fixed, they still must take the movement of the camera's eye into consideration. Sometimes a panning shot requires increased width or a vertical tilt greater height. The camera work, in the analog era, involved shooting the background drawings and production cels on film, but today Studio Ghibli uses computer-based compositing processes to overlay digital scans of the animation drawings onto the digitally photographed backgrounds (see "The Process: Characters").[76]

Once the visuals of the film are finished and the characters' voices recorded, sound effects and music are added. Tamaki Kojo, Ghibli's postproduction coordinator, stresses the value of focused location recordings: "At Studio Ghibli, we're able to work on all sorts of challenging tasks. During Howl's Moving Castle, for example, we went on a ten-day trip to France and Switzerland to record sounds for the film. [For Spirited Away] we rented a car to get the genuine sound of driving on cobblestone. We did this sort of location recording with Ponyo as well."[77]

The film's emotional life is enhanced by its musical score. Composer Joe Hisaishi's scores have been inextricably linked with Miyazaki's films since their initial collaboration on Nausicaä of the Valley of the Wind, released in 1984. To begin creating the signature style of music, Miyazaki shares with the composer his storyboard, notes, and other preparatory materials offering key information about the film's themes, characters, and settings. Hisaishi then writes what Studio Ghibli calls "image music," offering Miyazaki a variety of musical themes. Their process of exchange is flexible, and Miyazaki has on occasion provided song lyrics to Hisaishi as a starting point. For the creation of the actual score, the two invariably work closely together. As a result, Hisaishi's music succeeds in complementing and adding nuance to Miyazaki's imagery. Kojo prizes the melodic quality of Hisaishi's scores: "Music in film shouldn't be distracting, and [Hisaishi's] isn't. But somehow it lingers in your ears afterwards. That's the strength of his music. Even just listening to his soundtrack, it's still beautiful, even without the visual accompaniment. In Japan, at least, I can't think of anyone else as memorable as Joe Hisaishi."[78]

OPPOSITE, TOP: Castle in the Sky layout drawing (Sheeta falling into the mine, shot 77)

OPPOSITE, BOTTOM: Castle in the Sky background (the mine)

The layout drawing indicates the speed of Sheeta's fall and Pazu's sprint toward her. It also notes a bright light source inside the mine; smoke emanating from the mine is to be drawn on a cel.

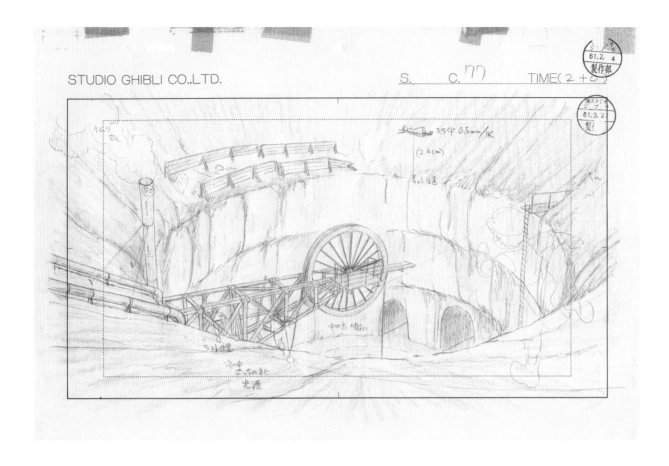

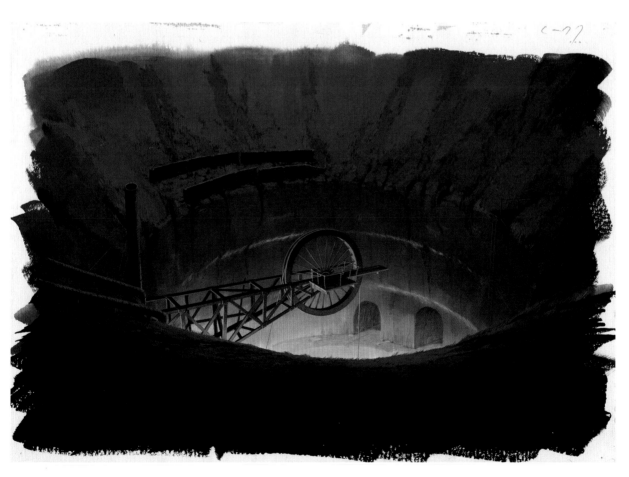

TOP: **Princess Mononoke**
background (Forest of the Deer God)

BOTTOM: **Princess Mononoke**
background (Forest of the Deer God)

These wide backgrounds
are used for panning shots.

"THIS WORLD DOESN'T JUST EXIST FOR HUMANS."

MAGIC AND SPIRITUALITY

INEXTRICABLY WOVEN WITH HAYAO MIYAZAKI'S WORLDS AND THE LIVES OF HIS CHARACTERS ARE CONCEPTS OF MAGIC AND SPIRITUALITY. The depiction of the extraordinary in the ordinary defines his films, reflecting a worldview that presumes the existence of spiritual life even in inanimate things. That life is everywhere present, that magic is a possibility, and that the human experience is defined by an innate spirituality—these ideas are crucial to understanding Miyazaki's oeuvre.

Drawing whatever can be imagined, reaching beyond the boundaries of reality, is of course what an animator does, and animated films often feature fantastical and otherworldly imagery. It is striking, however, that magic in Miyazaki's films is portrayed as something rather ordinary, as an organic part of the world or just another skill a character might possess. This normalizing of magic may have to do with Miyazaki's approach to creating films that are believable. Even the unreal must be shown in a credible way, functioning as an integral component of the film's framework, for the audience to accept it. Moreover, magic is intrinsic to the way the audience closest to Miyazaki's heart—children—encounter the world. In this sense, his films are reflective of children's perceptions and remind adults that inexplicable wonders can exist in the world.

Importantly, Miyazaki doesn't consider his films to be echoes of childhood events but rather opportunities to explore "lost possibilities" or other existences. "To be born means being compelled to choose an era, a place, and a life. To exist here, now, means to lose the possibility of being countless other potential selves."[79] The desire to depict something that "could have been but wasn't" motivates his work: "We animators are involved in this occupation because we have things that were left undone in our childhood. Those who enjoyed their childhood to the fullest don't go into this line of work. Those who fully graduated from their childhood leave it behind."[80]

The lives and worlds that Miyazaki's films imagine are alternative scenarios where childhood is experienced fully and magic is manifest in personal transformations, both physical and spiritual, of humans, witches, sorcerers, gods, and altogether fantastical creatures. The goldfish-girl in Ponyo undergoes several stages of transformation before she voluntarily gives up her magical abilities, passed down to her by her parents, in order to become fully human. In Howl's Moving Castle, the sorcerer Howl is a shapeshifter who can change his anthropomorphic form into that of a bird, as can the witch Yubaba in Spirited Away. Objects, too, can hold supernatural abilities. The pendant Sheeta wears in Castle in the Sky is connected to another crystal that keeps the distant sky kingdom of Laputa afloat; it holds ancient knowledge, eventually revealing the girl's secret identity as a descendant of Laputa's royal family.

While the filmmaker's depiction of magic derives from childhood perceptions, that of spirituality, and specifically the "idea that life exists in everything"—animism—is rooted in Japanese culture: "One of the hallmarks of the Japanese people is surely that they feel as though the rivers and mountains and forests are alive, even that their own houses are alive."[81] Japan's predominant religions, Shinto and Buddhism, both involve animism, but Miyazaki avoids expressing any personal religious belief. The spirituality that runs throughout his films attests to his broad sense that "if you go back far enough in human civilization, I think all peoples probably felt that spirits dwelled in the sky, the clouds, the earth, and the stars—even in rocks, grasses, and trees."[82]

The spirits and gods in Miyazaki's films are neither altogether comprehensible nor categorically good or evil, and they, too, can be traced to age-old Japanese concepts. Says Miyazaki, "It doesn't seem to me that Japanese people want a god who saves their souls." Instead of presenting human beings with solutions to life's struggles or the fear of death, Miyazaki's entities simply exist. Some live in total seclusion; others interact with the human world, and when they do so, "They can become wrathful. That's why they must be soothed; and when they are soothed, they become smiling, gentle gods."[83]

Spirit presences are palpable in Miyazaki's films even when they are not visible or concrete in form. "I like to imagine that where there is an updraft there might be some sort of air spirit that rises up, or that in another place the air spirit might be descending," he says.[84] Hence, in The Wind Rises, it may be a spirit hidden in a gust of wind that lets the protagonist, Jiro, know his beloved wife, Nahoko, has succumbed to her illness. To date, it should be noted, The Wind Rises is Miyazaki's only feature film not to include magical elements. Instead, the extraordinary is illustrated through the depiction of dreams.

Just as natural elements such as water, fire, and especially wind are alive with meaning in Miyazaki's films, natural environments foster transformative experiences. Most notably, trees herald extraordinary encounters, both spiritual and magical. In Princess Mononoke, the forest embodies sacred knowledge, demonstrating the filmmaker's conviction that "trees represent something I inherited from far, far in the past."[85] In My Neighbor Totoro, a tree is the gateway to a realm where a young girl befriends a giant forest spirit—whether this scene is "real or a dream" is intentionally "unclear," according to Miyazaki. About animating such moments, he adds, "Of course, I think they really happened."[86]

Spirited Away production imageboard (stone spirit guards tunnel entrance)

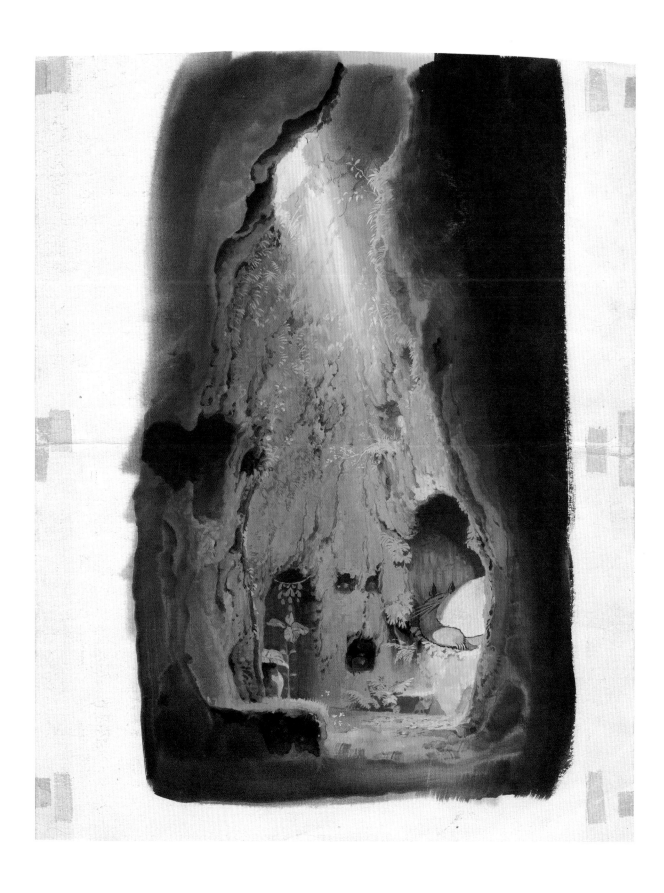

TOTORO AND THE MOTHER TREE

SOON AFTER MOVING TO A HOUSE IN THE COUNTRY with her father and older sister, four-year-old Mei discovers little spirits in the garden. She curiously follows them into the nearby forest and through a tree tunnel that leads to a gigantic tree; having fallen through a hollow in its trunk, Mei finds a huge creature lying asleep in a cavity inside. Intrigued, Mei pets this furry being and—undeterred by its growl-like snore—joyfully tickles her new friend, whom she names Totoro. Wanting to prove to her sister and father that her experience was real, Mei later finds the tree again, but is disappointed when Totoro doesn't appear. Mr. Kusakabe explains to his daughters that forest spirits are visible only when they choose to be seen, and he acknowledges the tree's significance: "This is a magnificent tree. I'm sure it's been standing here for ages and ages. Long ago, trees and people used to be friends. This tree is the reason Daddy wanted to move here." The family reverentially bows before the tree: "Thank you for helping Mei. We look forward to a long friendship!"

My Neighbor Totoro, Miyazaki's first film to be set in Japan, marvelously conveys that trees, like ancestors and sacred things, should be treated respectfully and with gratitude. In a dreamy nocturnal scene near the movie's end, sisters Satsuki and Mei gather with Totoros in their garden. Acorns the sisters planted there have long lain dormant, but through the joint efforts of the forest spirits and the sisters, they mature into saplings that quickly transform into a towering tree. To Miyazaki, trees "once functioned as our mother," and they remain a life-giving source.[87] "Our lives depend on trees," he says, "and we exist at their mercy."[88]

A tree, after all, could be the home of Totoro, who "lives as the lord of the forest."[89] The creation of this whimsical creature, according to Isao Takahata, might be Miyazaki's most influential achievement: "Totoro lives in the hearts of all children throughout Japan, and when they see trees now, they sense Totoro hidden in them."[90]

OPPOSITE: My Neighbor Totoro production imageboard (Totoro's tree cave)

MAGIC AND SPIRITUALITY

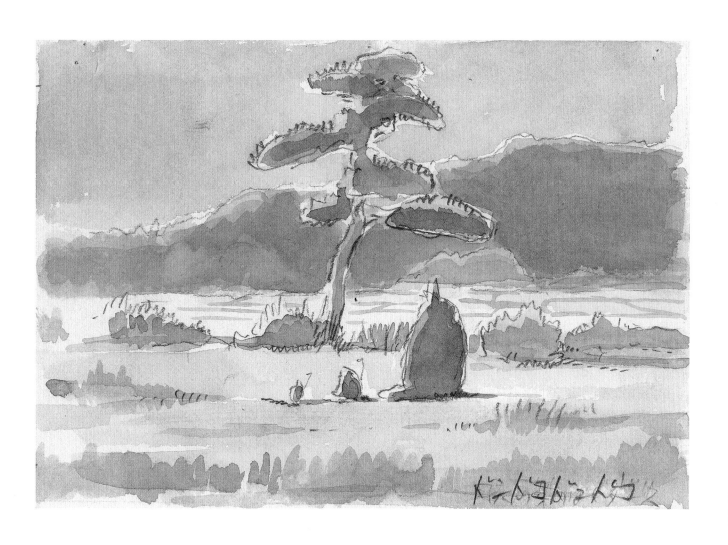

Hayao Miyazaki, *My Neighbor Totoro*
imageboards (Mei and Satsuki awaken
to the Totoros' drum dance)

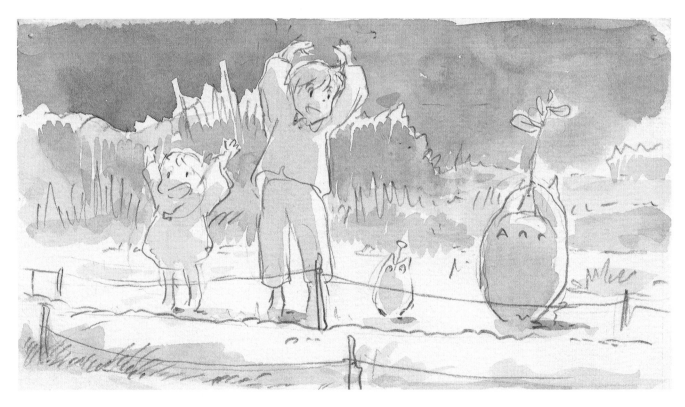

Hayao Miyazaki, *My Neighbor Totoro*
imageboards (Mei's acorn seed sprouts
into a Mother Tree in the moonlight)

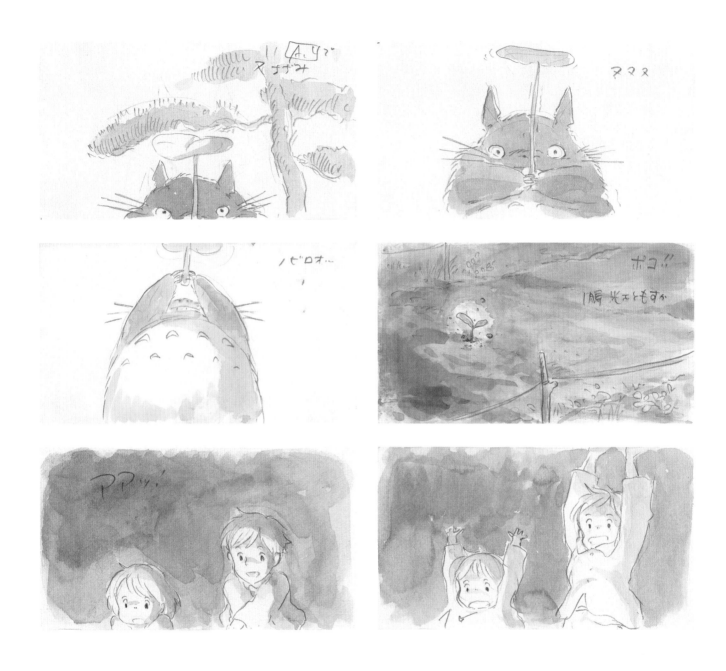

THE FOREST, KODAMA, AND THE DEER GOD

THE PRIMEVAL FOREST in Princess Mononoke, counterpart to the industrial Iron Town, is a hallowed place, dark and eerie and home to animals, spirits, and gods, with rays of light occasionally shining through the treetops. Miyazaki describes it as an archetypal world: "The setting for **Princess Mononoke** is not drawn from an actual forest. Rather, it is a depiction of the forest that has existed within the hearts of Japanese from ancient times."[91]

When the hero Ashitaka enters this forest, he is unnerved by the feeling of being watched—and indeed he is, by tree spirits called kodama ("tree spirit" in Japanese). About creating this world, the Forest of the Gods, Miyazaki recalls: "I wondered how to give shape to the image of the forest, from the time when it was not a collection of plants but had a spiritual meaning as well. . . . I wanted to express the feeling of mysteriousness that one feels when stepping into a forest—the feeling that someone is watching from somewhere or the strange sound that one can hear from somewhere. When I mulled over how I could give form to that feeling, I thought of the kodama. Those who can see them do, and those who can't don't see them. They appear and disappear, as a presence beyond good or evil."[92]

San, the film's heroine, is the only human inhabitant of this magical wilderness. She meets Ashitaka after he has been cursed by a demon spirit and guides him deeper and deeper into the forest in an effort to save his life. When they reach a moss-covered island surrounded by water, San leaves Ashitaka at this sacred place, where he awaits the powerful Deer God, master of life and death: "At night it walks around tending to the forest. During the day, it disappears and lives in the forest as one of the creatures. It has antlers like a deer's, the face of a human, the feet of a bird, and the body of a ram."[93] Ashitaka's fate is in the hands of this deity, yet what the Deer God will decide remains uncertain, for, like the kodama, his nature is mysterious. Ultimately, Ashitaka survives, but the demon's curse continues its damage.

San's determination to take her suffering companion to the heart of the somber forest reflects the Japanese belief that "in the forest there is something sacred that exists without a perceptible function. This is the central core, the navel of the world, and we want to return in time to that pure place."[94] As a sanctuary where humans go to reconnect with their surroundings and with something deep inside, the forest, as illustrated in **Princess Mononoke**, is the primal site of spirituality for Miyazaki.

OPPOSITE: **Princess Mononoke** production imageboard (primeval beech forest)

OPPOSITE, TOP: **Princess Mononoke**
production imageboard (primeval
beech forest)

OPPOSITE, BOTTOM: **Princess Mononoke**
background (Forest of the Deer God)

ABOVE: **Princess Mononoke**
background (pool of the Deer God)

Princess Mononoke foreground on
background (pool of the Deer God)

This background and seven-layer cel book was
photographed with a multi-plane camera technique
to create an extreme depth of field as the Deer God
emerges from the forest.

Princess Mononoke production imageboard
(Ashitaka rides Yakul)

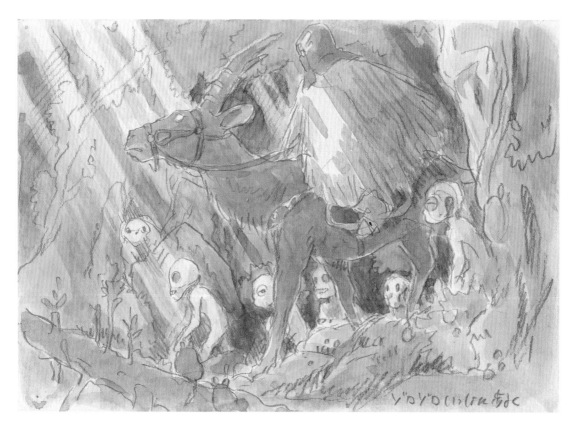

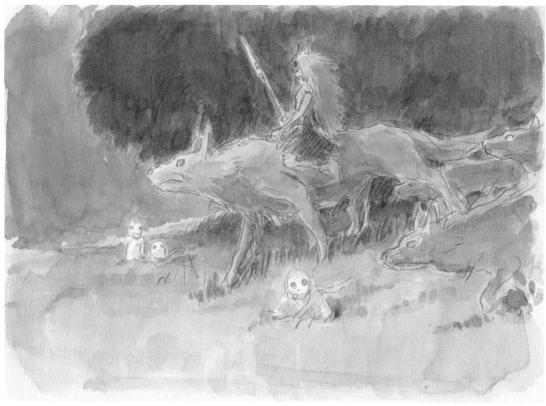

TOP: Hayao Miyazaki, Princess Mononoke imageboard (Ashitaka and Yakul enter the forest of the Deer God)

BOTTOM: Hayao Miyazaki, Princess Mononoke imageboard (San, wolf pack, and kodama)

OPPOSITE: Hayao Miyazaki, Princess Mononoke imageboard (kodama surround Ashitaka)

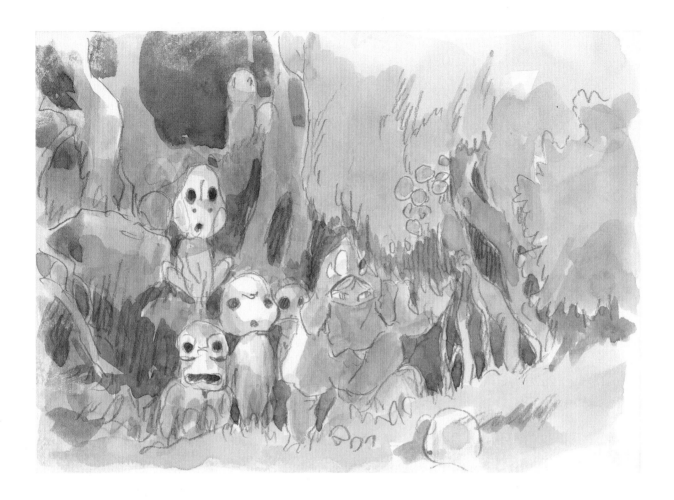

KODAMA TREE SPIRITS[×]

Just when they seemed to appear
They tittered in laughter and have already disappeared
Just when they seemed to be walking at my feet
They were already in the duskiness far away, laughing

When spoken to, they run off in shyness
When ignored, they come close

You small children, children of the forest
Ah, to you this forest that you inhabit is so full of fun

× Miyazaki, "Kodama Tree Spirits," in **Turning Point, 1997–2008**, trans. Beth Cary and Frederik L. Schodt (San Francisco: VIZ Media, 2014), 24. Originally published in Miyazaki, **The Art of Princess Mononoke** (San Francisco: VIZ Media, 2014).

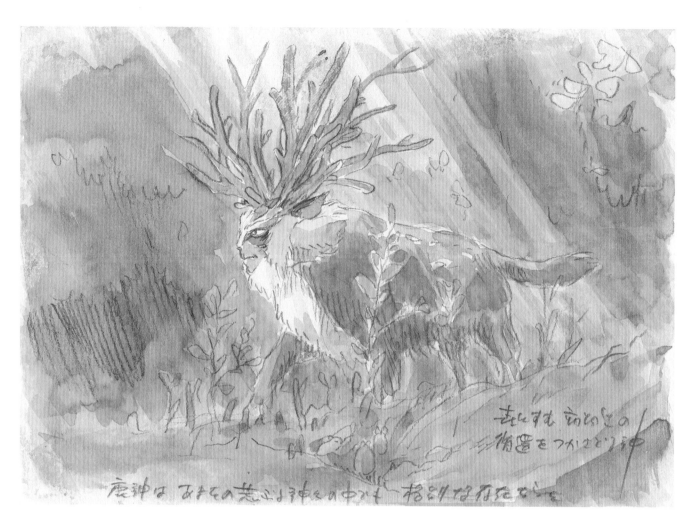

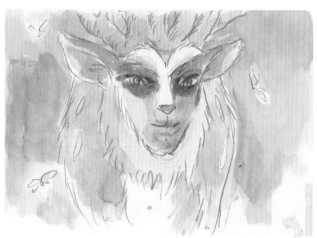

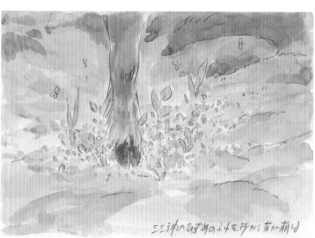

Hayao Miyazaki, Princess Mononoke
imageboards (Deer God)

Notes read: "God who presides over the life cycles of animals living
in the forest. The Deer God (Forest Spirit) is an exceptional presence
even among the reigning multitude of gods" and "Plants sprout where
the Deer God's (Forest Spirit's) hooves tread."

THE FOREST OF THE DEER GOD (FOREST SPIRIT)[×]

The forest that has existed since the world was born
In this world of deep shadows filled with the essence of all creation
Live creatures that have become extinct in the human world
A forest where the Deer God still dwells
A wondrous beast with antlers like branches, a stirring human face,
and the body of a deer
Dying with the moon and reviving with the new crescent moon
Having the memory of when the forest was born and the pure heart
of an infant
A brutal and beautiful Forest Spirit that presides over life and death

In the places touched by its hooves
Grasses put forth shoots, trees breathe life anew
Wounded animals regain their strength,
In the places reached by its breath
Death comes effortlessly, the grasses wither
Trees decay, animals die

The forest where the Forest Spirit lives is a world where life glistens
and sparkles
It is a forest that denies entry to humans

✕　Miyazaki, "The Forest of the Deer God (Forest Spirit)," in Turning Point, 26.
Originally published in The Art of Princess Mononoke.

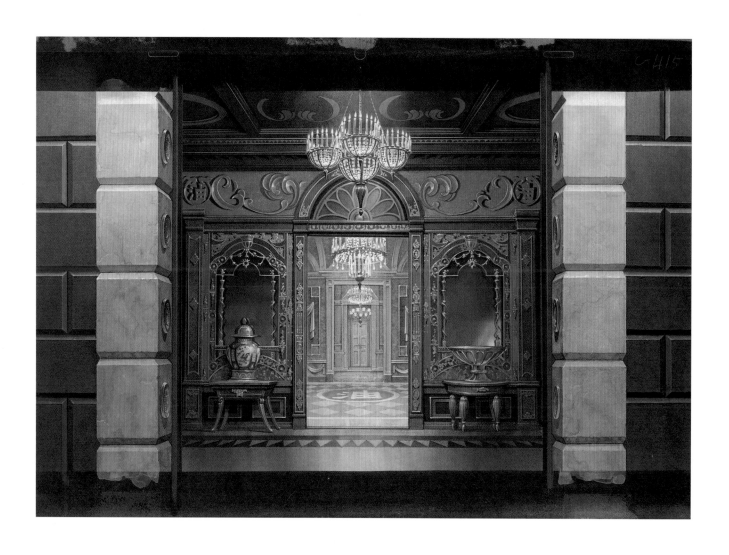

Spirited Away background
(entrance to Yubaba's quarters)

MAGIC PORTALS

SPIRITED AWAY LANDS YOUNG CHIHIRO ON HER OWN IN A STRANGE REALITY: a thoroughly alienating world populated by all kinds of spirits. They congregate in a mazelike bathhouse, a place of cleansing and relaxation managed by the powerful witch Yubaba. Miyazaki summarizes the film's story as one of spiritual strengthening, about a ten-year-old girl who "will learn about friendship and devotion, and will survive by making full use of her brain. She sees herself through the crisis, avoids danger and gets herself back to the ordinary world somehow. She manages not because she has destroyed the 'evil,' but because she has acquired the ability to survive."[95]

Wanting to control everything and everyone around her, Yubaba intimidates and threatens Chihiro, pulling her by overwhelming magical force through the bathhouse's long corridors and up to her top-floor office, where the frightened girl signs a contract to become the witch's employee, renamed Sen. Toiling away in the bathhouse, she realizes she has forgotten her original name and will likewise lose her sense of self under Yubaba's command—unless she finds her own way out of the spirit world. It is through persevering "in this extraordinary difficult world," Miyazaki points out, that "Chihiro truly comes alive."[96]

Yubaba, true to Miyazaki's characterization of villains, is not altogether evil: her good side is personified by her identical twin, Zeniba, who helps Chihiro break the spell on her parents and regain her name. The menacing Yubaba and the helpful alter ego Zeniba are, Miyazaki says, "really like two facets of the same person. When we're at work we're like Yubaba, yelling and making a mess and getting people to work, but when we go home we try to be good citizens. This schism is the painful part of being human."[97]

There is the suggestion, at the end of Spirited Away, that the magical world Chihiro encountered at the bathhouse was just an illusion. But, after she leaves the abandoned building that is the portal to the real world, she turns to take a parting glimpse. The hairband given to Chihiro by Zeniba is highlighted on-screen in this moment, revealing to viewers that her journey did happen. By learning how to live in a world utterly foreign and mysterious to her, Chihiro has grown into a person who is prepared to take on reality. Once more, Miyazaki finds words of encouragement to end his film. When, in driving away, her father tells her, "A new home and a new school, it is a bit scary," Chihiro determinedly responds, "I think I can handle it."

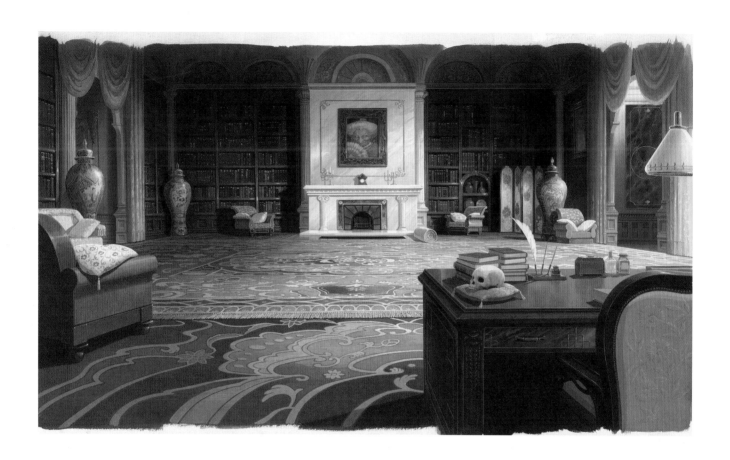

ABOVE: Spirited Away background
(Yubaba's office)

OPPOSITE: Spirited Away
backgrounds (hallway leading
to Yubaba's quarters)

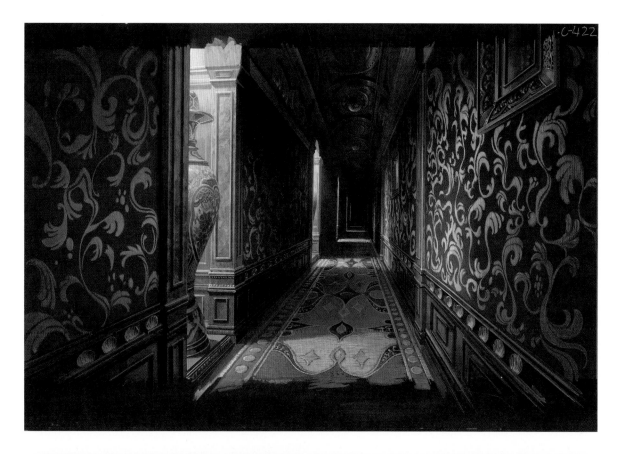

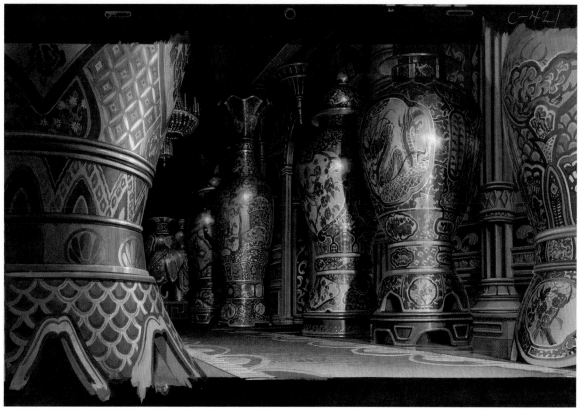

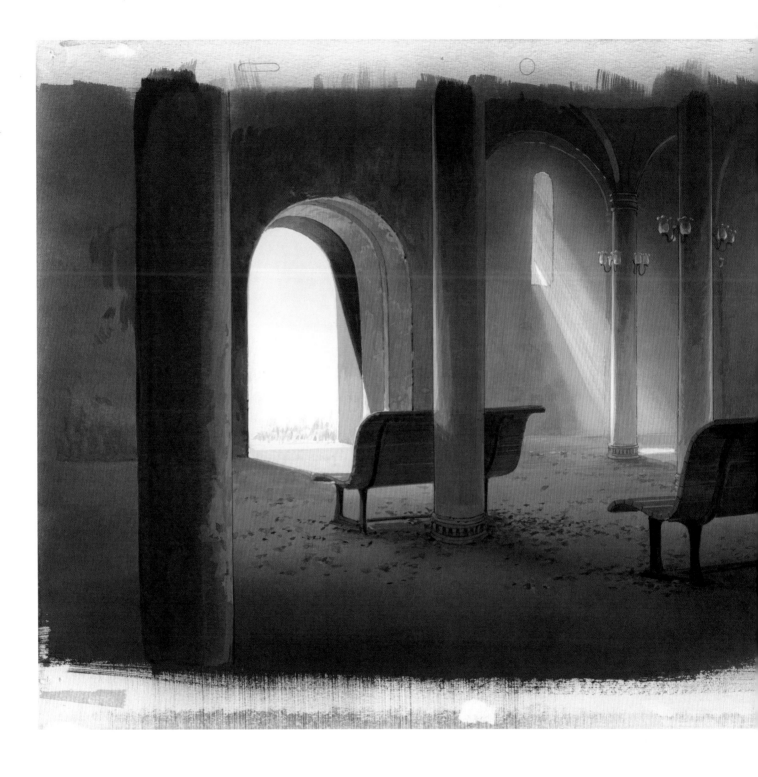

Spirited Away background
(tunnel interior)

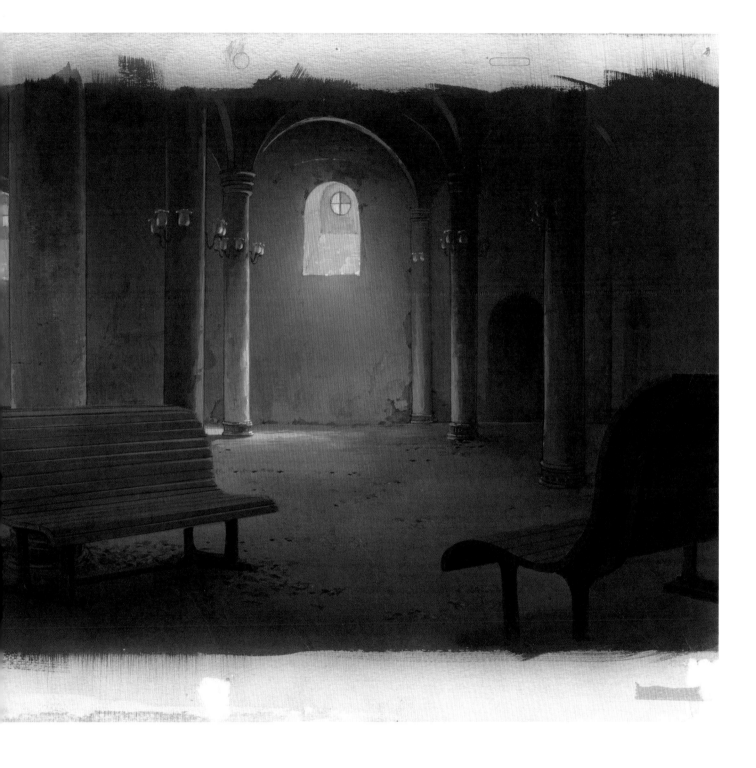

1 Hayao Miyazaki, "Nostalgia for a Lost World," in Starting Point, 1979–1996, trans. Beth Cary and Frederik L. Schodt (San Francisco: VIZ Media, 2009), 23. Originally published in Gekkan ehon bessatsu: Animeshon [Animation: Monthly Picture Book Special], March 1979.

2 Miyazaki, "Earth's Environment as Metaphor," in Starting Point, 430. Originally published in iichiko, nos. 33 (October 20, 1994) and 34 (January 20, 1995).

3 "The continuity sketches are the screenplay. With continuity sketches, you have drawings in frames and next to each frame a description of the content of the frame, with stage directions on the left side and dialogue on the right. When you look at the page, therefore, you can get a pretty good idea of what's going on, so it's what animators use to base their drawings on." Miyazaki, "The World of Anime and the Scenario," speech given at the Association of Scenario Writers, Japan, August 6, 1994, in Starting Point, 103. Originally published in Scenario, January 1995.

4 Miyazaki, "The Porco Rosso Memos: Directorial Memoranda," April 18, 1991, in Starting Point, 267.

5 Miyazaki, "'Don't Worry, You'll Be All Right': What I'd Like to Convey to Children," in Turning Point, 1997–2008, trans. Beth Cary and Frederik L. Schodt (San Francisco: VIZ Media, 2014), 215. Originally published in the roman album for Spirited Away (Tokyo: Tokuma Shoten, 2001).

6 Miyazaki, "Once Again, a World Where People Believe Everything Is Alive: A Dialogue with Tetsuo Yamaori," in Turning Point, 244. Originally published in Voice, January 2002.

7 Miyazaki, "Original Proposal for Castle in the Sky," December 7, 1984, in Starting Point, 253.

8 Miyazaki, "My Point of Origin," lecture, Joint Animation Studies Groups at Waseda University, Tokyo, June 5, 1982, in Starting Point, 50.

9 Miyazaki, "I've Always Wanted to Create a Film about Which I Could Say, 'I'm Just Glad I Was Born, So I Could Make This,'" press conference at the 62nd Venice International Film Festival, September 8, 2005, in Turning Point, 328.

10 Miyazaki, "A Child's Five Minutes Can Be Equivalent to a Grown-Up's Year," in Turning Point, 74–75. Originally published in Kodomo no Tomo [A Child's Companion] (Tokyo: Fukuinkan Shoten, 1997).

11 Miyazaki, "I've Always Wanted to Create a Film about Which I Could Say, 'I'm Just Glad I Was Born, So I Could Make This,'" 327–28.

12 Miyazaki, "What Is Most Important for Children," interview by Masao Ota, in Turning Point, 171. Originally published in Kikan: Ningen to Kyoiku [Quarterly: Human Beings and Education], no. 10 (June 1996). On "embracing contradiction," see Miyazaki, "My Old Man's Back," in Starting Point, 209. Originally published in Asahi Shimbun, September 4, 1995.

13 Miyazaki, "Earth's Environment as Metaphor," 429–30.

14 Miyazaki, "Speaking of Conan," interview by Yoko Tomizawa, in Starting Point, 288. Originally published in Mata aeta, ne! [We Meet Again!], ed. Yoko Tomizawa, Animage Bunko series (Tokyo: Tokuma Shoten, 1983).

15 Kitaro Kosaka (animator), interview by Jessica Niebel and Raúl Guzmán, Studio Ghibli, Tokyo, January 31, 2019. Kosaka has worked with Miyazaki since Nausicaä of the Valley of the Wind and is credited as supervising animator on The Wind Rises.

16 Miyazaki, "Those Who Live in the Natural World All Have the Same Values," interview by Kentaro Fujiki, in Turning Point, 40. Originally published in Seiryu, August 1997.

17 Miyazaki, "A Film That Can Be Enjoyed by People Who Have Never Read the Original Story," press release material, June 20, 1983, in Starting Point, 251.

18 Miyazaki, "The Way to Nausicaä," in The Art of Nausicaä of the Valley of the Wind Watercolor Impressions (San Francisco: VIZ Media, 2007), 151.

19 Miyazaki, "Nature Is Both Generous, and Ferocious," in Starting Point, 333. Originally published in the roman album for Nausicaä of the Valley of the Wind (Tokyo: Tokuma Shoten, 1984).

20 Miyazaki, "On Nausicaä," in Starting Point, 283. Originally published in Animage Comics, wide edition of Nausicaä of the Valley of the Wind, vol. 1 (Tokyo: Tokuma Shoten, 1982). Nausicaä is the name of a princess in Homer's Odyssey, and Miyazaki also turned to Bernard Evslin's Gods, Demigods & Demons: An Encyclopedia of Greek Mythology (New York: Scholastic, 1975). The insect princess story is from the Heian-period collection Tsutsumi chu-nagon monogatari [Tales of the Tsutsumi Middle Counselor]. On "wind masters," see Miyazaki, "The Way to Nausicaä," 150.

21 Miyazaki, "Nature Is Both Generous, and Ferocious," 334.

22 Miyazaki, "The Way to Nausicaä," 152.

23 Miyazaki, The Art of My Neighbor Totoro (San Francisco: VIZ Media, 2005), 164.

24 Miyazaki, "Totoro Was Not Made as a Nostalgia Piece," interview by Hiroaki Ikeda, in Starting Point, 377. Originally published in the roman album for My Neighbor Totoro (Tokyo: Tokuma Shoten, 1988).

25 Miyazaki, 372.

26 "When my mother was in the hospital and I returned home from school to an empty house, I definitely experienced loneliness," Miyazaki remembers about his own childhood. "A ten-year-old can do kitchen chores. I did. I also cleaned house, fired up the bath, and cooked. . . . I was overly self-conscious, and my mother was that way too. When I went to see her in the hospital, I couldn't rush to hug her." Miyazaki, 369, 372. See also Raz Greenberg, Hayao Miyazaki: Exploring the Early Work of Japan's Greatest Animator (New York: Bloomsbury, 2018), 1.

27 Miyazaki, "Kiki—The Spirit and the Hopes of Contemporary Girls," in Starting Point, 262. See also Miyazaki, "I Wanted to Show the Various Faces of One Person in This Film," in Starting Point, 383. Originally published in the roman album for Kiki's Delivery Service (Tokyo: Tokuma Shoten, 1989). "Most of Kiki's mannerisms are taken from what I have observed of the behavior of young women animators I trained when they were new hires."

28 Miyazaki, "Kiki—The Spirit and the Hopes of Contemporary Girls," 263.

29 Miyazaki, "I Wanted to Show the Various Faces of One Person in This Film," 380.

30 Miyazaki, "Kiki—The Spirit and the Hopes of Contemporary Girls," 264.

31 Miyazaki, "I Wanted to Show the Various Faces of One Person in This Film," 378.

32 Miyazaki, 379.

33 Miyazaki, "The Pictures Are Already Moving Inside My Head," in Starting Point, 410. Originally published in Atarashii gazo gaido: Suisai [A New Guide to Art Materials: Watercolors] (Tokyo: Bijutsu Shuppansha, 1994).

34 Miyazaki, "Princess Mononoke Planning Memo," April 19, 1995, in Starting Point, 272.

35 Miyazaki, "Traditional Japanese Aestheticism in Princess Mononoke: An Interview by Roger Ebert," September 19, 1999, in Turning Point, 186. Originally published in Roman Album Ghibli (Tokyo: Tokuma Shoten/Studio Ghibli Jigyo Honbu, 2000).

36 "At any rate, it would be false to say that because we're on the side of justice, we can go ahead and destroy our opponents and the world will be at peace. That, at least, I can say would be a total lie. Now, I know that there are such things as good and evil in the world, and that people do good things. But people who do good things are not necessarily good people, they just happen to be people who have done good things. The next instant they might wind up doing something bad, and if we don't take that into account in our view of humans, we'll constantly make mistakes when making political decisions or decisions about ourselves." Miyazaki, "On Completing Nausicaä of the Valley of the Wind," in Starting Point, 398. Originally published in Yomu, June 1994.

37 Miyazaki, "Princess Mononoke Planning Memo," 274.

38 Miyazaki, "From Idea to Film: 2," in Starting Point, 35. Originally published in Gekkan ehon bessatsu: Animeshon, July 1979.

39 About the character Chihiro in Spirited Away, animator Kitaro Kosaka notes: "How thin the neck is changes how the head/face looks, and this changes scene to scene. There is a flexibility that Miyazaki has that changes these parts depending on the scene." Kosaka, interview by Niebel and Guzmán.

40 Tamaki Kojo (postproduction coordinator), interview by Jessica Niebel and Raúl Guzmán, Studio Ghibli, Tokyo, January 31, 2019.

41 Miyazaki, "Totoro Was Not Made as a Nostalgia Piece," 361.

42 "It's an imaginary world, but it should seem to actually exist as an alternate world, and the people who live there should appear to think and act in a realistic way." Miyazaki, "Speaking of Conan," 307.

43 Yoji Takeshige (art director), interview by Jessica Niebel and Raúl Guzmán, Studio Ghibli, Tokyo, January 31, 2019. Takeshige has worked with Miyazaki since My Neighbor Totoro and is credited as art director on Spirited Away.

44 Miyazaki, "I've Always Wanted to Create a Film about Which I Could Say, 'I'm Just Glad I Was Born, So I Could Make This,'" 323.

45 Miyazaki, "What's Important for the Spirit: Text of a Speech to Be Given on the Occasion of Receiving the Japan Foundation Award for 2005," in Turning Point, 340.

46 Miyazaki, "Forty-four Questions on Princess Mononoke for Director Hayao Miyazaki from International Journalists at the Berlin International Film Festival," in Turning Point, 90. Originally published in the roman album Animage Special: Hayao Miyazaki to Hideaki Anno (Tokyo: Tokuma Shoten, 1998).

47 Miyazaki, "What Takei Sanshodo Means to Me," in Starting Point, 239. Originally published in Edo Tokyo Tatemono En monogatari [The Story of the Edo-Tokyo Open-Air Architectural Museum] (Tokyo: Edo-Tokyo Museum, 1995).

48 Miyazaki, "About Ryotaro Shiba-san," in Starting Point, 213. Originally published in Shueisha Playboy [Weekly Playboy], March 26, 1996.

49 Miyazaki, 213.

50 Miyazaki, "It's a Tough Era, But It May Be the Most Interesting of All: A Conversation with Tetsuya Chikushi," in Turning Point, 240. Originally published in Shukan kinyobi, January 11, 2002.

51 Miyazaki, The Art of The Wind Rises (San Francisco: VIZ Media, 2014), 8.

52 Miyazaki, The Art of Castle in the Sky (San Francisco: VIZ Media, 2016), 5.

53 Miyazaki, "Forty-four Questions on Princess Mononoke," 85.

54 Miyazaki, "Earth's Environment as Metaphor," 417.

55 "I thought it would be interesting to overturn the concept of defenseless plants always being destroyed and instead create a forest that was on the offensive." Miyazaki, 417.

56 Miyazaki, "'Don't Worry, You'll Be All Right,'" 220.

57 Miyazaki, The Art of Ponyo (San Francisco: VIZ Media, 2013), 121.

58 "The sea represents the feminine principle, and the land represents the masculine principle." Miyazaki, "Memo on Music for Joe Hisaishi," September 5, 2007, in Turning Point, 423.

59 Miyazaki, "On Ponyo," June 5, 2006, in Turning Point, 419.

60 Miyazaki, The Art of Ponyo, 11. CGI was used to various extents in Princess Mononoke, Spirited Away, and Howl's Moving Castle.

61 Noboru Yoshida, interview, in Miyazaki, The Art of Ponyo, 23.

62 Miyazaki, "On Ponyo," 421.

63 Miyazaki, 421.

64 Michiyo Yasuda, interview, in Miyazaki, The Art of Ponyo, 76–77.

65 Miyazaki, "'Don't Worry, You'll Be All Right,'" 218.

66 Miyazaki, 217–18.

67 "The reds were emphasized throughout the film, including the background drawings of the clock towers, the bath house walls, the hanging lanterns in the restaurant district, and the bridge railing. So I came up with the color design and assignments based on this red, which we might refer to as the film's 'theme color.'" Yoji Takeshige (art director), quoted in Miyazaki, The Art of Spirited Away (San Francisco: VIZ Media, 2002), 72.

68 Takeshige, 72.

69 Takeshige, interview by Niebel and Guzmán.

70 Miyazaki, "From Idea to Film: 1," in Starting Point, 28. Originally published in Gekkan ehon bessatsu: Animeshon, May 1979.

71 Miyazaki, 29.

72 Miyazaki, "Speaking of Conan," 307.

73 Miyazaki, "Animation Directing Class, Higashi Koganei Sonjuku II School Opening: Urging at Least One Seedling to Sprout! Theories on Directing for Aspiring Young Directors," in Turning Point, 131. Originally published in the roman album Animage Special: Hayao Miyazaki to Hideaki Anno.

74 Takeshige, interview by Niebel and Guzmán.

75 Takeshige. The art director overseeing the background artists' work will revise all of the backgrounds to achieve an overall balance. Connoisseurs may nonetheless attempt to identify individual artists by studying the backgrounds.

76 Atsushi Okui (director of digital imaging), interview by Jessica Niebel and Raúl Guzmán, Studio Ghibli, Tokyo, January 31, 2019. Okui has worked with Miyazaki since Porco Rosso and has been credited as director of digital imaging since Spirited Away.

77 Kojo, interview by Niebel and Guzmán.

78 Kojo.

79 "For example, I might have been the captain of a pirate ship, sailing with a lovely princess by my side. . . . Yet once born there is no turning back." Miyazaki, "Speaking of Conan," 306–7.

80 Miyazaki, "What Grown-ups Can Tell Children So That They Can Live in a Happy Time," interview by Norio Koyama, in Turning Point, 154. Originally published in Jojo bungee, Summer 1998.

81 Miyazaki, "Welcome to the Ghibli Forest Short Film 'House Hunting,'" in Turning Point, 366–67. Originally published in the pamphlet House Hunting (Tokyo: Tokuma Memorial Cultural Foundation for Animation, 2006).

82 Miyazaki, 366–67. "I do like animism. I can understand the idea of ascribing character to stones and wind. But I didn't want to laud it as a religion." Miyazaki, "Nature Is Both Generous, and Ferocious," 333.

83 Miyazaki, "Totoro Was Not Made as a Nostalgia Piece," 367.

84 Miyazaki, "The Type of Film I'd Like to Create," in Starting Point, 153. First presented as a talk at Hachiman Elementary School, Sendai City, Japan, June 19, 1992.

85 Miyazaki, "Things That Live in a Tree," in Starting Point, 163. Originally published in Kyoboku o mi ni iku [On Going to See a Giant Tree] (Tokyo: Kodansha, 1994).

86 Miyazaki, "Totoro Was Not Made as a Nostalgia Piece," 364.

87 Miyazaki, "Things That Live in a Tree," 163. Miyazaki's short film Boro the Caterpillar impressively illustrates insects' dependence on the trees they inhabit. Within nature, any tree is a fully functioning, life-supporting microcosm; thus "a single, very ordinary tree in a wooded area starts to seem like a truly incredible world." Miyazaki, 163.

88 Miyazaki, "We Should Each Start Doing What We Can," in Turning Point, 276. Originally published in Midori no bokindayori [Report on Fundraising for Greenery] (Japan: National Land Afforestation Program, Spring 2002).

89 Miyazaki, "Totoro Was Not Made as a Nostalgia Piece," 362.

90 Isao Takahata, afterword to Starting Point, 457.

91 Miyazaki, "Forty-four Questions on Princess Mononoke," 88.

92 Miyazaki, 82.

93 Miyazaki, "Animation and Animism: Thoughts on the Living 'Forest,'" discussion moderated by Keiichi Makino, in Turning Point, 115. Originally published in Kino Hyoron, Rinji Zokan, October 25, 1998.

94 "We still feel that there is a place where, if we go deep into the mountains, we can find a forest full of beautiful greenery and pure running water that is like a dreamscape. And this kind of sensibility, I think, links us to our spirituality." Miyazaki, "The Elemental Power of the Forest Also Lives Within the Hearts of Human Beings," in Turning Point, 36. Originally published in Cine Front, July 1997.

95 Miyazaki, The Art of Spirited Away, 15.

96 Miyazaki, "Chihiro, from a Mysterious Town— The Goal of This Film," in Turning Point, 198. From the proposal for Spirited Away, November 8, 1999, first published in Toho Co., Ltd., pamphlet, 2000.

97 Miyazaki, "'Don't Worry, You'll Be All Right,'" 223.

SELECTED WORKS

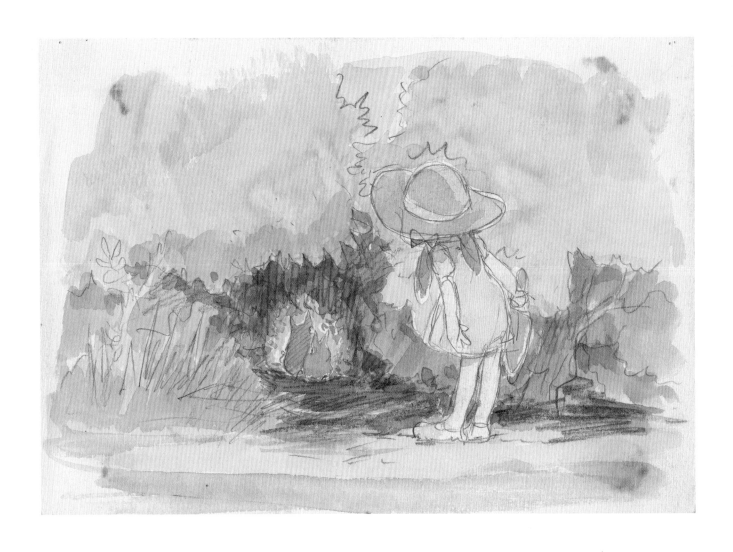

Hayao Miyazaki, My Neighbor Totoro initial
imageboard (Mei looks into the tree tunnel)

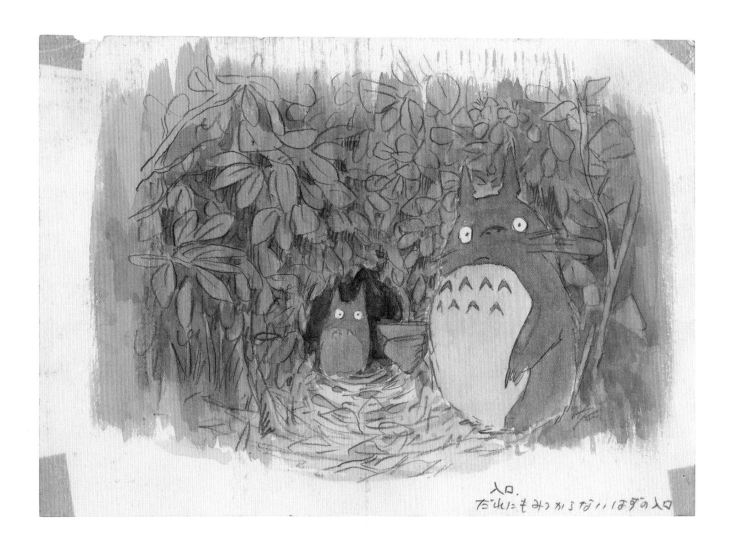

Hayao Miyazaki, *My Neighbor Totoro* initial imageboard (entrance to Totoro's tree cave)

Note reads: "No one should be able to find this entrance."

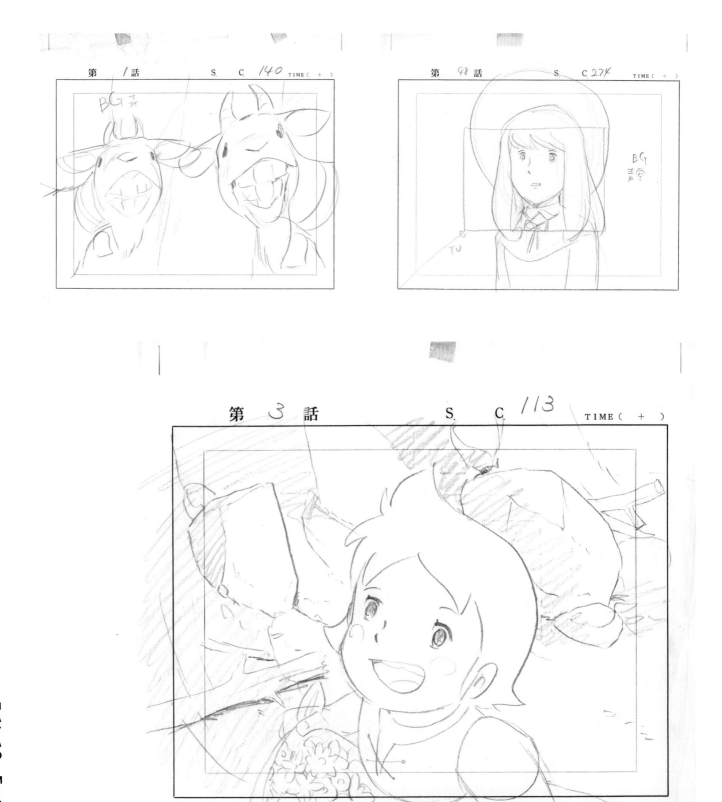

TOP LEFT: Hayao Miyazaki, Heidi, Girl of the Alps
layout drawing, episode 1 (goats)

TOP RIGHT: Hayao Miyazaki, Heidi, Girl of the Alps
layout drawing, episode 48 (Clara)

BOTTOM: Hayao Miyazaki, Heidi, Girl of the Alps
layout drawing, episode 3 (Heidi)

第 48 話　　　　　S. C. 14　　TIME（ + ）

第 35 話　　　　　S. C. 270　TIME（ + ）

TOP: Hayao Miyazaki, Heidi, Girl of the Alps
layout drawing, episode 48 (Peter)

BOTTOM: Hayao Miyazaki, Heidi, Girl of the Alps
layout drawing, episode 35 (mountain hut)

第　回　　　　　　　　S.　　C. 58　　　　TIME (　+　)

第　　　　　　　　　　　　　　　　　　　　TIME (　+　)

株式会社テレコム・アニメーション・フィルム

上下ダップ使用

OPPOSITE, CLOCKWISE FROM TOP LEFT: From the Apennines to the Andes layout drawing, episode 41; Future Boy Conan layout drawing, opening sequence; Future Boy Conan layout drawing, episode 5; Sherlock Hound layout drawing, episode 1; Anne of Green Gables layout drawing, episode 7; From the Apennines to the Andes layout drawing, episode 29

THIS PAGE: Sherlock Hound layout drawing, episode 4

第　回　　　　　　S.　　C. 50　　　　TIME (　+　)

LONEBACH
AIRCRAFT MUSEUM
1907 — 1950

NA NANDA KANDA KONO
HM10:00 —— PM 4:00

T.C.S.　　　　　　　　　　　株式会社テレコム・アニメーション・フィルム

S　　　C 1391.　　　　　　　　　　　　　　　　　秒

株式会社 東京ムービー新社

S C 973.
973

秒

株式会社 東京ムービー新社

OPPOSITE, TOP: **Lupin the 3rd** layout drawing, episode 145

OPPOSITE, BOTTOM: **Lupin the 3rd: The Castle of Cagliostro** layout drawing (Roman ruins emerge from receding water)

ABOVE: **Lupin the 3rd: The Castle of Cagliostro** layout drawing (Lupin injured after a fight)

Hayao Miyazaki, Nausicaä of the Valley of the Wind
illustration (old map of Torumekia on the Sea of Decay)

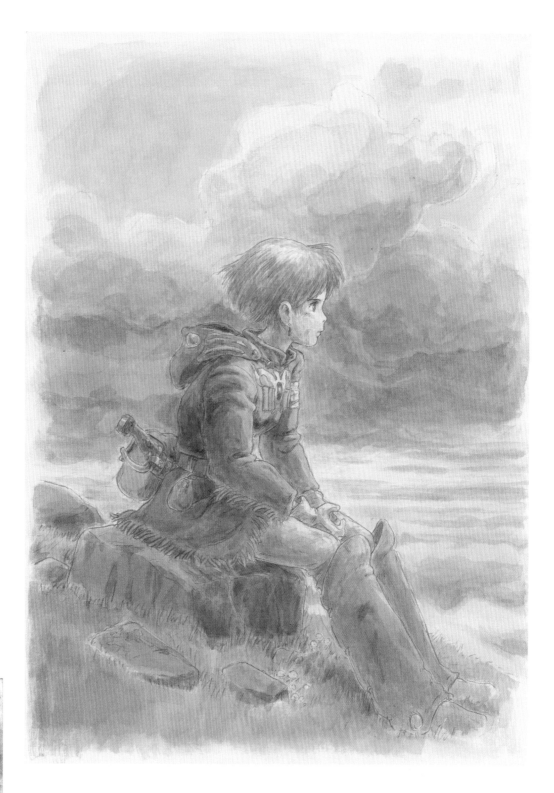

LEFT: Animage (April 1990 cover)

ABOVE: Hayao Miyazaki, Nausicaä of the Valley of the Wind illustration for Animage

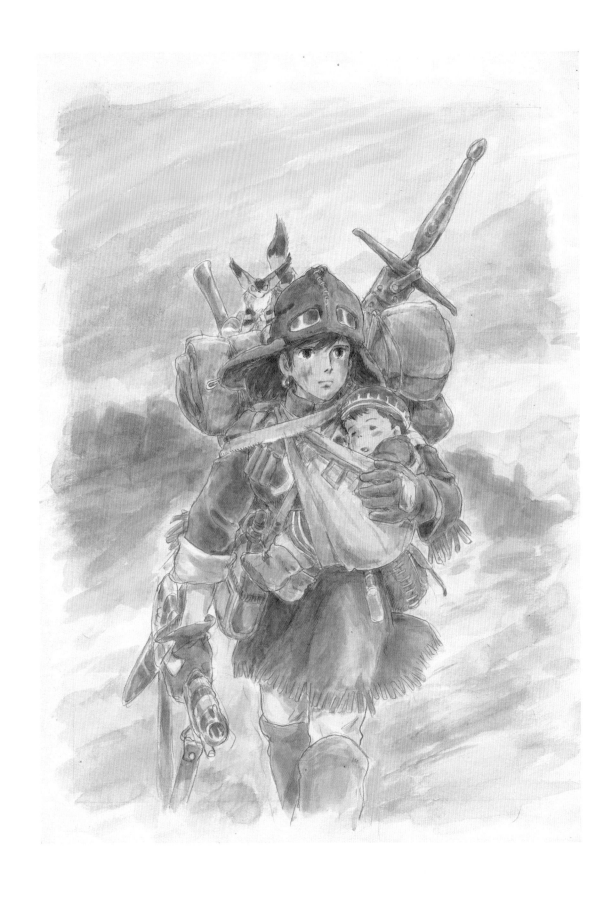

Hayao Miyazaki, Nausicaä of the Valley of the Wind
illustration for Animage (August 1984 cover)

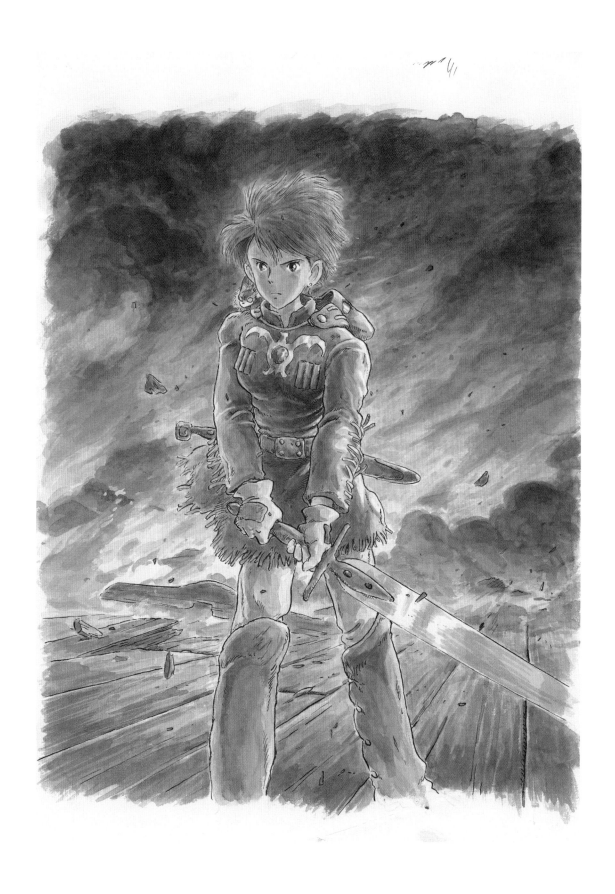

Hayao Miyazaki, *Nausicaä of the Valley of the Wind*
illustration for Animage Comics (vol. 6 cover)

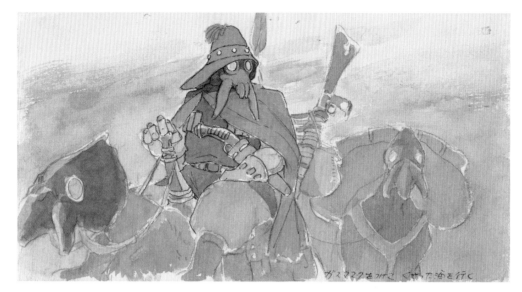

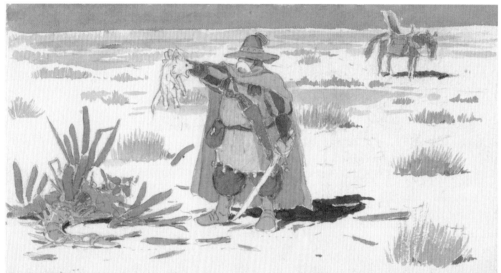

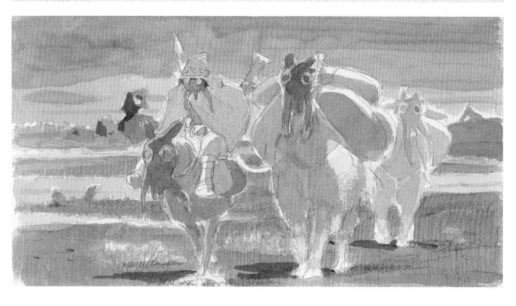

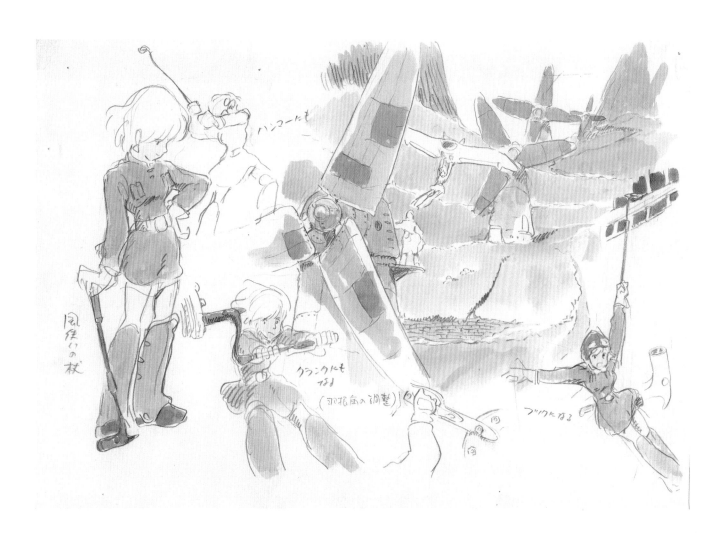

OPPOSITE: Hayao Miyazaki, *Nausicaä of the Valley of the Wind* imageboards (Lord Yupa travels through the Sea of Decay)

ABOVE: Hayao Miyazaki, *Nausicaä of the Valley of the Wind* imageboard (Nausicaä uses Wind Rider's staff as hook, hammer, and crank)

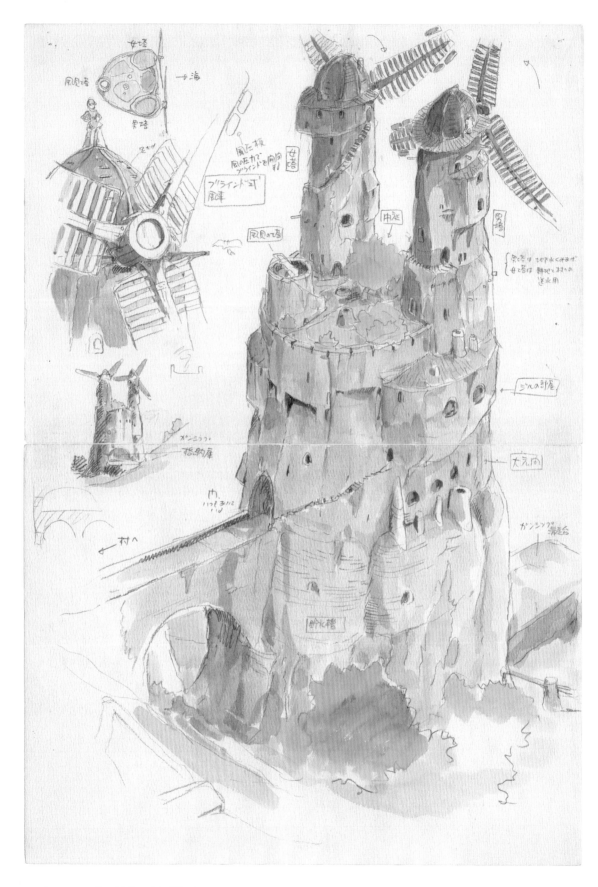

Hayao Miyazaki, Nausicaä of the Valley of the Wind imageboard
(Castle of the Valley of the Wind)

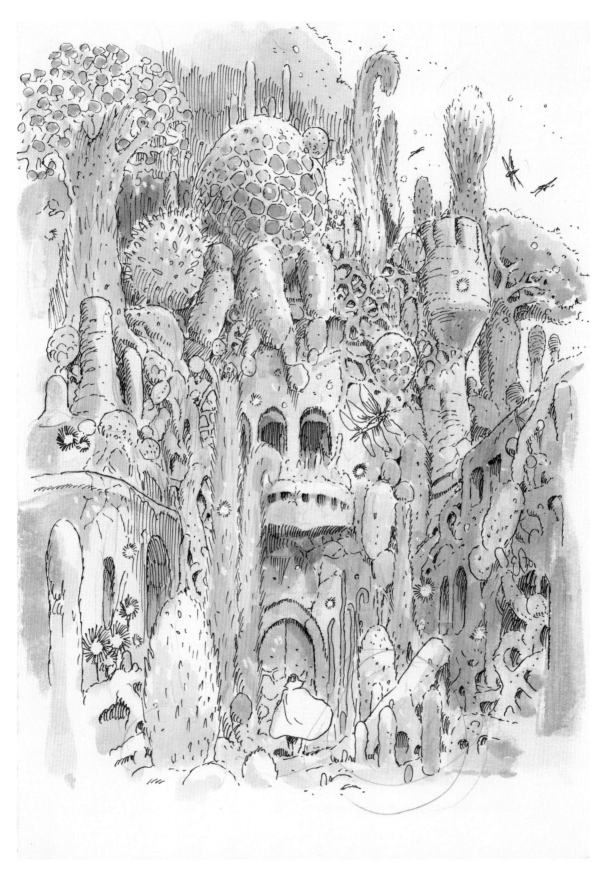

Hayao Miyazaki, Nausicaä of the Valley of the Wind imageboard
(Lord Yupa at the Sea of Decay)

Hayao Miyazaki, *Nausicaä of the Valley of the Wind* storyboard (scene 1516–1521)

Note reads: "The Ohm's attack mode is starting to diminish . . . Ohm as the mist lifts, eyes turn blue, they stop."

Hayao Miyazaki, *Nausicaä of the Valley of the Wind*
storyboards (scenes 1522A–1529, 1532–1537B)

TOPCRAFT CO.,LTD.　　S.　C. 45　TIME(+)

TOPCRAFT CO.,LTD.　　S.　C. 56　TIME(+)

TOP: Hayao Miyazaki, Nausicaä of the Valley of the Wind layout drawing (Nausicaä retrieves an ohm shell, scene 45)

BOTTOM: Hayao Miyazaki, Nausicaä of the Valley of the Wind layout drawing (Nausicaä atop an ohm shell, scene 56)

OPPOSITE, TOP: Nausicaä of the Valley of the Wind layout drawing (Nausicaä and Kushana in the cockpit, scene 695A)

OPPOSITE, BOTTOM: Nausicaä of the Valley of the Wind layout drawing (Nausicaä on her glider, scene 808)

TOPCRAFT CO.,LTD.　　　　　　S.　　C. 695A. TIME(＋)

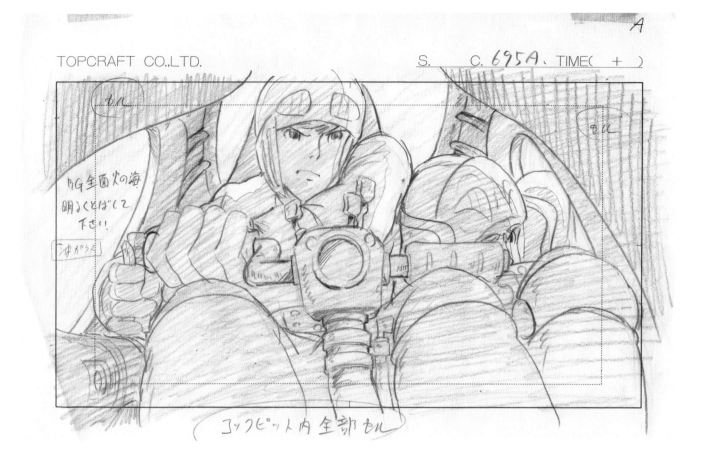

TOPCRAFT CO.,LTD.　　　　　　S.　　C. 808. TIME(＋)

A

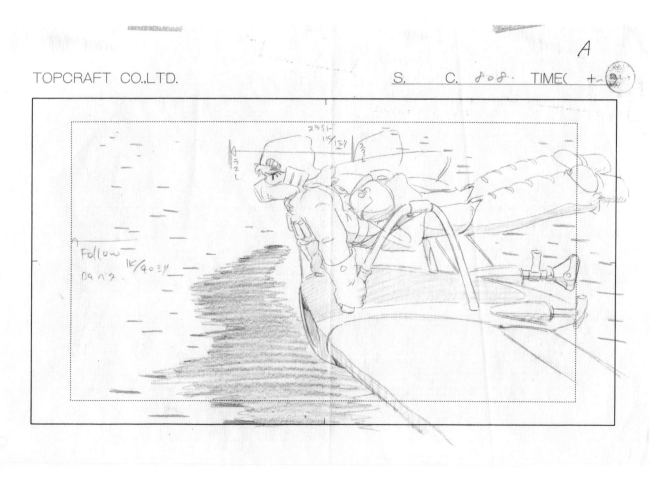

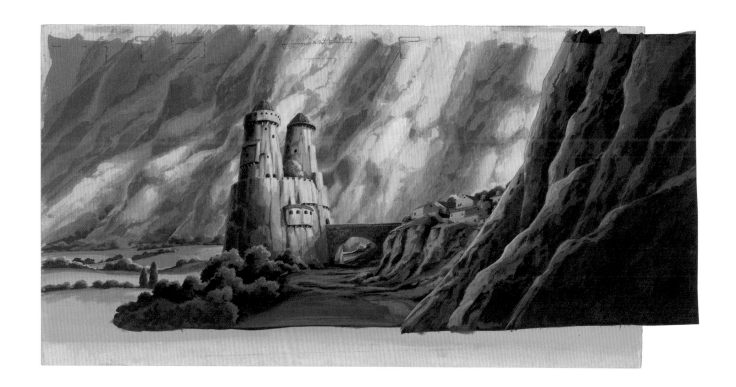

Nausicaä of the Valley of the Wind foreground
on background (Valley of the Wind)

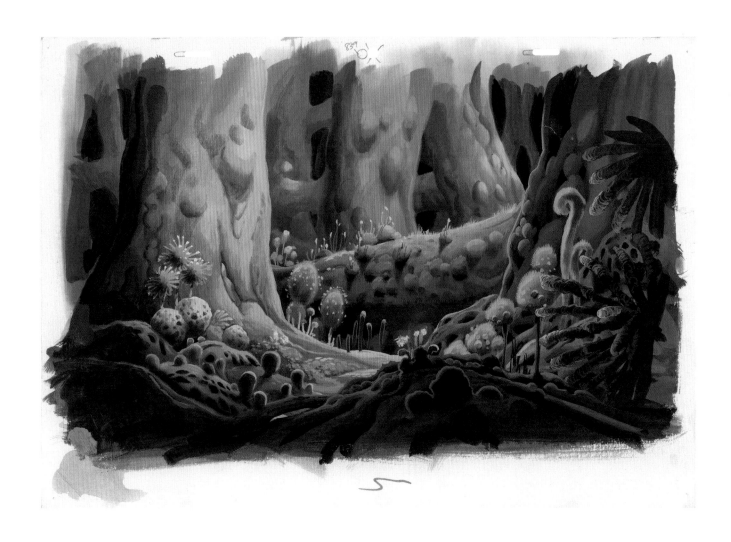

Nausicaä of the Valley of the Wind
background (the Sea of Decay)

Nausicaä of the Valley of the Wind
production imageboard (buildings
swallowed up by the Sea of Decay)

Nausicaä of the Valley of the Wind
background (ohm shell)

ラピュタのみどりの天蓋

ABOVE: Hayao Miyazaki, Castle in the Sky
imageboard (Laputa)

OPPOSITE: Castle in the Sky background
(Laputa, castle and gardens)

ゲンカン
もう少し小いっせ

My Neighbor Totoro production
design drawing (Kusakabe residence)

My Neighbor Totoro production
imageboard (Kusakabe residence)

Kiki's Delivery Service production imageboard
(Okino residence, sunroom)

Kiki's Delivery Service background
(Okino residence, exterior)

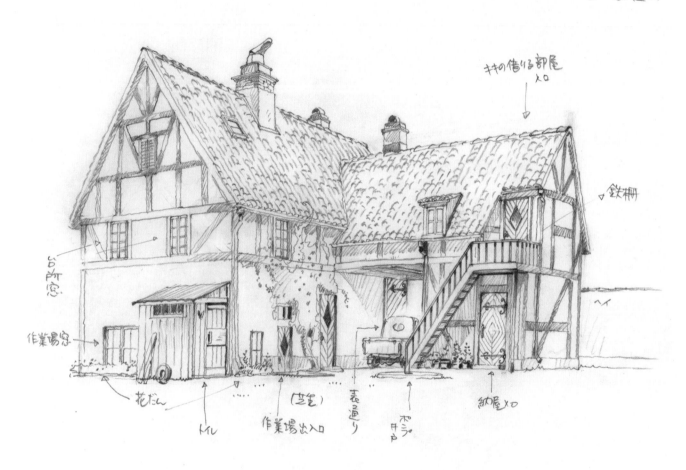

パン屋の裏庭の

キキの借りる部屋 入口

鉄柵

台所窓

作業場窓

花だん

トイレ

[芝生]

作業場出入口

表通り

ポプラ
チラ
P

納屋入口

Kiki's Delivery Service production
design drawing (bakery)

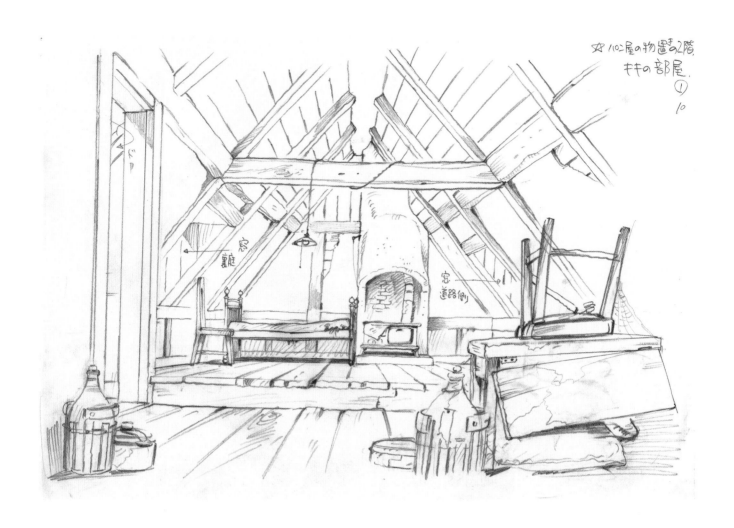

文 パン屋の物置きの2階
キキの部屋
①
10

窓
調庭

窓
道路側

Kiki's Delivery Service production
design drawing (Kiki's attic room)

ABOVE: Porco Rosso background
(islands, aerial view)

OPPOSITE: Porco Rosso foreground
on background (Porco's hideout)

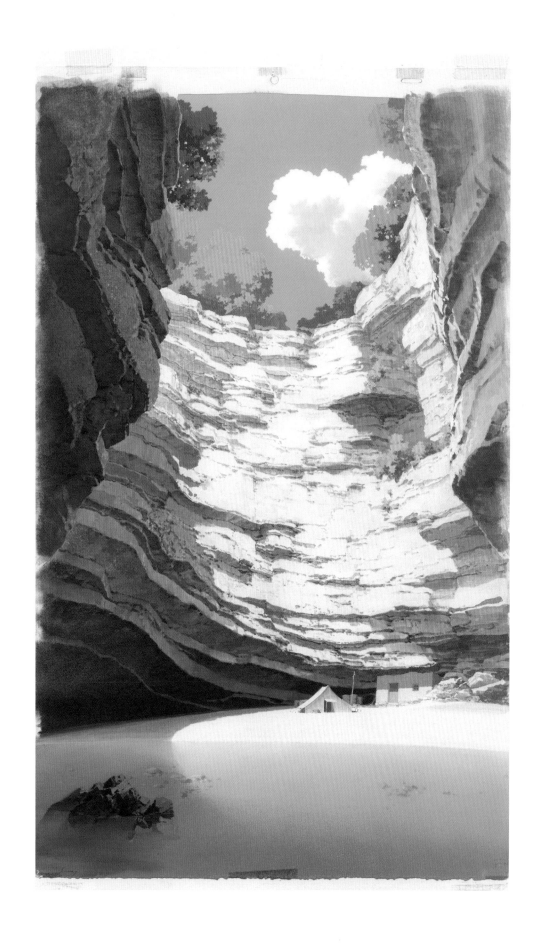

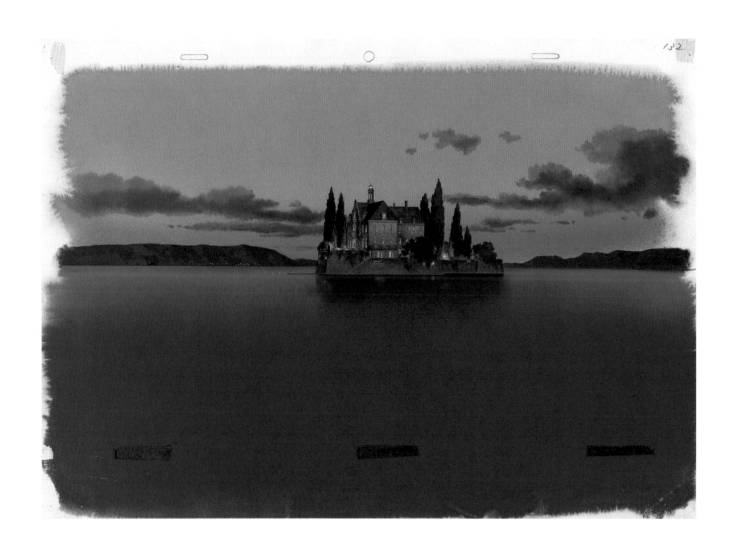

Porco Rosso background
(Hotel Adriano, dusk)

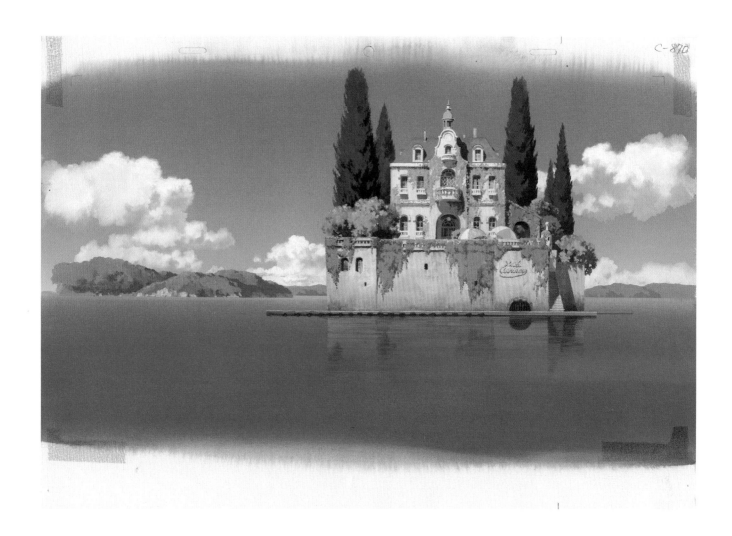

Porco Rosso background
(Hotel Adriano, day)

Princess Mononoke foreground on background
(new forest growth)

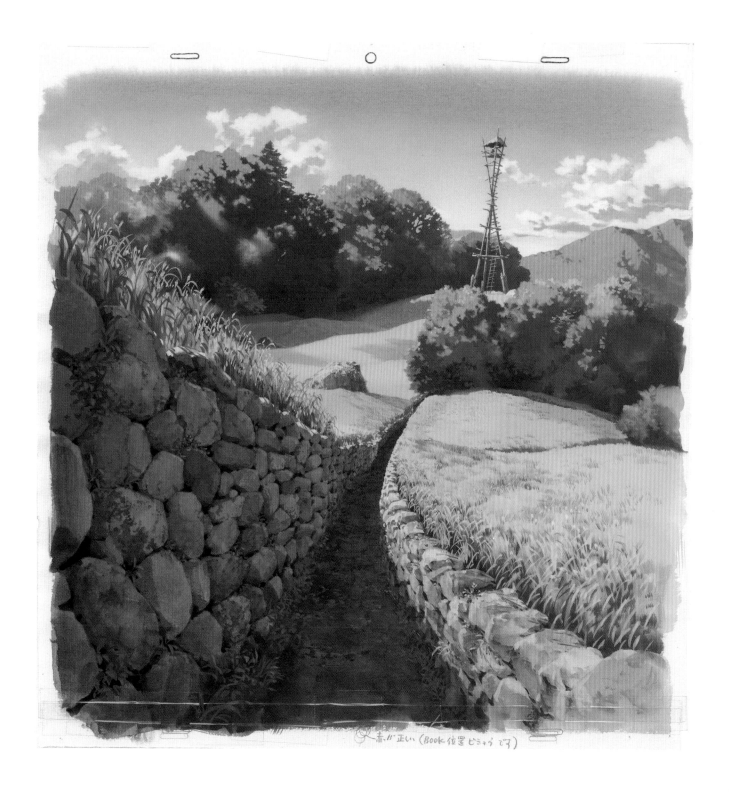

Princess Mononoke foreground on background
(road leading to watchtower)

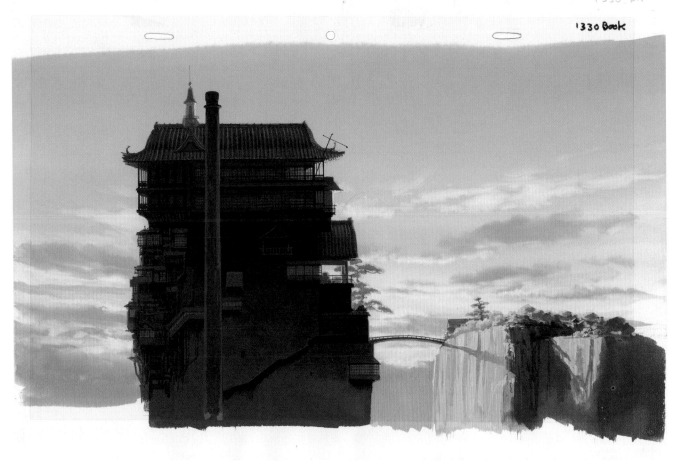

Spirited Away foreground on
background (bathhouse at daybreak)

Spirited Away background
(landscape, view from train)

OPPOSITE, BOTTOM: Howl's Moving
Castle background (farmer's house)

TOP: Howl's Moving Castle
background (the high moors)

BOTTOM: Howl's Moving Castle
background (Howl's childhood cottage)

金具なし

影、Bookに
描き込み.

352

ABOVE: Howl's Moving Castle
production imageboard
(Howl's bathroom)

OPPOSITE: Howl's Moving Castle
production imageboards
(Howl's castle)

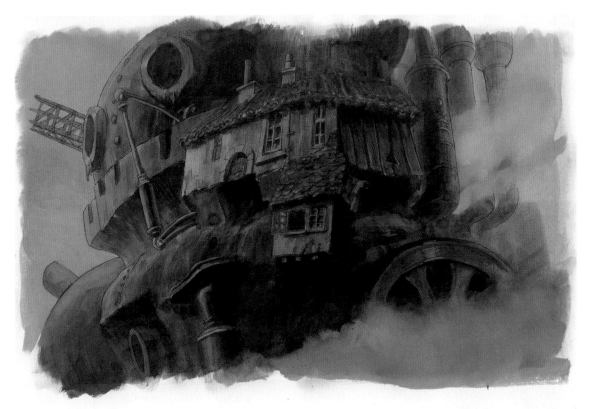

にくくるに鼓

C-915

Ponyo background
(submerged forest)

Ponyo backgrounds
(the submerged town)

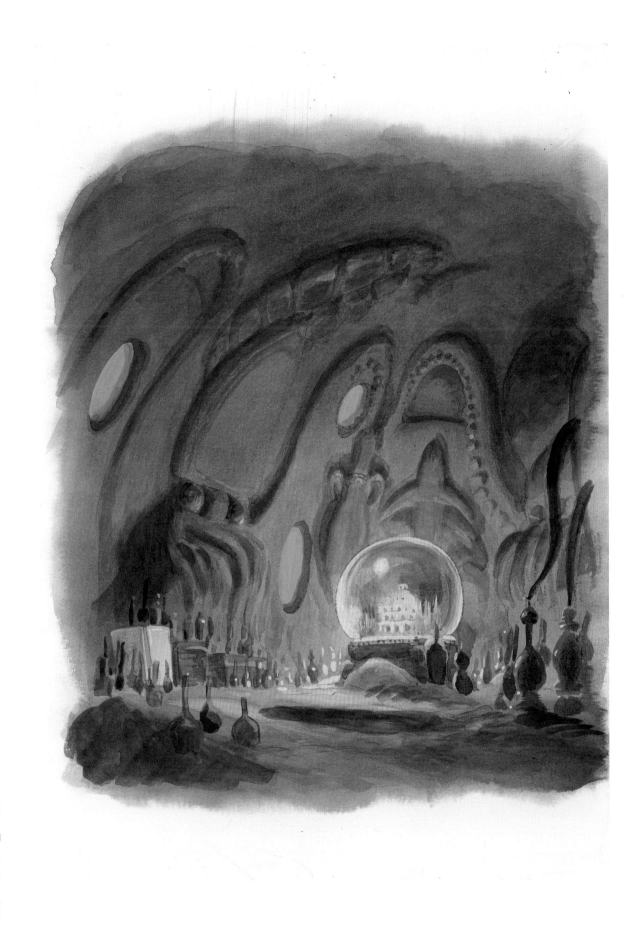

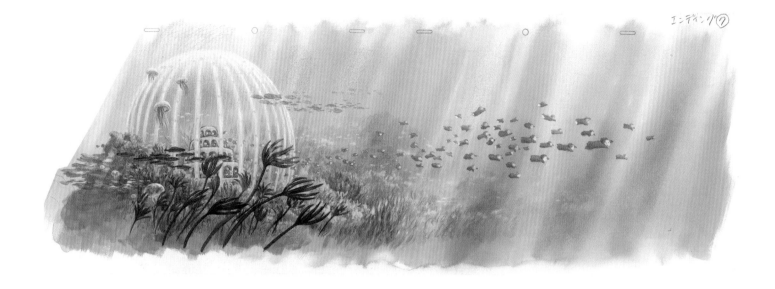

エンディング⑦

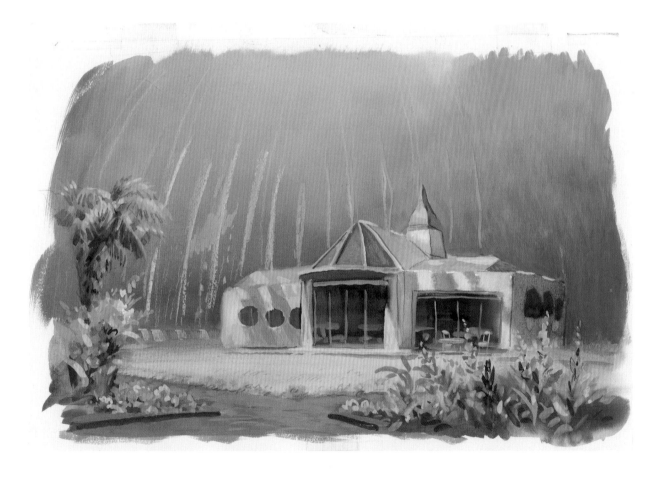

OPPOSITE: Ponyo production imageboard (Coral Tower, interior)

TOP: Ponyo background for end credits (Nursery Tower)

BOTTOM: Ponyo production imageboard (Sunflower House inside jellyfish)

TOP: The Wind Rises background
(Jiro's elementary school on
shop-lined street)

BOTTOM: The Wind Rises background
(Horikoshi residence, garden)

OPPOSITE: The Wind Rises background
(Horikoshi residence, interior)

C-89.

c-431.

OPPOSITE, TOP: The Wind Rises
foreground (carriage of the Class
6700 steam locomotive)

OPPOSITE, BOTTOM: The Wind Rises
background (Town's Bridge)

ABOVE: The Wind Rises background
(Mitsubishi Internal Combustion
Engine Company campus)

C-1218

The Wind Rises background
(train bridge, mountains)

The Wind Rises background
(Kurokawa guesthouse with
cherry blossom tree in bloom)

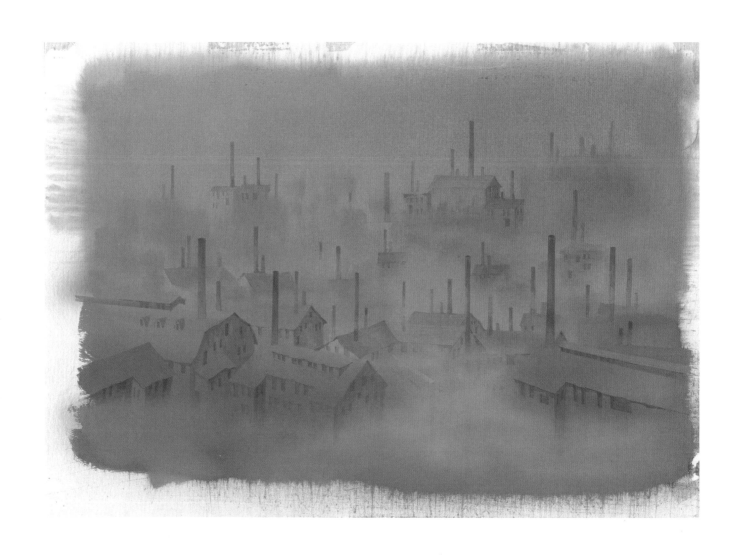

ABOVE: Castle in the Sky background (Slag Ravine)

OPPOSITE, TOP: Castle in the Sky background (Slag Ravine)

OPPOSITE, BOTTOM: Castle in the Sky production imageboard (Slag Ravine)

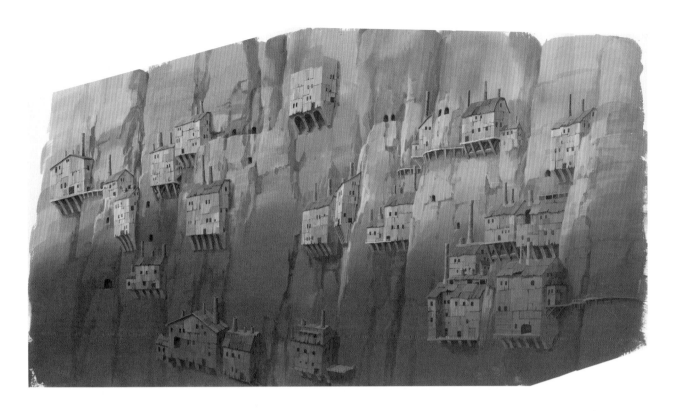

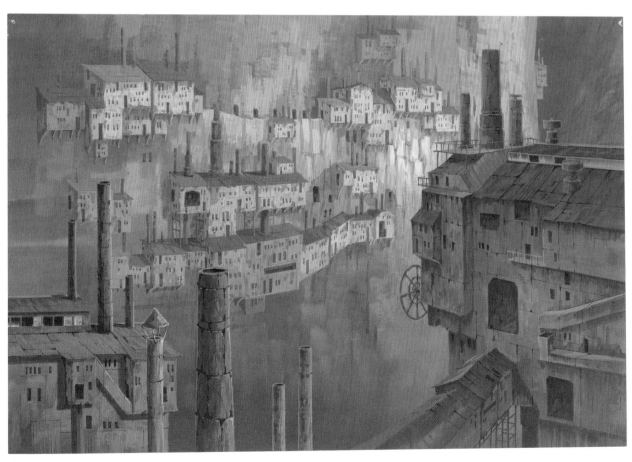

STUDIO GHIBLI CO.,LTD. S. C. 306 TIME

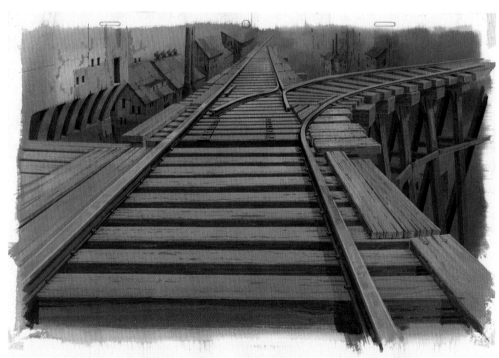

TOP: Castle in the Sky layout
drawing (train chase, scene 306)

BOTTOM: Castle in the Sky
background (Slag Ravine,
train tracks)

OPPOSITE, TOP: Castle in the Sky
layout drawing (Pazu on the
mine steam lift, scene 87)

OPPOSITE, BOTTOM: Castle in the Sky
background (mine steam lift)

STUDIO GHIBLI CO.,LTD. S. C.87 TIME

Hayao Miyazaki, Princess Mononoke
initial imageboard (large ironworks,
aerial map)

The map indicates the location of the
merchant shops, ironworks, blacksmith,
warehouses, wells, and cowshed.

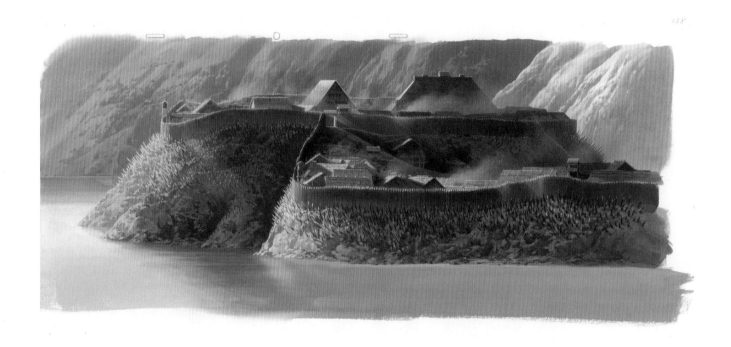

Princess Mononoke foreground
on background (Iron Town)

TOP: Princess Mononoke layout drawing
(Iron Town workers, scene 340)

BOTTOM: Hayao Miyazaki, Princess Mononoke
layout drawing (Toki peers through the gate,
scene 1573)

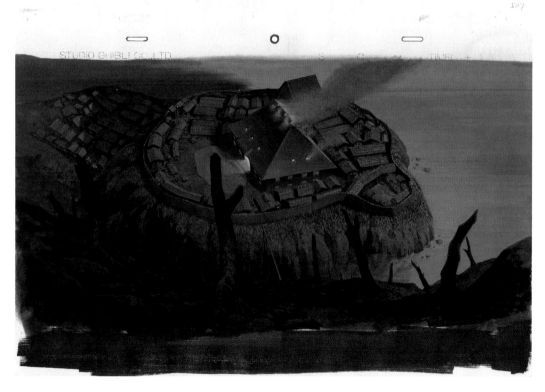

TOP: **Princess Mononoke** foreground on background (Iron Town gate, sunset)

BOTTOM: **Princess Mononoke** background (Iron Town, night)

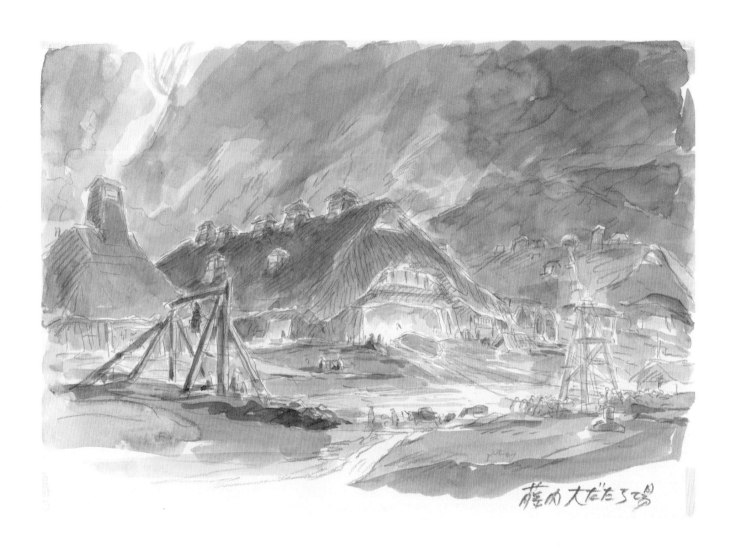

藤の大だたら場

ABOVE: Hayao Miyazaki,
Princess Mononoke imageboard
(the flaming ironworks)

OPPOSITE, TOP: Princess Mononoke
layout drawing (ironworks, scene 433)

OPPOSITE, BOTTOM: Princess Mononoke
layout drawing (scene 1638)

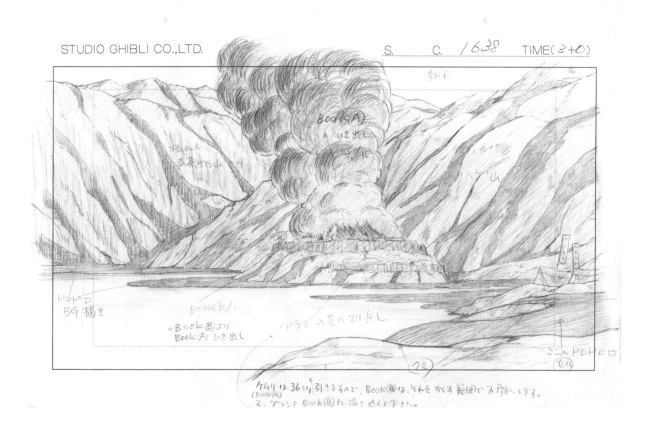

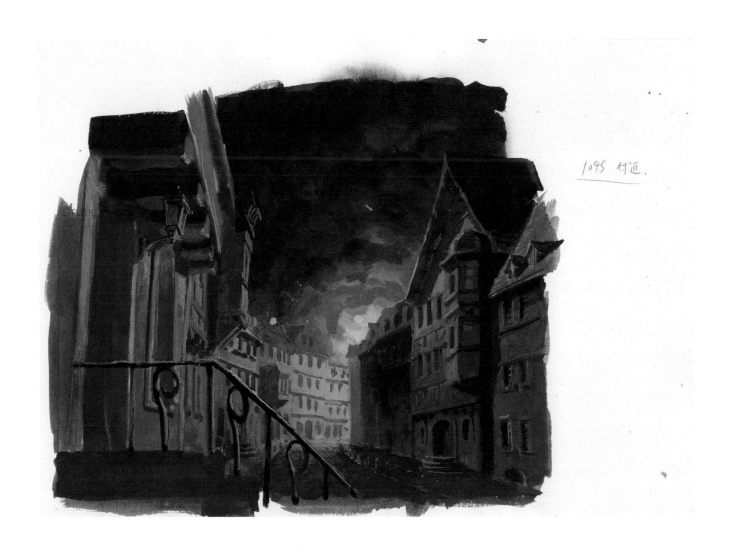

1045 付近.

Howl's Moving Castle production
imageboard (town in flames)

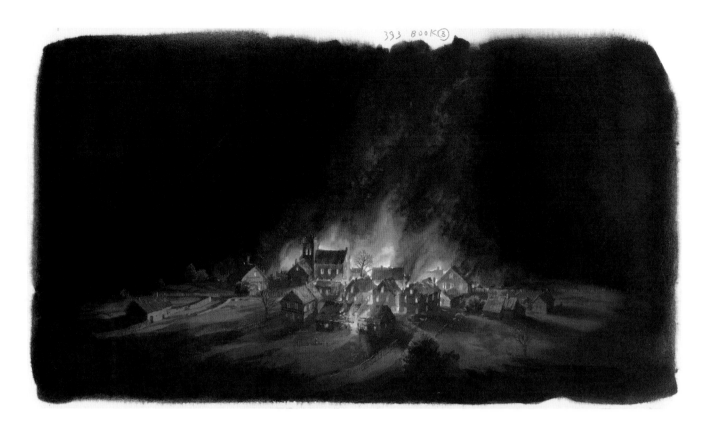

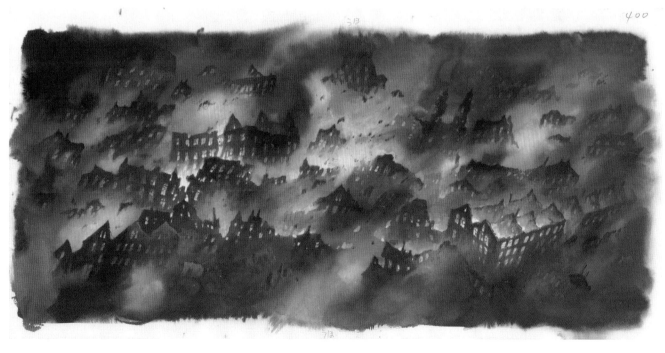

TOP: Howl's Moving Castle foreground (bombed town)

BOTTOM: Howl's Moving Castle background (burning town)

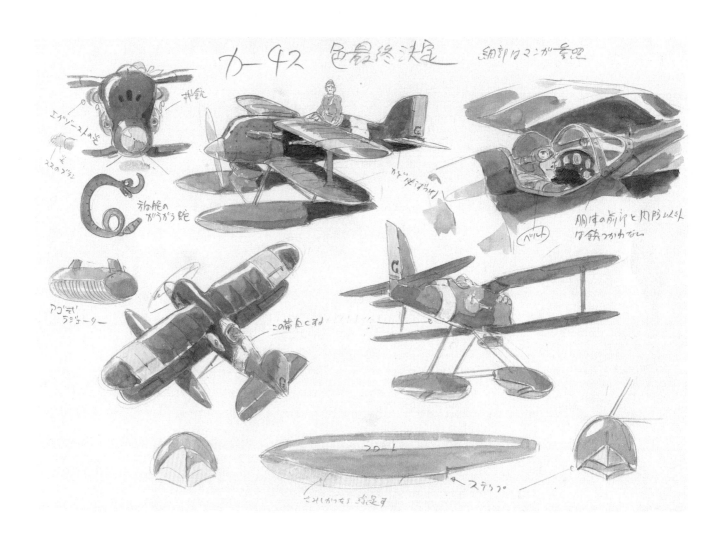

ABOVE: Hayao Miyazaki, Porco Rosso imageboard (Curtis's R3C-0 seaplane)

OPPOSITE, TOP: Porco Rosso cel on background (Curtis flies his R3C-0)

OPPOSITE, BOTTOM: Porco Rosso cel on background (Porco flies his Savoia S-21)

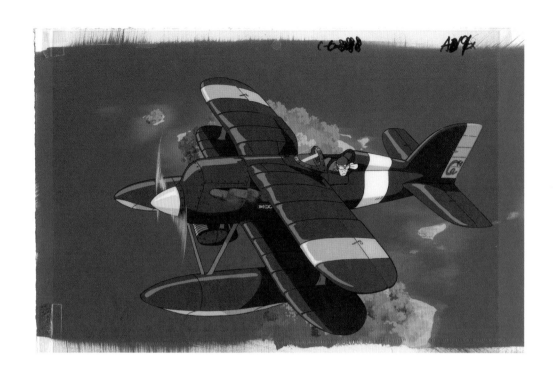

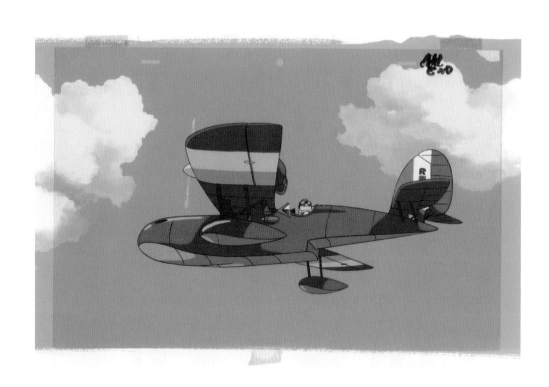

THIS SPREAD AND FOLLOWING PAGE:
Porco Rosso key animation set
(Porco in flight)

Key animation drawings made by the key animator (top row) are then
corrected and annotated by Miyazaki (middle row). The supervising
animator cleans up and incorporates the corrections (bottom row).

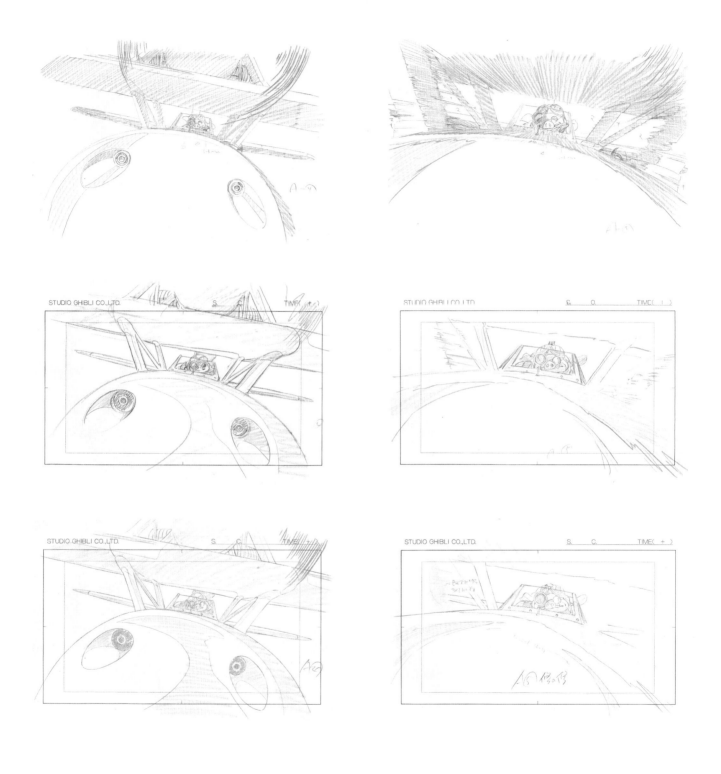

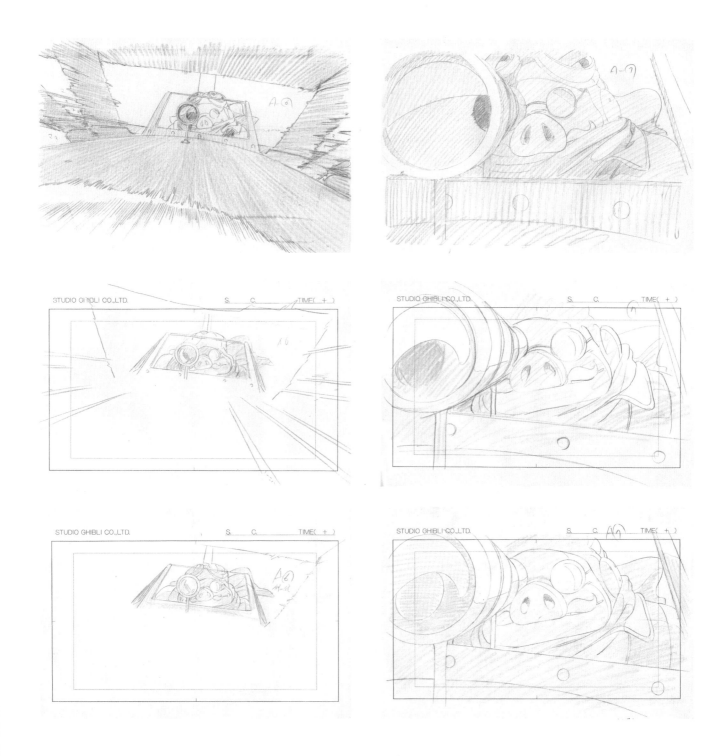

Hayao Miyazaki, Porco Rosso
illustration (ending scene)

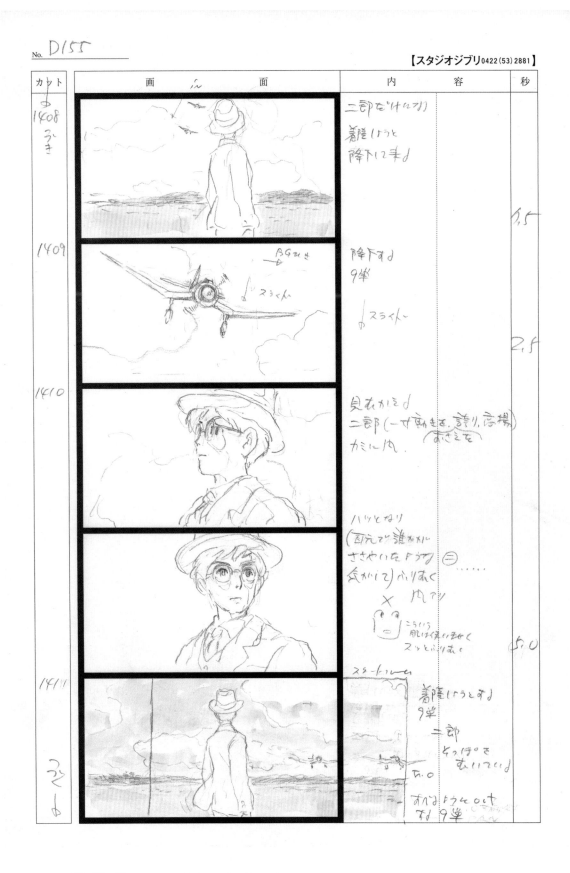

No. D155

【スタジオジブリ 0422(53) 2881】

Hayao Miyazaki, The Wind Rises
storyboards (scene 1408–1413)

Jiro's designed 9-shin single-seat
fighter plane successfully takes flight.

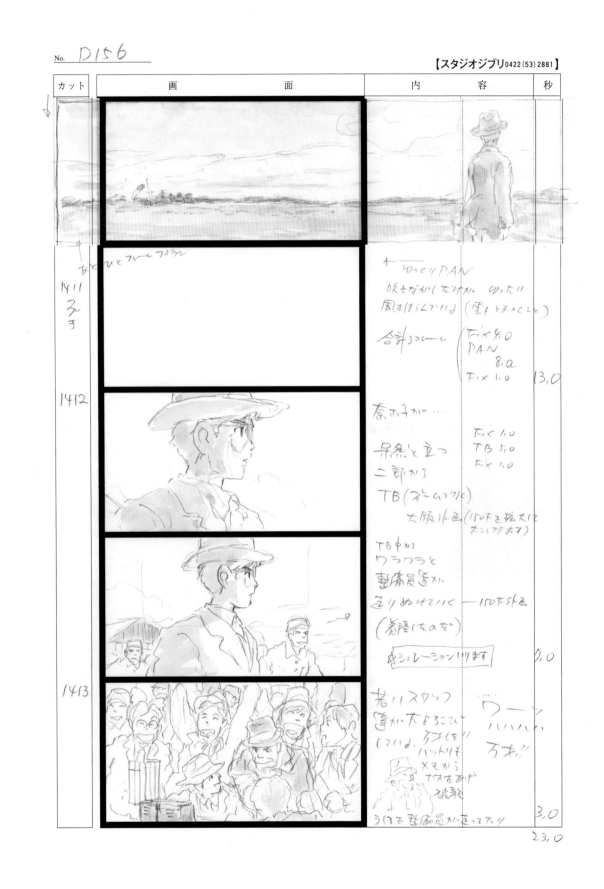

カット	画　　面　　面	内　　容	秒

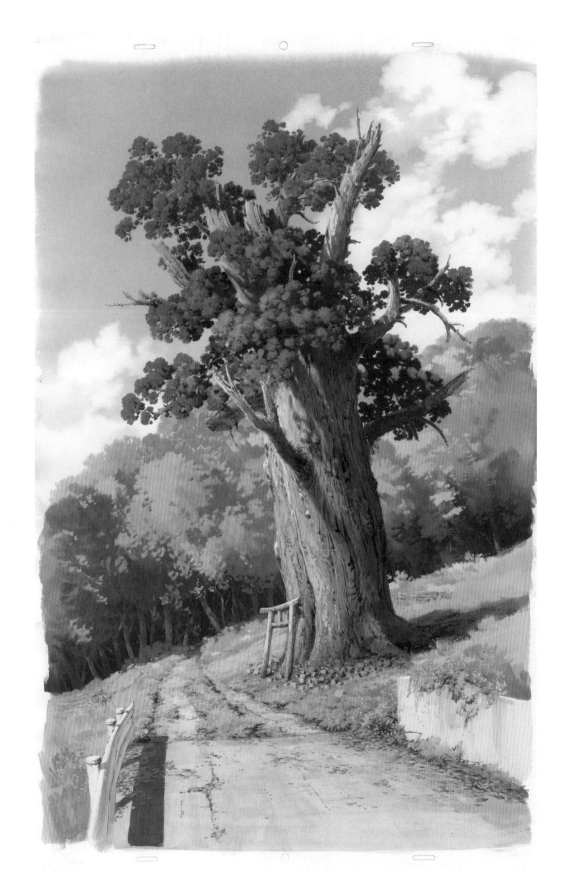

Spirited Away background
(ancient towering tree with Shinto gateway)

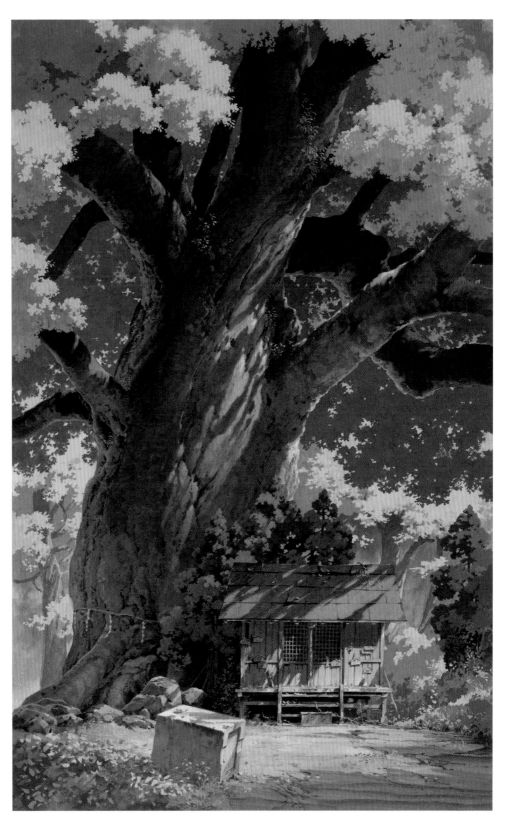

My Neighbor Totoro background
(camphor tree and Suitengu shrine)

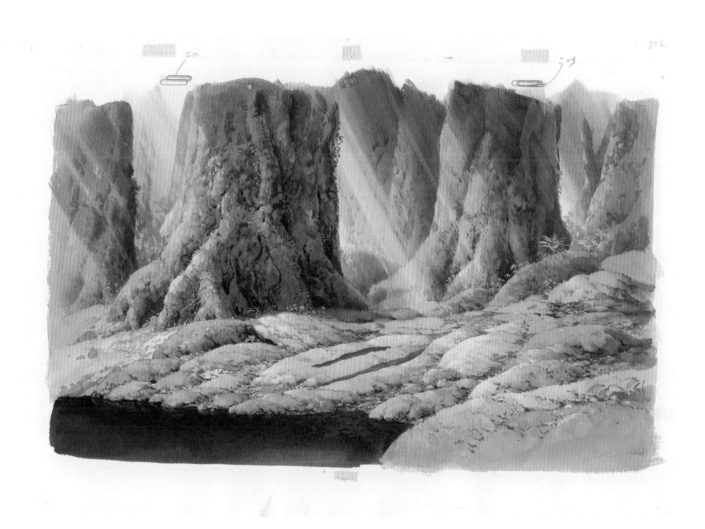

Princess Mononoke background
(forest floor with sunlight)

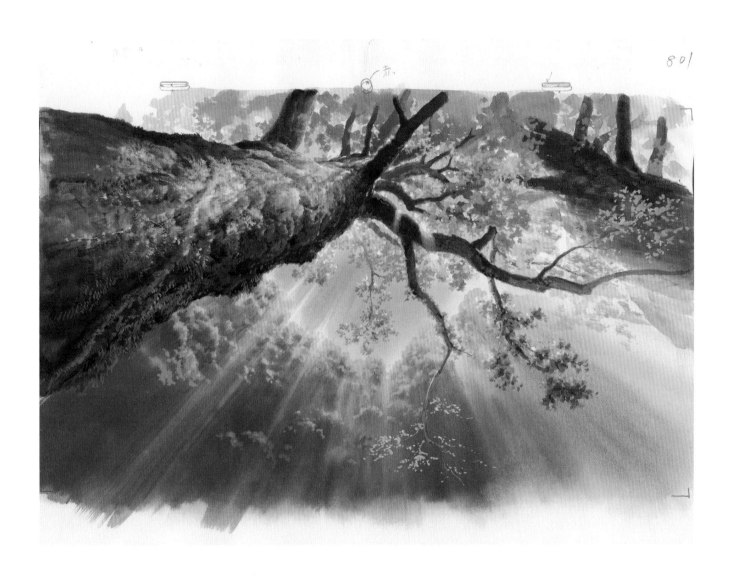

Princess Mononoke background
(sky above the pool of the Deer God)

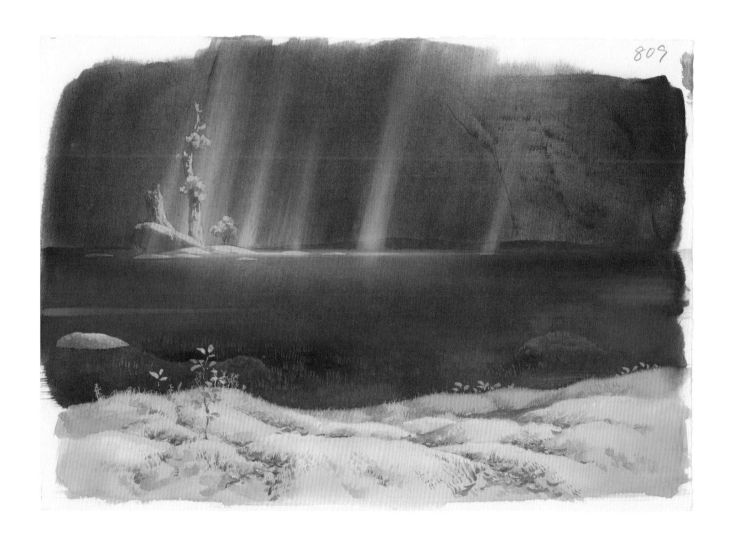

Princess Mononoke production
imageboard (pool of the Deer God)

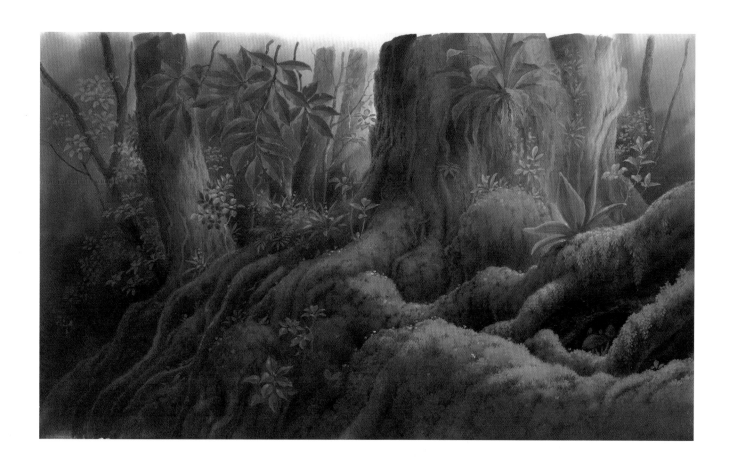

Princess Mononoke background
(Forest of the Deer God)

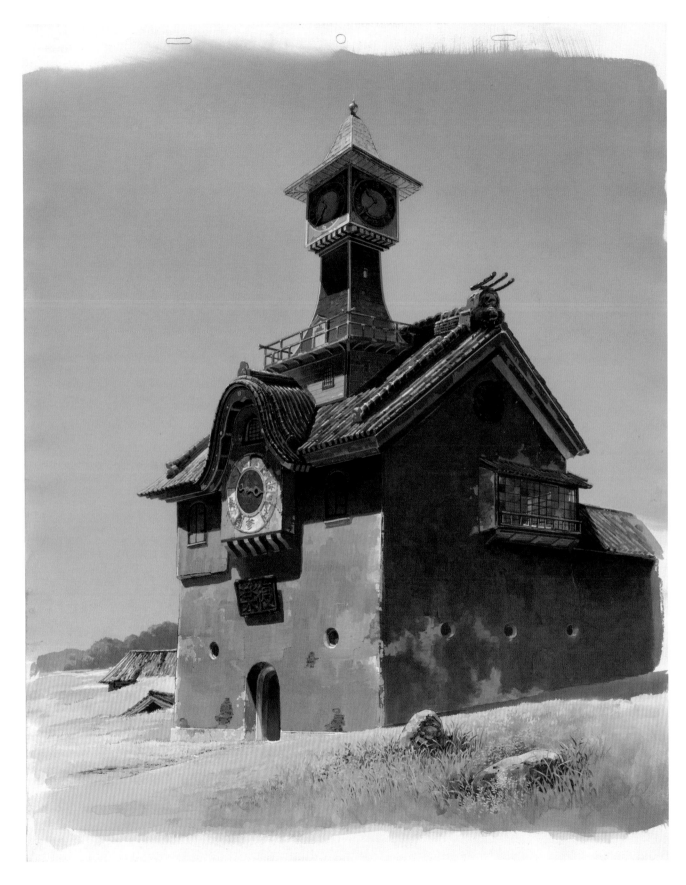

Spirited Away background
(the strange clocktower)

Spirited Away backgrounds
(clocktower interior bathed
in colorful light)

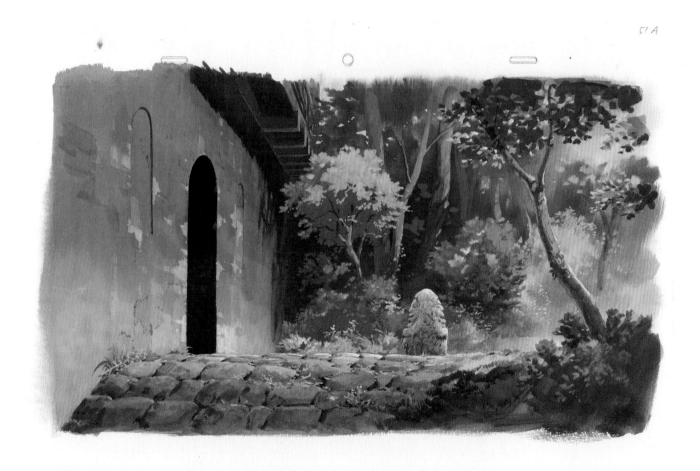

Spirited Away backgrounds
(stone spirit guards the tunnel)

Spirited Away background
(tunnel entrance, overgrown)

Spirited Away film still (Chihiro looks back)

FILMOGRAPHY

Compiled by

J. RAÚL GUZMÁN

EARLY WORK

1963
Wan wan chushingura
Doggie March
DIRECTED BY Daisaku Shirakawa.
PRODUCTION: Toei Animation. Feature film,
81 min., mono, color, 2.35:1, 35mm.
In-between animation

1963–65
Okami shonen Ken
Ken, the Wolf Boy
PRODUCTION: Toei Animation. Television series,
86 episodes, 25 min. In-between animation

1964–65
Shonen ninja kaze no Fujimaru
Fujimaru of the Wind
PRODUCTION: Toei Animation. Television series,
65 episodes, 25 min. Key animation

1965
Gulliver no uchu ryoko
Gulliver's Travels beyond the Moon
DIRECTED BY Yoshio Kuroda. PRODUCTION: Toei
Animation. Feature film, 80 min., mono,
color, 2.35:1, 35mm. In-between animation

1965–66
Hassuru Punch
Hustle Punch
PRODUCTION: Toei Animation. Television series,
26 episodes, 25 min. Key animation

1966–67
Rainbow sentai Robin
Robin in the Rainbow Troops
PRODUCTION: Toei Animation. Television series,
48 episodes, 25 min. Key animation

1966–68
Mahotsukai Sally
Sally the Witch
PRODUCTION: Toei Animation. Television series,
109 episodes, 25 min. Key animation

1968
Taiyo no oji: Hols no daiboken
Little Norse Prince Valiant
A FILM BY Isao Takahata. PRODUCTION: Toei
Animation. Feature film, 82 min.,
mono, color, 2.35:1, 35mm. Scene design,
key animation

1969
Nagagutsu wo haita neko
Puss in Boots
DIRECTED BY Kimio Yabuki. PRODUCTION: Toei
Animation. Feature film, 80 min.,
mono, color, 2.35:1, 35mm. Key animation

1969
Soratobu yureisen
Flying Phantom Ship
DIRECTED BY Hiroshi Ikeda. PRODUCTION: Toei
Animation. Feature film, 60 min.,
mono, color, 2.35:1, 35mm. Key animation

1969–70
Himitsu no Akko-chan
Akko's Secret
PRODUCTION: Toei Animation. Television series,
94 episodes, 25 min. Key animation

1969–70
Moomin
PRODUCTION: Tokyo Movie, Mushi Production.
Television series, 65 episodes, 25 min.
Key animation

1971
Dobutsu takarajima
Animal Treasure Island
DIRECTED BY Hiroshi Ikeda. PRODUCTION: Toei
Animation. Feature film, 78 min.,
mono, color, 2.35:1, 35mm. Scene
development, key animation

1971
Alibaba to yonjuppiki no tozoku
Ali Baba and the Forty Thieves
DIRECTED BY Hiroshi Shidara. PRODUCTION: Toei
Animation. Feature film, 55 min., mono,
color, 2.35:1, 35mm. Key animation

This filmography covers Hayao Miyazaki's animated works and includes all Studio Ghibli feature productions,
as well as selected Studio Ghibli shorts. For early television work, Miyazaki's creative role is summarized;
date ranges indicate broadcast years, and his participation in individual episodes has not been identified. —JRG

1971–72
Sarutobi Ecchan
Ecchan the Ninja
PRODUCTION: Toei Animation. Television series,
26 episodes, 25 min. Key animation

1971–72
Lupin sansei
Lupin the 3rd
PRODUCTION: Tokyo Movie. Television series,
23 episodes, 25 min. Codirection,
key animation

1972
Yuki no taiyo
Yuki's Sun
A FILM BY Hayao Miyazaki. PRODUCTION: Tokyo
Movie. Pilot, 5 min., mono, color, 1.37:1,
35mm. Storyboard, key animation

1972–73
Akado Suzunosuke
Little Samurai
PRODUCTION: Tokyo Movie. Television series,
52 episodes, 25 min. Storyboard

1972
Panda kopanda
Panda! Go Panda!
A FILM BY Isao Takahata. PRODUCTION: Tokyo
Movie. Short film, 34 min., mono, color,
1.37:1, 35mm. Original concept,
screenplay, set design, key animation

1973
**Panda kopanda amefuri circus
no maki**
Panda! Go Panda! Rainy Day Circus
A FILM BY Isao Takahata. PRODUCTION: Tokyo
Movie. Short film, 38 min., mono, color,
1.37:1, 35mm. Screenplay, art design,
layout, key animation

1973–74
Koya no shonen Isamu
Isamu the Wilderness Boy
PRODUCTION: Tokyo Movie. Television series,
52 episodes, 25 min. Key animation

1973–74
Samurai Giants
PRODUCTION: Tokyo Movie. Television series,
46 episodes, 25 min. Key animation

1974
Alps no shojo Heidi
Heidi, Girl of the Alps
PRODUCTION: Zuiyo. Television series,
52 episodes, 25 min. Scene design, layout,
key animation

1975
Flanders no inu
Dog of Flanders
PRODUCTION: Nippon Animation. Television
series, 52 episodes, 25 min. Key
animation

1976
Haha wo tazunete sanzenri
From the Apennines to the Andes
PRODUCTION: Nippon Animation. Television
series, 52 episodes, 25 min. Scene design,
layout, key animation

1977
Araiguma Rascal
Rascal the Raccoon
PRODUCTION: Nippon Animation. Television
series, 52 episodes, 25 min. Key
animation

1977
Sogen no ko Tenguri
Tenguri, Boy of the Plains
DIRECTED BY Yasuo Otsuka. PRODUCTION: Sakura
Motion Picture. Promotional film, 22 min.,
mono, color, 1.37:1, 35mm. Layout

1978
Mirai shonen Conan
Future Boy Conan
PRODUCTION: Nippon Animation. Television
series, 26 episodes, 29 min. Direction,
storyboard

1979
Akage no Anne
Anne of Green Gables
PRODUCTION: Nippon Animation. Television
series, 50 episodes, 25 min. Scene design,
layout

1977–80
Lupin sansei
Lupin the 3rd
PRODUCTION: Tokyo Movie Shinsha.
Television series, 155 episodes, 25 min.
Direction, screenplay, storyboard

1980–81
Tetsujin 28 go
Iron Man 28
PRODUCTION: Tokyo Movie Shinsha.
Television series, 51 episodes, 25 min.
Key animation

1982
Space Adventure Cobra
DIRECTED BY Osamu Dezaki. PRODUCTION: Tokyo
Movie Shinsha. Feature film, 99 min.,
Dolby Stereo, color, 1.85:1, 35mm. Key
animation

1984–85
Meitantei Holmes
Sherlock Hound
PRODUCTION: Tokyo Movie Shinsha, RAI.
Television series, 26 episodes, 25 min.
Direction, storyboard, screenplay

FEATURE FILMS

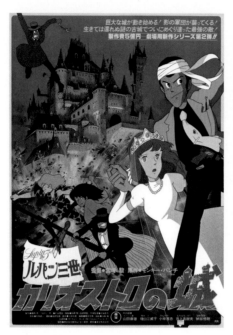

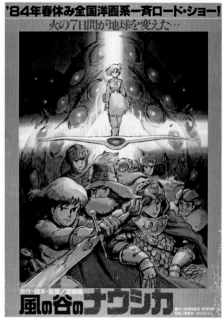

1979
Lupin sansei: Cagliostro no shiro
Lupin the 3rd: The Castle of Cagliostro

A FILM BY Hayao Miyazaki

ORIGINAL STORY: Monkey Punch. SCREENPLAY: Hayao Miyazaki, Haruya Yamazaki. SUPERVISING ANIMATOR: Yasuo Otsuka. ART DIRECTION: Shichiro Kobayashi. COLOR DESIGN: Hiroko Kondo. CAMERA SUPERVISOR: Hirokata Takahashi. MUSIC: Yuji Ono. VOICE CAST: Yasuo Yamada, Sumi Shimamoto, Taro Ishida, Goro Naya, Kiyoshi Kobayashi, Eiko Masuyama, Makio Inoue. PRODUCER: Tetsuo Katayama. PRODUCTION: Tokyo Movie Shinsha, 100 min., mono, color, 1.85:1, 35mm. RELEASE DATE (JAPAN): December 15, 1979.

1984
Kaze no tani no Nausicaä
Nausicaä of the Valley of the Wind

A FILM BY Hayao Miyazaki

ORIGINAL STORY AND SCREENPLAY: Hayao Miyazaki. SUPERVISING ANIMATOR: Kazuo Komatsubara. ART DIRECTION: Mitsuki Nakamura. COLOR DESIGN: Michiyo Yasuda, Fukuo Suzuki. CAMERA SUPERVISOR: Takaharu Shiragami. MUSIC: Joe Hisaishi. VOICE CAST: Sumi Shimamoto, Goro Naya, Yoji Matsuda, Yoshiko Sakakibara, Ichiro Nagai, Iemasa Kayumi. PRODUCER: Isao Takahata. PRODUCTION: Top Craft, 116 min., mono, color, 1.85:1, 35mm. RELEASE DATE (JAPAN): March 11, 1984.

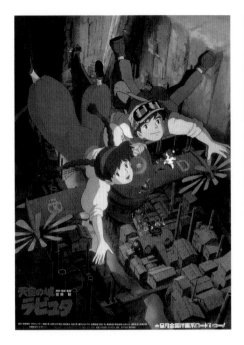

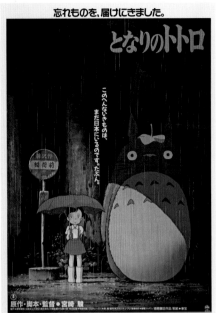

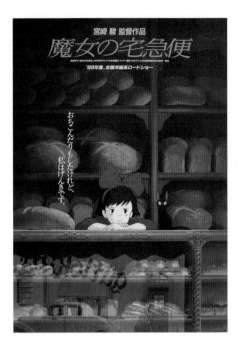

1986

Tenku no shiro Laputa
Castle in the Sky

A FILM BY Hayao Miyazaki

ORIGINAL STORY AND SCREENPLAY: Hayao Miyazaki.
SUPERVISING ANIMATOR: Tsukasa Tannai. ART DIRECTION:
Toshiro Nozaki, Nizo Yamamoto.
COLOR DESIGN: Michiyo Yasuda. CAMERA SUPERVISOR:
Hirokata Takahashi. MUSIC: Joe Hisaishi.
VOICE CAST: Mayumi Tanaka, Keiko Yokozawa,
Kotoe Hatsui, Minori Terada, Fujio Tokita,
Ichiro Nagai. PRODUCER: Isao Takahata.
PRODUCTION: Studio Ghibli, 124 min., Dolby
Stereo, color, 1.85:1, 35mm. RELEASE DATE (JAPAN):
August 2, 1986.

1988

Tonari no Totoro
My Neighbor Totoro

A FILM BY Hayao Miyazaki

ORIGINAL STORY AND SCREENPLAY: Hayao Miyazaki.
SUPERVISING ANIMATOR: Yoshiharu Sato. ART DIRECTION:
Kazuo Oga. COLOR DESIGN: Michiyo Yasuda.
CAMERA SUPERVISOR: Hisao Shirai. MUSIC: Joe
Hisaishi. VOICE CAST: Noriko Hidaka, Chika
Sakamoto, Shigesato Itoi, Sumi Shimamoto,
Tanie Kitabayashi, Hitoshi Takagi. PRODUCER:
Toru Hara. PRODUCTION: Studio Ghibli, 86
min., Dolby Stereo, color, 1.85:1, 35mm.
RELEASE DATE (JAPAN): April 16, 1988.

1989

Majo no takkyubin
Kiki's Delivery Service

A FILM BY Hayao Miyazaki

ORIGINAL STORY: Eiko Kadono. SCREENPLAY: Hayao
Miyazaki. SUPERVISING ANIMATORS: Shinji Otsuka,
Katsuya Kondo, Yoshifumi Kondo. ART
DIRECTION: Hiroshi Ono. COLOR DESIGN: Michiyo
Yasuda. CAMERA SUPERVISOR: Juro Sugimura.
MUSIC: Joe Hisaishi. MUSIC DIRECTION: Isao
Takahata. VOICE CAST: Minami Takayama,
Rei Sakuma, Kappei Yamaguchi, Haruko
Kato, Keiko Toda. PRODUCER: Hayao Miyazaki.
ASSOCIATE PRODUCER: Toshio Suzuki. PRODUCTION:
Studio Ghibli, 102 min., Dolby Stereo, color,
1.85:1, 35mm. RELEASE DATE (JAPAN): July 29, 1989.

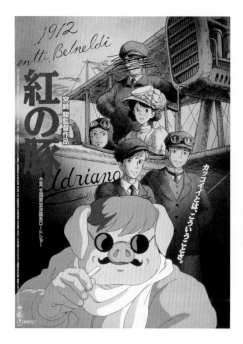

1992
Kurenai no buta
Porco Rosso

A FILM BY Hayao Miyazaki

ORIGINAL STORY AND SCREENPLAY: Hayao Miyazaki.
SUPERVISING ANIMATORS: Megumi Kagawa, Toshio
Kawaguchi. ART DIRECTION: Katsu Hisamura.
COLOR DESIGN: Michiyo Yasuda. CAMERA SUPERVISOR:
Atsushi Okui. MUSIC: Joe Hisaishi. VOICE CAST:
Shuichiro Moriyama, Tokiko Kato,
Sanshi Katsura, Tsunehiko Kamijo,
Akemi Okamura, Akio Otsuka. PRODUCER:
Toshio Suzuki. PRODUCTION: Studio Ghibli,
93 min., Dolby Stereo, color, 1.85:1,
35mm. RELEASE DATE (JAPAN): July 18, 1992.

1997
Mononoke Hime
Princess Mononoke

A FILM BY Hayao Miyazaki

ORIGINAL STORY AND SCREENPLAY: Hayao Miyazaki.
SUPERVISING ANIMATORS: Masashi Ando, Kitaro
Kosaka, Yoshifumi Kondo. ART DIRECTION:
Nizo Yamamoto, Naoya Tanaka, Yoji
Takeshige, Satoshi Kuroda, Kazuo Oga.
COLOR DESIGN: Michiyo Yasuda. CAMERA SUPERVISOR:
Atsushi Okui. MUSIC: Joe Hisaishi. VOICE CAST:
Yoji Matsuda, Yuriko Ishida, Yuko Tanaka,
Kaoru Kobayashi, Masahiko Nishimura,
Tsunehiko Kamijo, Akihiro Miwa,
Mitsuko Mori, Hisaya Morishige. PRODUCER:
Toshio Suzuki. PRODUCTION: Studio Ghibli,
133 min., Dolby Digital, color, 1.85:1, 35mm.
RELEASE DATE (JAPAN): July 12, 1997.

2001
Sen to Chihiro no kamikakushi
Spirited Away

A FILM BY Hayao Miyazaki

ORIGINAL STORY AND SCREENPLAY: Hayao Miyazaki.
SUPERVISING ANIMATORS: Masashi Ando, Kitaro
Kosaka, Megumi Kagawa. ART DIRECTION:
Yoji Takeshige. COLOR DESIGN: Michiyo Yasuda.
DIGITAL IMAGING: Atsushi Okui. MUSIC: Joe Hisaishi.
VOICE CAST: Rumi Hiiragi, Miyu Irino, Mari
Natsuki, Takashi Naito, Yasuko Sawaguchi,
Tsunehiko Kamijo, Takehiko Ono,
Bunta Sugawara. PRODUCER: Toshio Suzuki.
PRODUCTION: Studio Ghibli, 125 min., Dolby
Digital Surround EX/DTS-ES, color,
1.85:1, 35mm/DCP. RELEASE DATE (JAPAN):
July 20, 2001.

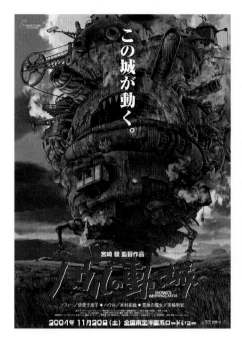

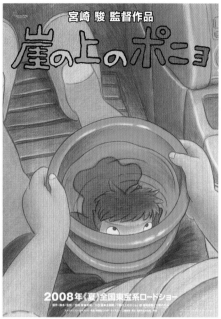

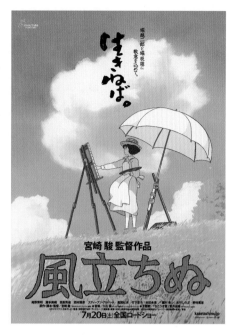

2004

Howl no Ugoku Shiro
Howl's Moving Castle

A FILM BY Hayao Miyazaki

BASED ON THE NOVEL BY Diana Wynne Jones.
SCREENPLAY: Hayao Miyazaki. SUPERVISING
ANIMATORS: Akihiko Yamashita, Takeshi
Inamura, Kitaro Kosaka. ART DIRECTION: Yoji
Takeshige, Noboru Yoshida. COLOR DESIGN:
Michiyo Yasuda. DIGITAL IMAGING: Atsushi
Okui. MUSIC: Joe Hisaishi. VOICE CAST: Chieko
Baisho, Takuya Kimura, Akihiro Miwa,
Tatsuya Gashuin, Ryunosuke Kamiki,
Yo Oizumi, Daijiro Harada, Haruko Kato.
PRODUCER: Toshio Suzuki. PRODUCTION: Studio
Ghibli, 119 min., Dolby Digital Surround
EX/DTS-ES, color, 1.85:1, 35mm/DCP.
RELEASE DATE (JAPAN): November 20, 2004.

2008

Gake no ue no Ponyo
Ponyo (Ponyo on the Cliff by the Sea)

A FILM BY Hayao Miyazaki

ORIGINAL STORY AND SCREENPLAY: Hayao Miyazaki.
SUPERVISING ANIMATOR: Katsuya Kondo. ART DIRECTION:
Noboru Yoshida. COLOR DESIGN: Michiyo
Yasuda. DIGITAL IMAGING: Atsushi Okui. MUSIC:
Joe Hisaishi. VOICE CAST: Tomoko Yamaguchi,
Kazushige Nagashima, Yuki Amami,
George Tokoro, Yuria Nara, Hiroki Doi,
Rumi Hiiragi, Akiko Yano, Kazuko
Yoshiyuki, Tomoko Naraoka. PRODUCER:
Toshio Suzuki. EXECUTIVE PRODUCER: Koji Hoshino.
PRODUCTION: Studio Ghibli, 101 min., Dolby
Digital Surround EX/DTS-ES, color, 1.85:1,
35mm/DCP. RELEASE DATE (JAPAN): July 19, 2008.

2013

Kaze Tachinu
The Wind Rises

A FILM BY Hayao Miyazaki

ORIGINAL STORY AND SCREENPLAY: Hayao Miyazaki.
SUPERVISING ANIMATOR: Kitaro Kosaka. ART DIRECTION:
Yoji Takeshige. COLOR DESIGN: Michiyo Yasuda.
DIGITAL IMAGING: Atsushi Okui. MUSIC: Joe Hisaishi.
VOICE CAST: Hideaki Anno, Miori Takimoto,
Hidetoshi Nishijima, Masahiko Nishimura,
Stephen Alpert, Morio Kazama, Keiko
Takeshita, Mirai Shida, Jun Kunimura,
Shinobu Otake, Mansai Nomura. EXECUTIVE
PRODUCER: Koji Hoshino. PRODUCER: Toshio
Suzuki. PRODUCTION: Studio Ghibli, 126 min.,
mono, color, 1.85:1, DCP. RELEASE DATE (JAPAN):
July 20, 2013.

SHORT FILMS

1992
Sorairo no tane
The Blue Seed

A FILM BY Hayao Miyazaki. ORIGINAL STORY: Rieko Nakagawa. ORIGINAL ILLUSTRATIONS: Yuriko Omura. DIRECTING ANIMATOR: Yoshifumi Kondo. COLOR DESIGN: Michiyo Yasuda. CAMERA: Hisao Shirai, Motoaki Ikegami. MUSIC: Shigeru Nagata. PRODUCER: Toshio Suzuki. PRODUCTION: Studio Ghibli, 90 sec., stereo, color, 1.37:1. INITIAL BROADCAST DATE (JAPAN): December 23, 1992.

1995
On Your Mark

A FILM BY Hayao Miyazaki. ORIGINAL STORY AND SCREENPLAY: Hayao Miyazaki. SUPERVISING ANIMATOR: Masashi Ando. ART DIRECTION: Yoji Takeshige. COLOR DESIGN: Michiyo Yasuda. CAMERA SUPERVISOR: Atsushi Okui. MUSIC AND PERFORMANCE: Chage and Aska. PRODUCER: Toshio Suzuki. PRODUCTION: Studio Ghibli, 6 min., Dolby Digital, color, 1.85:1, 35mm. RELEASE DATE (JAPAN): July 15, 1995.

2001
Kujira-tori
The Whale Hunt

A FILM BY Hayao Miyazaki. ORIGINAL STORY: Rieko Nakagawa. ORIGINAL ILLUSTRATIONS: Yuriko Omura. SCREENPLAY: Hayao Miyazaki. DIRECTING ANIMATOR: Takeshi Inamura. ART DIRECTION: Sayaka Hirahara. COLOR SUPERVISOR: Michiyo Yasuda. DIGITAL IMAGING SUPERVISOR: Atsushi Okui. MUSIC: Yuji Nomi. VOICE CAST: Keito Ishihara, Shinsuke Nonaka. PRODUCER: Toshio Suzuki. PRODUCTION: Studio Ghibli, 16 min., DTS, color, 1.85:1, 35mm. RELEASE DATE (JAPAN): October 1, 2001 (Ghibli Museum, Mitaka).

2002
Koro no osanpo
Koro's Big Day Out

A FILM BY Hayao Miyazaki. ORIGINAL STORY AND SCREENPLAY: Hayao Miyazaki. DIRECTING ANIMATOR: Hideaki Yoshio. ART DIRECTION: Noboru Yoshida. COLOR SUPERVISOR: Michiyo Yasuda. DIGITAL IMAGING SUPERVISOR: Atsushi Okui. MUSIC: Yuji Nomi. PRODUCER: Toshio Suzuki. PRODUCTION: Studio Ghibli, 15 min., DTS, color, 1.85:1, 35mm. RELEASE DATE (JAPAN): January 3, 2002 (Ghibli Museum, Mitaka).

2002
Mei to Koneko Basu
Mei and the Baby Cat Bus

A FILM BY Hayao Miyazaki. ORIGINAL STORY AND SCREENPLAY: Hayao Miyazaki. DIRECTING ANIMATORS: Makiko Futaki, Sachiko Sugino, Hiromasa Yonebayashi. ART DIRECTION: Ryoko Ina. COLOR DESIGN: Michiyo Yasuda. DIGITAL IMAGING: Atsushi Okui. MUSIC: Joe Hisaishi. VOICE CAST: Chika Sakamoto, Hayao Miyazaki. PRODUCER: Toshio Suzuki. PRODUCTION: Studio Ghibli, 14 min., DTS, color, 1.85:1, 35mm. RELEASE DATE (JAPAN): September 29, 2002 (Ghibli Museum, Mitaka).

2002
Kuso no sora tobu kikaitachi
Imaginary Flying Machines

A FILM BY Hayao Miyazaki. ORIGINAL STORY AND SCREENPLAY: Hayao Miyazaki. SUPERVISING ANIMATOR: Hiromasa Yonebayashi. ART DIRECTION: Yoji Takeshige. COLOR DESIGN: Michiyo Yasuda. DIGITAL IMAGING: Atsushi Okui. MUSIC: Joe Hisaishi. NARRATION: Hayao Miyazaki. PRODUCER: Toshio Suzuki. PRODUCTION: Studio Ghibli, 6 min., Dolby SR, color, 1.37:1, 35mm. RELEASE DATE (JAPAN): October 1, 2002 (Ghibli Museum, Mitaka).

2006
Yadosagashi
House Hunting

A FILM BY Hayao Miyazaki. ORIGINAL STORY AND SCREENPLAY: Hayao Miyazaki. DIRECTING ANIMATOR: Katsuya Kondo. ART DIRECTION: Sayaka Hirahara. COLOR DESIGN: Michiyo Yasuda. DIGITAL IMAGING: Atsushi Okui. VOICE CAST: Tamori, Akiko Yano. PRODUCER: Toshio Suzuki. PRODUCTION: Studio Ghibli, 12 min., DTS/Dolby Digital, color, 1.85:1, 35mm. RELEASE DATE (JAPAN): January 3, 2006 (Ghibli Museum, Mitaka).

2006
Mizugumo Monmon
Mon Mon the Water Spider

A FILM BY Hayao Miyazaki. ORIGINAL STORY AND SCREENPLAY: Hayao Miyazaki. DIRECTING ANIMATOR: Atsuko Tanaka. ART DIRECTION: Yoichi Watanabe. COLOR DESIGN: Michiyo Yasuda. DIGITAL IMAGING: Atsushi Okui. MUSIC: Rio Yamase. VOICE CAST: Akiko Yano. PRODUCER: Toshio Suzuki. PRODUCTION: Studio Ghibli, 15 min., DTS/Dolby Digital, color, 1.85:1, 35mm. RELEASE DATE (JAPAN): January 3, 2006 (Ghibli Museum, Mitaka).

2006
Hoshi wo katta hi
The Day I Bought a Star

A FILM BY Hayao Miyazaki. ORIGINAL STORY: Naohisa Inoue. SCREENPLAY: Hayao Miyazaki. DIRECTING ANIMATOR: Megumi Kagawa. ART DIRECTION: Yohei Takamatsu. COLOR DESIGN: Michiyo Yasuda. DIGITAL IMAGING: Atsushi Okui. MUSIC: Norihiro Tsuru, Yuriko Nakamura. VOICE CAST: Ryunosuke Kamiki, Kyoka Suzuki, Yo Oizumi, Genzo Wakayama. PRODUCER: Toshio Suzuki. PRODUCTION: Studio Ghibli, 16 min., DTS/Dolby Digital, color, 1.85:1, 35mm. RELEASE DATE (JAPAN): January 3, 2006 (Ghibli Museum, Mitaka).

2010
Pandane to Tamago-hime
Mr. Dough and the Egg Princess

A FILM BY Hayao Miyazaki. ORIGINAL STORY AND SCREENPLAY: Hayao Miyazaki. SUPERVISING ANIMATOR: Kitaro Kosaka. ART DIRECTION: Yoji Takeshige. COLOR DESIGN: Michiyo Yasuda, Yukie Tamura. DIGITAL IMAGING: Atsushi Okui. MUSIC: Joe Hisaishi. PRODUCER: Toshio Suzuki. PRODUCTION: Studio Ghibli, 12 min., DTS/Dolby Digital, color, 1.85:1, 35mm. RELEASE DATE (JAPAN): November 20, 2010 (Ghibli Museum, Mitaka).

2018
Kemushi no Boro
Boro the Caterpillar

A FILM BY Hayao Miyazaki. ORIGINAL STORY AND SCREENPLAY: Hayao Miyazaki. SUPERVISING ANIMATOR: Takeshi Honda. CG SUPERVISOR: Yukinori Nakamura. ART DIRECTION: Yoji Takeshige, Noboru Yoshida. COLOR DESIGN: Fumiko Numahata. DIGITAL IMAGING: Atsushi Okui. MUSIC: Joe Hisaishi. VOICE AND SOUND EFFECTS: Tamori. PRODUCER: Toshio Suzuki. PRODUCTION: Studio Ghibli, 14 min., 1.1 ch, color, 1.85:1, DCP. RELEASE DATE (JAPAN): March 21, 2018 (Ghibli Museum, Mitaka).

STUDIO GHIBLI
FEATURE FILMS

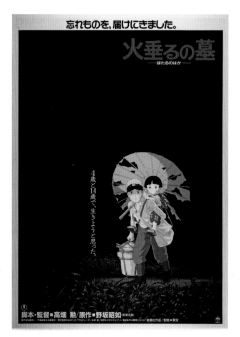

1988
Hotaru no haka
Grave of the Fireflies

A FILM BY Isao Takahata. ORIGINAL STORY:
Akiyuki Nosaka. SCREENPLAY: Isao Takahata.
CHARACTER DESIGN AND SUPERVISING ANIMATOR:
Yoshifumi Kondo. LAYOUT DESIGN: Yoshiyuki
Momose. ART DIRECTION: Nizo Yamamoto.
COLOR DESIGN: Michiyo Yasuda. CAMERA SUPERVISOR:
Nobuo Koyama. MUSIC: Michio Mamiya.
VOICE CAST: Tsutomu Tatsumi, Ayano Shiraishi.
PRODUCER: Toru Hara. PRODUCTION: Studio Ghibli,
88 min., Dolby Stereo, color, 1.85:1,
35mm. RELEASE DATE (JAPAN): April 16, 1988.

1991
Omoide Poro Poro
Only Yesterday

A FILM BY Isao Takahata. ORIGINAL COMIC: Hotaru
Okamoto, Yuko Tone. SCREENPLAY: Isao
Takahata. CHARACTER DESIGN: Yoshifumi Kondo.
LAYOUT AND STORYBOARD DESIGN: Yoshiyuki Momose.
SUPERVISING ANIMATORS: Yoshifumi Kondo,
Katsuya Kondo, Yoshiharu Sato. ART
DIRECTION: Kazuo Oga. COLOR DESIGN: Michiyo
Yasuda. CAMERA SUPERVISOR: Hisao Shirai.
MUSIC: Katz Hoshi. VOICE CAST: Miki Imai,
Toshiro Yanagiba. PRODUCER: Toshio Suzuki.
GENERAL PRODUCER: Hayao Miyazaki. PRODUCTION:
Studio Ghibli, 119 min., Dolby Stereo,
color, 1.85:1, 35mm. RELEASE DATE (JAPAN):
July 20, 1991.

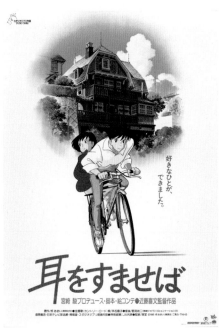

1994
Heisei tanuki gassen ponpoko
Pom Poko

A FILM BY Isao Takahata. PLANNING: Hayao Miyazaki. ORIGINAL STORY AND SCREENPLAY: Isao Takahata. LAYOUT DESIGN: Yoshiyuki Momose. CHARACTER DESIGN: Shinji Otsuka. SUPERVISING ANIMATORS: Shinji Otsuka, Megumi Kagawa. ART DIRECTION: Kazuo Oga. COLOR DESIGN: Michiyo Yasuda. CAMERA SUPERVISOR: Atsushi Okui. MUSIC: Koryu, Manto Watanobe, Yoko Ino, Masaru Goto (Shang Shang Typhoon), Ryojiro Furusawa. VOICE CAST: Shincho Kokontei, Makoto Nonomura, Yuriko Ishida, Norihei Miki, Nijiko Kiyokawa, Shigeru Izumiya, Gannosuke Ashiya, Takehiro Murata, Kobuhei Hayashiya, Akira Fukuzawa, Yorie Yamashita, Beicho Katsura, Bunshi Katsura, Kosan Yanagiya. PRODUCER: Toshio Suzuki. PRODUCTION: Studio Ghibli, 119 min., Dolby Stereo, color, 1.85:1, 35mm. RELEASE DATE (JAPAN): July 16, 1994.

1995
Mimi wo Sumaseba
Whisper of the Heart

A FILM BY Yoshifumi Kondo. ORIGINAL COMIC: Aoi Hiiragi. SCREENPLAY AND STORYBOARD: Hayao Miyazaki. SUPERVISING ANIMATOR: Kitaro Kosaka. ART DIRECTION: Satoshi Kuroda. COLOR DESIGN: Michiyo Yasuda. CAMERA SUPERVISOR: Atsushi Okui. MUSIC: Yuji Nomi. VOICE CAST: Yoko Honna, Issei Takahashi, Takashi Tachibana, Shigeru Muroi, Shigeru Tsuyuguchi, Keiju Kobayashi. PRODUCER: Toshio Suzuki. GENERAL PRODUCER: Hayao Miyazaki. PRODUCTION: Studio Ghibli, 111 min., Dolby Digital, color, 1.85:1, 35mm. RELEASE DATE (JAPAN): July 15, 1995.

1999
Ho-hokekyo tonari no Yamada-kun
My Neighbors the Yamadas

A FILM BY Isao Takahata. ORIGINAL COMIC STRIP: Hisaichi Ishii. SCREENPLAY: Isao Takahata. ASSOCIATE DIRECTORS: Osamu Tanabe, Yoshiyuki Momose. SUPERVISING ANIMATOR: Kenichi Konishi. ART DIRECTION: Naoya Tanaka, Yoji Takeshige. COLOR DESIGN: Michiyo Yasuda. DIGITAL IMAGING: Atsushi Okui. MUSIC: Akiko Yano. VOICE CAST: Yukiji Asaoka, Toru Masuoka, Masako Araki, Hayato Isohata, Naomi Uno. PRODUCER: Toshio Suzuki. PRODUCTION: Studio Ghibli, 104 min., Dolby Digital/DTS, color, 1.85:1, 35mm. RELEASE DATE (JAPAN): July 17, 1999.

2002
Neko no ongaeshi
The Cat Returns

A FILM BY Hiroyuki Morita. PROJECT CONCEPT: Hayao Miyazaki. ORIGINAL MANGA: Aoi Hiiragi. SCREENPLAY: Reiko Yoshida. CHARACTER AND LAYOUT DESIGN: Satoko Morikawa. SUPERVISING ANIMATORS: Ei Inoue, Kazutaka Ozaki. ART DIRECTION: Naoya Tanaka. COLOR DESIGN: Osamu Misaka. DIGITAL IMAGING: Kentaro Takahashi. MUSIC: Yuji Nomi. VOICE CAST: Chizuru Ikewaki, Yoshihiko Hakamada, Aki Maeda, Takayuki Yamada, Hitomi Sato, Kenta Satoi, Mari Hamada, Tetsu Watanabe, Yosuke Saito, Kumiko Okae, Tetsuro Tanba. GENERAL PRODUCERS: Toshio Suzuki, Nozomu Takahashi. PRODUCTION: Studio Ghibli, 75 min., Dolby Digital/DTS, color, 1.85:1, 35mm/DCP. RELEASE DATE (JAPAN): July 20, 2002.

2006
Gedo Senki
Tales from Earthsea

A FILM BY Goro Miyazaki. BASED ON THE "EARTHSEA" SERIES BY Ursula K. Le Guin. INSPIRED BY THE GRAPHIC NOVEL *SHUNA'S JOURNEY* BY Hayao Miyazaki. SCREENPLAY: Goro Miyazaki, Keiko Niwa. DIRECTOR OF ANIMATION: Akihiko Yamashita. SUPERVISING ANIMATOR: Takeshi Inamura. ART DIRECTION: Yoji Takeshige. COLOR DESIGN: Michiyo Yasuda. DIGITAL IMAGING: Atsushi Okui. MUSIC: Tamiya Terashima. VOICE CAST: Junichi Okada, Aoi Teshima, Yuko Tanaka, Teruyuki Kagawa, Jun Fubuki, Takashi Naito, Mitsuko Baisho, Yui Natsukawa, Kaoru Kobayashi, Bunta Sugawara. PRODUCER: Toshio Suzuki. PRODUCTION: Studio Ghibli, 115 min., Dolby Digital Surround EX/DTS-ES, color, 1.85:1, 35mm/DCP. RELEASE DATE (JAPAN): July 29, 2006.

2010
Karigurashi no Arrietty
The Secret World of Arrietty (Arrietty)

A FILM BY Hiromasa Yonebayashi. PLANNING: Hayao Miyazaki. BASED ON *THE BORROWERS* BY Mary Norton. SCREENPLAY: Hayao Miyazaki, Keiko Niwa. SUPERVISING ANIMATORS: Megumi Kagawa, Akihiko Yamashita. ART DIRECTION: Yoji Takeshige, Noboru Yoshida. COLOR DESIGN: Naomi Mori. DIGITAL IMAGING: Atsushi Okui. MUSIC: Cécile Corbel. VOICE CAST: Mirai Shida, Ryunosuke Kamiki, Shinobu Otake, Keiko Takeshita, Tatsuya Fujiwara, Tomokazu Miura, Kirin Kiki. PRODUCER: Toshio Suzuki. EXECUTIVE PRODUCER: Koji Hoshino. PRODUCTION: Studio Ghibli, 94 min., Dolby Digital/DTS, color, 1.85:1, 35mm/DCP. RELEASE DATE (JAPAN): July 17, 2010.

2011

Kokuriko-zaka kara
From Up on Poppy Hill

A FILM BY Goro Miyazaki. PLANNING: Hayao Miyazaki. BASED ON THE GRAPHIC NOVEL BY Chizuru Takahashi, Tetsuro Sayama. SCREENPLAY: Hayao Miyazaki, Keiko Niwa. CHARACTER DESIGN: Katsuya Kondo. SUPERVISING ANIMATORS: Atsushi Yamagata, Shunsuke Hirota, Kitaro Kosaka, Takeshi Inamura, Akihiko Yamashita. ART DIRECTION: Noboru Yoshida, Kamon Oba, Yohei Takamatsu, Takashi Omori. COLOR DESIGN: Naomi Mori, Kanako Takayanagi. DIGITAL IMAGING: Atsushi Okui. MUSIC: Satoshi Takebe. VOICE CAST: Masami Nagasawa, Junichi Okada, Keiko Takeshita, Yuriko Ishida, Rumi Hiiragi, Jun Fubuki, Takashi Naito, Shunsuke Kazama, Nao Omori, Teruyuki Kagawa. PRODUCER: Toshio Suzuki. EXECUTIVE PRODUCER: Koji Hoshino. PRODUCTION: Studio Ghibli, 91 min., Dolby Digital/DTS 5.0 ch, color, 1.85:1, 35mm/DCP. RELEASE DATE (JAPAN): July 16, 2011.

2013

Kaguyahime no monogatari
The Tale of The Princess Kaguya

A FILM BY Isao Takahata. BASED ON THE JAPANESE FOLKTALE "THE TALE OF THE BAMBOO CUTTER." ORIGINAL CONCEPT: Isao Takahata. SCREENPLAY: Isao Takahata, Riko Sakaguchi. CHARACTER DESIGN AND DIRECTING ANIMATOR: Osamu Tanabe. SUPERVISING ANIMATOR: Kenichi Konishi. ART DIRECTION: Kazuo Oga. COLOR SETTING: Yukiko Kakita. DIGITAL IMAGING: Keisuke Nakamura. MUSIC: Joe Hisaishi. VOICE CAST: Aki Asakura, Kengo Kora, Takeo Chii, Nobuko Miyamoto. PLANNING: Toshio Suzuki. PRODUCER: Yoshiaki Nishimura. GENERAL PRODUCER: Koji Hoshino. PRODUCTION: Studio Ghibli, 137 min., 5.1 ch, color, 1.85:1, DCP. RELEASE DATE (JAPAN): November 23, 2013.

2014

Omoide no Marnie
When Marnie Was There

A FILM BY Hiromasa Yonebayashi. BASED ON THE NOVEL *WHEN MARNIE WAS THERE* BY Joan G. Robinson. SCREENPLAY: Keiko Niwa, Masashi Ando, Hiromasa Yonebayashi. SUPERVISING ANIMATOR: Masashi Ando. PRODUCTION DESIGNER: Yohei Taneda. COLOR DESIGN: Yuki Kashima. DIGITAL IMAGING: Atsushi Okui. MUSIC: Takatsugu Muramatsu. VOICE CAST: Sara Takatsuki, Kasumi Arimura, Nanako Matsushima, Susumu Terajima, Toshie Negishi, Ryoko Moriyama, Kazuko Yoshiyuki, Hitomi Kuroki. PRODUCER: Yoshiaki Nishimura. GENERAL PRODUCER: Koji Hoshino. EXECUTIVE PRODUCER: Toshio Suzuki. PRODUCTION: Studio Ghibli, 103 min., 5.0 ch, color, 1.85:1, DCP. RELEASE DATE (JAPAN): July 19, 2014.

2016
La tortue rouge
The Red Turtle

A FILM BY Michael Dudok de Wit. ORIGINAL STORY AND SCREENPLAY: Michael Dudok de Wit. ADAPTATION: Pascale Ferran, Michael Dudok de Wit. DESIGN: Michael Dudok de Wit. ANIMATION SUPERVISOR: Jean-Christophe Lie. BACKGROUND SUPERVISOR: Julien De Man. COMPOSITING SUPERVISORS: Jean-Pierre Bouchet, Arnaud Bois. MUSIC: Laurent Perez Del Mar. ARTISTIC PRODUCER: Isao Takahata. PRODUCERS: Toshio Suzuki, Vincent Maraval. PRODUCTION: Prima Linea Productions, 81 min., 5.1 ch, color, 1.85:1, DCP. RELEASE DATE (JAPAN): September 17, 2016.

2021
Aya to Majo
Earwig and the Witch

A FILM BY Goro Miyazaki. BASED ON THE NOVEL BY Diana Wynne Jones. PLANNING: Hayao Miyazaki. SCREENPLAY: Keiko Niwa, Emi Gunji. CHARACTER DESIGN: Katsuya Kondo. CG SUPERVISOR: Yukinori Nakamura. ANIMATION SUPERVISOR: Tan Se Ri. ART DIRECTION: Yuhki Takeuchi. MUSIC: Satoshi Takebe. VOICE CAST: Shinobu Terajima, Etsushi Toyokawa, Gaku Hamada, Kokoro Hirasawa. PRODUCER: Toshio Suzuki. EXECUTIVE PRODUCERS: Isao Yoshikuni, Keisuke Tsuchihashi, Koji Hoshino, Kiyofumi Nakajima. PRODUCTION: Studio Ghibli, 82 min., 5.1 ch, color, 1.85:1, DCP.

NHK broadcast poster

SHORT FILMS/TELEVISION

1993
Umi ga kikoeru
Ocean Waves

A FILM BY Tomomi Mochizuki. ORIGINAL STORY: Saeko Himuro. SCREENPLAY: Kaori Nakamura. CHARACTER DESIGN AND SUPERVISING ANIMATOR: Katsuya Kondo. ART DIRECTION: Naoya Tanaka. COLOR DESIGN: Yumi Furuya. CAMERA SUPERVISOR: Atsushi Okui. MUSIC: Shigeru Nagata. PRODUCER: Nozomu Takahashi. PLANNING: Toshio Suzuki, Seiji Okuda. PRODUCTION: The Future Producers of Studio Ghibli, 72 min., stereo, color, 1.85:1, 35mm. BROADCAST DATE (JAPAN): May 5, 1993.

2002
Giburi-zu Episode 2
The GHIBLIES episode 2

A FILM BY Yoshiyuki Momose. ORIGINAL CHARACTER DESIGN: Toshio Suzuki. SPECIAL CHARACTER DESIGN: Hisaichi Ishii. SCREENPLAY: Yoshiyuki Momose. ART DIRECTION: Noboru Yoshida. COLOR DESIGN: Michiyo Yasuda. DIGITAL IMAGING: Atsushi Okui. MUSIC: Manto Watanobe. PRODUCER: Hiroyuki Watanabe. GENERAL PRODUCERS: Toshio Suzuki, Nozomu Takahashi. PRODUCTION: Studio Ghibli, 25 min., Dolby Digital/DTS, color, 1.85:1, 35mm/DCP. RELEASE DATE (JAPAN): July 20, 2002.

2010
Chu Zumo
A Sumo Wrestler's Tail

A FILM BY Akihiko Yamashita. BASED ON A JAPANESE FOLKTALE. PLANNING AND SCREENPLAY: Hayao Miyazaki. ART DIRECTION: Naoya Tanaka. COLOR DESIGN: Yukie Tamura. DIGITAL IMAGING: Junji Yabuta. MUSIC: Manto Watanobe. PRODUCER: Toshio Suzuki. PRODUCTION: Studio Ghibli, 13 min., DTS/Dolby Digital, color, 1.85:1, 35mm. RELEASE DATE (JAPAN): January 3, 2010 (Ghibli Museum, Mitaka).

2011
Takarasagashi
Treasure Hunting

ORIGINAL STORY: Rieko Nakagawa. ORIGINAL ILLUSTRATIONS: Yuriko Omura. PLANNING AND ADAPTATION: Hayao Miyazaki. DIRECTING ANIMATOR: Takeshi Inamura. ART DIRECTION: Naomi Kasugai. COLOR DESIGN: Hiromi Takahashi, Eiko Matsushima. DIGITAL IMAGING: Atsushi Okui. MUSIC: MICHIRU. PRODUCER: Toshio Suzuki. PRODUCTION: Studio Ghibli, 9 min., DTS/Dolby Digital, color, 1.85:1, 35mm. RELEASE DATE (JAPAN): June 4, 2011 (Ghibli Museum, Mitaka).

SELECTED CHRONOLOGY

1941 —— Hayao Miyazaki, is born January 5, Bunkyo Ward, Tokyo.

1943 —— The Miyazaki family moves to Utsunomiya City where Miyazaki Airplane Corporation is established.

1945 —— Utsunomiya City is bombed in the final weeks of World War II, and the family is evacuated to Kanuma City.

1947–52 —— Attends elementary school. Becomes an avid reader of Tetsuji Fukushima's science-fiction manga serial Devil of the Desert (Sabaku no mao).

1953–55 —— Attends middle school. Frequents the cinema, sometimes with his father, and sees two realist films about postwar Japanese society that will later stand out in his memory: Repast (Meshi, Japan, 1951), directed by Mikio Naruse, and Twilight Saloon (Tasogare sakaba, Japan, 1955), directed by Tomu Uchida.

1956–58 —— While attending high school, begins to actively pursue drawing studies, wanting to become a manga artist. Develops an interest in animation after seeing Japan's first color animated feature film, Panda and the Magic Serpent (Hakujaden, 1958), directed by Taiji Yabushita.

1959 —— Enters Gakushuin University, Tokyo. Studies political science and economics with a focus on Japanese industrial theory. Joins children's literature club. Begins drawing manga. Accumulates several thousand pages of story ideas and approaches manga publishers specializing in kashihon'ya, the rental library market.

1960 —— Witnesses and develops interest in demonstrations against the renewal of the Treaty of Mutual Cooperation and Security between the United States and Japan.

1963 —— Graduates from Gakushuin University. Hired at Toei Animation in Tokyo as an in-between animator. His first project is the feature film Doggie March. Works on the television series Ken, the Wolf Boy.

1964 —— Works as key animator on the television series Fujimaru of the Wind and as in-between animator on the feature film Gulliver's Travels beyond the Moon. Becomes general secretary of Toei's labor union. Isao Takahata serves as vice chair.

1965 —— Marries fellow Toei animator Akemi Ota. During preproduction for Little Norse Prince Valiant, draws the character Iwaotoko. Takahata directs the film as his first full-length animated feature and focuses on social and political issues rarely shown in animation.

1966 —— Continues working on scene design and key animation for Little Norse Prince Valiant. Contributes as key animator on the television series Robin in the Rainbow Troops.

1967 —— First son, Goro, is born in January.

1968 —— Works as key animator on the television series Sally the Witch. Takahata's Little Norse Prince Valiant is released in theaters.

1969 —— Second son, Keisuke, is born in April. Under the pseudonym Saburo Akitsu, publishes the manga People of the Desert (Sabaku no Tami) in weekly installments in the youth newspaper Shonen shojo shinbun.

1971 —— Departs Toei for A Production along with Takahata and animator Yoichi Kotabe. Preproduction begins on a never-realized television series based on the book Pippi Longstocking; a research trip to Sweden includes location scouting on the island of Gotland, where the live-action film had been shot, but a meeting with author Astrid Lindgren does not happen. Codirects with Takahata the television series Lupin the 3rd.

1972 —— Directs the pilot project Yuki's Sun. Works in multiple roles on Takahata's mid-length feature film Panda! Go Panda! Creates storyboards for the television series Little Samurai.

1973 —— Leaves A Production to work at Zuiyo Enterprise, again with Takahata and Kotabe. Scouts locations in Switzerland during preproduction for Takahata's animated television series Heidi, Girl of the Alps. Works as screenwriter, scene designer, layout artist, and key animator on the sequel Panda! Go Panda! Rainy Day Circus.

1974 —— Creates layouts and scene designs for all episodes of Heidi, Girl of the Alps.

1975 —— Contributes as key animator on the television series Dog of Flanders. Prepares for the television series From the Apennines to the Andes, directed by Takahata, traveling to Italy and Argentina to scout locations. Begins work at Nippon Animation, which is established by former staff of Zuiyo Enterprise.

1976 —— Creates layouts and scene designs for From the Apennines to the Andes.

1977 — Works as key animator on the television series Rascal the Raccoon. Embarks on his first directorial work to go into production, the animated television series Future Boy Conan.

1978 — Future Boy Conan airs on Japan's national broadcasting service, NHK.

1979 — Works as scene designer and layout artist for Takahata's television series Anne of Green Gables. Joins Telecom Animation Film to direct his first feature film, Lupin the 3rd: The Castle of Cagliostro, which opens in theaters at year's end.

1980 — Trains new employees at Telecom Animation Film. Under the pseudonym Tsutomu Teruki works on two episodes of the second Lupin the 3rd television series. Begins drawing imageboards for what will become Princess Mononoke and My Neighbor Totoro many years later.

1981 — Tries to adapt the comic book Rowlf by Richard Corben but is unable to secure the rights. Participates in planning a feature film based on Winsor McCay's comic strip Little Nemo in Slumberland but leaves before the project is completed; it is eventually released as Little Nemo: Adventures in Slumberland in 1989. Travels to the United States and Italy prior to directing the animated television series Sherlock Hound. The Japanese anime magazine Animage, published by Tokuma Shoten, devotes a full issue to Miyazaki.

1982 — Publishes Nausicaä of the Valley of the Wind as a manga serial starting in the February issue of Animage, collaborating with Animage editor Toshio Suzuki. Resigns from Telecom Animation Film.

1983 — Starts production of the animated version of Nausicaä of the Valley of the Wind at Top Craft studio. Publishes the illustrated story Shuna's Journey (Shuna no Tabi) with Tokuma Shoten under its Animage Bunko imprint.

1984 — Nausicaä of the Valley of the Wind premieres theatrically in March along with two episodes of Sherlock Hound. Opens his own office, Nibariki. With Takahata begins production on the feature-length documentary The Story of Yanagawa Waterways (Yanagawa horiwari monogatari).

1985 — The newly founded Studio Ghibli opens its offices in Kichijoji, Musashino City, Tokyo. Preproduction starts on Castle in the Sky with location scouting in England and Wales.

1986 — Castle in the Sky is released in theaters in August along with two episodes of Sherlock Hound.

1987 — At Studio Ghibli, preproduction starts on My Neighbor Totoro and Takahata's Grave of the Fireflies.

1988 — My Neighbor Totoro is released in April as a Studio Ghibli double bill with Grave of the Fireflies. Joins the production of Kiki's Delivery Service as director.

1989 — In July, Kiki's Delivery Service opens in theaters.

1990 — Publishes The Age of the Flying Boat (Hikotei jidai), the manga precursor to Porco Rosso, in the March–May issues of Model Graphix magazine as part of its long-running series Hayao Miyazaki's Daydream Notes (Miyazaki Hayao no Zasso noto).

1991 — Produces the Takahata-directed feature film Only Yesterday. Begins preproduction on Porco Rosso, originally planned as an in-flight film for Japan Airlines. Publishes the illustrated collection of essays The House Where Totoro Lives (Totoro no sumu ie) with Asahi Shimbun Sha.

1992 — Porco Rosso is released in theaters in July. Studio Ghibli's new headquarters open in Koganei City, Tokyo, based on Miyazaki's basic architectural plans.

1993 — The Studio Ghibli film Ocean Waves, directed by Tomomi Mochizuki, is broadcast on Nippon Television (NTV).

1994 — Publishes final chapter of Nausicaä of the Valley of the Wind manga in March issue of Animage. Works on planning the feature film Pom Poko, directed by Takahata, which opens in theaters in July.

1995 — Finalizes project proposal for Princess Mononoke, begins drawing storyboards, and travels with staff to Yakushima Island for location scouting. In Japanese theaters, the promotional music film for the song "On Your Mark" by rock duo Chage and Aska accompanies the Studio Ghibli film Whisper of the Heart, directed by Yoshifumi Kondo and written and produced by Miyazaki.

1996 — Publishes the collection of essays Starting Point: 1979–1996 (Shuppatsu Ten: 1979–1996) with Tokuma Shoten.

1997 — Princess Mononoke is released in theaters in July. The film wins best picture at the Japanese Academy Awards.

1998 — Travels to the Sahara Desert to retrace the activities of the aviator and writer Antoine de Saint-Exupéry, author of The Little Prince. Forms and leads the workshop Higashi Koganei Sonjuku II for the instruction of emerging animation directors. Begins conceptualizing and planning the construction of a museum dedicated to Studio Ghibli in Tokyo's Inokashira Onshi Park. Publishes first chapter of the manga Tiger in the Mire (Doromamire no Tora) in the December issue of Model Graphix.

1999 — Completes project proposal for Spirited Away. Takahata's My Neighbors the Yamadas debuts in theaters in July.

2000 — Yasuyoshi Tokuma, founder and president of Tokuma Shoten, Studio Ghibli's parent company, dies on September 20.

2001 — Spirited Away breaks box-office records in Japan. Acts as executive director—credited with the original concept and planning, and as a producer—of the newly opened Ghibli Museum, Mitaka, where his short film The Whale Hunt premieres.

2002 — Spirited Away wins the Golden Bear for best film at the 52nd Berlin International Film Festival. Miyazaki visits Pixar Animation Studios in the US. The exhibition "Castle in the Sky" and Imaginary Science Fiction Machines opens at the Ghibli Museum, Mitaka, and Imaginary Flying Machines screens in conjunction. The museum debuts the short films Koro's Big Day Out and Mei and the Baby Cat Bus; the latter is a sequel to My Neighbor Totoro. Preproduction begins on Howl's Moving Castle, based on the novel by Diana Wynne Jones. Studio Ghibli releases the feature film The Cat Returns, directed by Hiroyuki Morita, and the short film The GHIBLIES episode 2, directed by Yoshiyuki Momose, in theaters.

2003 — Spirited Away wins the Oscar® for Best Animated Feature Film at the 75th Academy Awards®.

2004 — Howl's Moving Castle wins the Osella Award at the 61st Venice International Film Festival. Visits Aardman Animations studio in the United Kingdom.

2005 — Named one of Time magazine's "100 Most Influential People" of the year. Receives the Golden Lion for Lifetime Achievement at the 62nd Venice International Film Festival and a Japan Foundation Award. Studio Ghibli becomes independent from Tokuma Shoten. Organizes Heidi, Girl of the Alps exhibition at the Ghibli Museum, Mitaka.

2006 — Begins preproduction on Ponyo. The short films House Hunting, Mon Mon the Water Spider, and The Day I Bought a Star premiere at the Ghibli Museum, Mitaka. The Studio Ghibli film Tales from Earthsea, directed by Goro Miyazaki and partially inspired by his father's manga Shuna's Journey, is released in theaters.

2007 — The Three Bears exhibition, planned and designed by Miyazaki, debuts at the Ghibli Museum, Mitaka, in May.

2008 — Designs and starts the preschool Sanbiki no Kuma no ie, or "House of the Three Bears," for the children of Studio Ghibli employees. Ponyo premieres theatrically in July.

2009 — At Toyota Motor Corporation headquarters in Toyota City, opens Ghibli West to train new Studio Ghibli recruits.

2010 — Works on planning and screenplay for the Studio Ghibli film The Secret World of Arrietty, directed by Hiromasa Yonebayashi, which is released in theaters in July. The short film Mr. Dough and the Egg Princess and another, A Sumo Wrestler's Tail, directed by Akihiko Yamashita from Miyazaki's planning and screenplay, premiere at the Ghibli Museum, Mitaka.

2011 — The short film Treasure Hunting, adapted by Miyazaki from an original story by Rieko Nakagawa, premieres at the Ghibli Museum, Mitaka. The Studio Ghibli film From Up on Poppy Hill, directed by Goro Miyazaki, is released in theaters.

2012 — Honored as a Person of Cultural Merit by the Japanese government.

2013 — Enters official retirement from feature filmmaking after The Wind Rises opens in theaters in July. The documentary The Kingdom of Dreams and Madness (Yume to kyoki no okoku), directed by Mami Sunada, follows Miyazaki, Takahata, and Suzuki during two Studio Ghibli film productions. Takahata's last feature film, The Tale of The Princess Kaguya, is released in theaters in November.

2014 — The Wind Rises is nominated for an Academy Award for Best Animated Feature Film. Miyazaki receives an Honorary Academy Award at the 6th Annual Governors Awards. The Studio Ghibli film When Marnie Was There, directed by Hiromasa Yonebayashi, opens in theaters.

2016 — Never-Ending Man: Hayao Miyazaki (Owaranai hito: Miyazaki Hayao), a documentary directed by Kaku Arakawa about the making of Boro the Caterpillar, Miyazaki's eighth short for the Ghibli Museum, Mitaka, airs on NHK. The Studio Ghibli coproduction The Red Turtle, directed by Michael Dudok de Wit, opens in theaters.

2017 — Leaves retirement to direct the feature film Kimitachi wa do ikiruka (How Will You Live?).

2018 — Boro the Caterpillar premieres at the Ghibli Museum, Mitaka, in March. Studio Ghibli cofounder and director Isao Takahata passes away on April 5.

2020 — Studio Ghibli makes its film catalogue available on streaming platforms outside of Japan for the first time. Release date announced for the Studio Ghibli film Earwig and the Witch, directed by Goro Miyazaki.

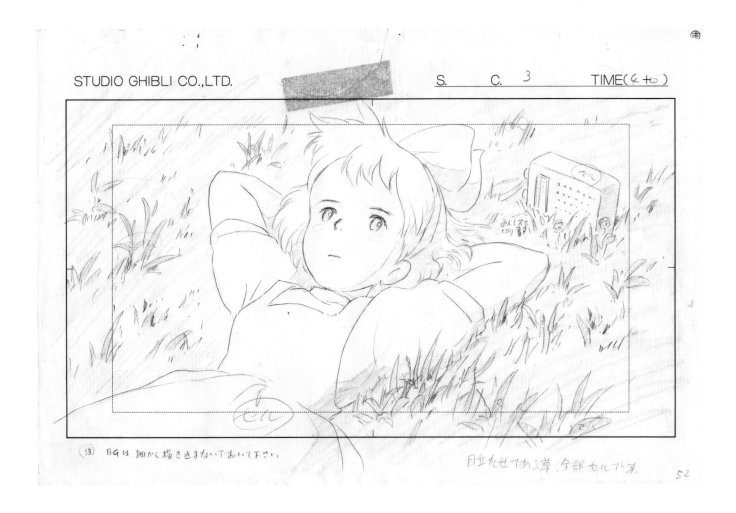

STUDIO GHIBLI CO.,LTD. S. C. 3 TIME()

Kiki's Delivery Service layout drawing
(Kiki on the grassy knoll with transistor radio)

GLOSSARY

ANIME: the Japanese term for animation. In the West, anime is generally used to describe a type of Japanese animation known for its stylized and colorful art.

ART DIRECTION: the development of art exploring the visual style for the film.

BACKGROUND: hand-painted art, most often depicting landscapes or interiors, that serves as the setting for the action. Poster color is the paint most commonly used for Studio Ghibli's backgrounds.

CEL: short for celluloid, a clear plastic sheet onto which animation drawings, such as characters and foreground elements, are transferred and then painted.

CGI: short for computer-generated imagery, the use of digital tools for photography, color, paint, and special effects. Generally, when Studio Ghibli uses CGI, it is to enhance the hand-drawn look.

CHARACTER DESIGN: the development of animated characters through drawings to test how they will appear on screen. Usually undertaken at Studio Ghibli by the supervising animator, who renders different poses, facial types, proportions, gestures, and expressions based on Miyazaki's imageboards.

COLOR DESIGN: the development of a color palette for the characters, with color specifications given for each scene.

DOUBLE EXPOSURE: also known as daburashi, a filming technique that combines two underexposed images in a single frame. At Studio Ghibli, it is used to bring out transparent elements such as smoke.

FOLLOW: a filming technique in which the subject in motion remains parallel to the camera with the background or foreground moving instead.

FOLLOW PAN: a filming technique, called tsuke pan, that conveys a camera that swivels while tracking its subject from a fixed distance.

FOREGROUND: also known as book, a group of drawings, on cel or paper, layered onto the background as additional elements of a setting.

FRAME: a single still image within a moving picture. Most Japanese animation studios, including Studio Ghibli, animate "on threes," meaning they produce eight unique drawings for every 24 frames (or one second) of film.

GHIBLI: a dry, hot wind of the Sahara Desert. Also the name of a twin-engine Italian aircraft used for reconnaissance during World War II (the Caproni Ca.309 Ghibli).

HARMONY: a method of drawing the texture of background art onto the cel in order to give dimensionality to otherwise flat images.

IMAGEBOARD: a concept sketch that describes the visual style and story of the film. Miyazaki's original imageboards show his initial ideas for characters, plot, and settings; Studio Ghibli staff refer to these imageboards throughout production for guidance and inspiration. They are expanded on by the art director, who creates the production imageboards; these provide instruction to the background art staff, communicating the color palette and other details of each scene.

IN-BETWEEN ANIMATION: drawings that fill in the gaps between key animation frames, completing a sequence.

INK AND PAINT: the department that colors each frame according to the color design specifications, either by hand or with a computer.

KEY ANIMATION: drawings that depict primary phases of motion. The intermediate steps between these essential frames are finished by in-between animators.

LAYOUT: drawings that indicate the composition of a scene, including the characters and their relationship to the background, camera movement, and special effects. At Studio Ghibli, these are usually created by the key animator based on Miyazaki's storyboard.

MANGA: a Japanese comic or graphic novel.

MULTI-PLANE: typically shortened to multi, a filming technique that creates the illusion of spatial depth by separating the cel and/or paper elements of a scene. The space between these parallel layers, or planes, can be increased or decreased to bring certain elements into or out of focus during filming. For a close (micchaku) multi, the layers are only minimally separated, and all elements appear in equal focus.

PAN: a filming technique that conveys a camera's swivel-style movement horizontally or vertically over the background from a fixed position.

PHOTOGRAPHY: the process of shooting animation cels, books, and backgrounds. Elements may then be digitally composited.

PRODUCTION DESIGN: the development of reference drawings for a film's background art, including buildings and landscapes, produced at Studio Ghibli by the art director in pencil and/or ink.

STORYBOARD: the visual annotated blueprint for an entire film. Miyazaki draws every scene by hand on storyboard paper, adding notes for Studio Ghibli staff about plot, characters, settings, scene composition, dialogue, sound effects, timing, and camera movement.

TRACK UP/BACK: a filming technique that replicates the effect of a live-action zoom by moving oversize production materials toward or away from the camera.

TRANSMITTED LIGHT: a special effect, called *thoka-kou*, that backlights a drawing for photography. Elements in the drawing can thus appear to emit light.

ACKNOWLEDGMENTS

It is always wonderful to collaborate closely with filmmakers—to gain insights into their thinking, their processes, and the things they value most—but the opportunity to present an exhibition of the work of Hayao Miyazaki has been truly exceptional. It has been a great honor to meet such a visionary filmmaker and to develop this exhibition with his team. His films, writings, and philosophy have taught me so much about life. Through his oeuvre, I have personally rediscovered the profound joy of embracing the beauty of this world, even in challenging times. **Domo arigato, Miyazaki-san!**

I am immensely grateful that Studio Ghibli joined us as partners in this exhibition, contributing in bountiful ways: through loans, advice, feedback, and, best of all, meaningful conversations. They opened their doors, let us in, and showed us what they are all about. I wish to respectfully thank Toshio Suzuki, producer and executive director of Studio Ghibli, who made this project possible and provided such a felicitous foreword, and also Koji Hoshino, chairman of Studio Ghibli. Both were consistent advocates of our project, and I am very grateful for their support over the years. I am deeply indebted to the entire Ghibli team, especially Mikiko Takeda, who perceptively translated my ideas to her colleagues and built bridges between cultures in the project's early days. From the beginning, Takayuki Aoki was an essential team member, and Nao Amisaki and Fumi Matsushima joined him as our main contacts and advisers. Their knowledge and expertise advanced the project and enhanced its quality significantly.

The opportunity to interview key production staff at Ghibli—Shinsuke Nonaka, Kitaro Kosaka, Yoji Takeshige, Atsushi Okui, and Tamaki Kojo—was a remarkable privilege. They shared their experiences of working with Miyazaki and showed us how films are made at Studio Ghibli. Special recognition also goes to Kazuki Anzai and the team at the Ghibli Museum, Mitaka. I also thank Shin Hashida for his part in the project and for the incredible moments of deliciousness he created by regularly presenting seasonal treats at our tea breaks.

The journey to opening the first film museum in Los Angeles has been unforgettable. The planning and organization of **Hayao Miyazaki**, the Academy Museum's first temporary exhibition, was a momentous task made possible by the vision and hard work of many individuals, only some of whom are named here. For their ongoing support and faith in Team Miyazaki, I'd first like to recognize the Academy Museum's leadership: Director and President Bill Kramer and Chief Operating Officer and General Counsel Brendan Connell, Jr., as well as the museum's founding director, Kerry Brougher, and former Deputy Director of Advancement and External Relations Katharine DeShaw. Through their passion and commitment, they have created the foundation for more exhibitions like **Hayao Miyazaki** to be realized.

A film exhibition should always be both entertaining and educational. It needs a balance of objects, film projections, installations, architecture, graphic design, and lighting to create a unique experience. I am tremendously grateful to Vice President of Exhibition Design and Production Shraddha Aryal for perfectly harmonizing content and design, embracing the curatorial concept and contributing her own brilliant ideas. This was an exceptionally fruitful and enjoyable collaboration. I thank everyone who participated in designing, building, and bringing this singular exhibition to life, especially the Exhibitions team of Senior AV Manager Christopher Richmond, Fabrication Manager Andy Mueller, Lighting Technician Omar Madkour, and Design Coordinator Sherry Huang; Creative Director Peter Raphael Castro and Exhibitions Graphic Design Manager Vanessa McKenzie; Senior Media Production Manager Ryan Sosa and Editor Josh Porro; and the talented teams at Cinnabar and Available Light. Vice President of Exhibition Planning Susan Jenkins (a.k.a. the Great Wizard Jenkins) handled challenging contracts, budgets, and schedules with great patience and diplomacy. I want to express my sincere gratitude to her for accompanying me on my first trip to Japan and acknowledge the invaluable support of Senior

Exhibition Planning Coordinator Kate Weinberg and Exhibition Planning Specialist Cindy Ha (always the first to show up to our calisthenics sessions on "Miyazaki Fridays").

Studio Ghibli has never allowed so many original production materials to leave their archives, let alone Japan. The task of safely transporting and exhibiting hundreds of exhibition objects, including many fragile drawings, was expertly handled by Senior Director of Registration and Collections Management Sonja Wong Leaon along with Loans and Exhibitions Registrar Ross Auerbach, Objects Conservator Sophie Hunter, and the Academy's Associate Director of Library Conservation Dawn Jaros. I extend my gratitude to the entire advancement and external relations department, enthusiastic supporters from the project's start, especially Senior Director of Foundation and Government Relations Dawn Mori, Director of Planned Giving Barbara Turman, Associate Director of Corporate Partnerships Christine Joyce Rodriguez, and Associate Director of Major Gifts Omar Sharif Jr. I am also most grateful to Vice President of Marketing and Communications Shawn Anderson, Director of Communications Stephanie Sykes, Senior Communications Manager Daniel Gomez, Marketing and Advertising Manager Adriana Fernández, and Digital Media Manager Allen Fernandez for their unparalleled expertise and positive energy.

While the exhibition includes many of the most memorable sequences from Miyazaki's films, nothing compares to watching his masterworks in the place they were meant to be seen: the movie theater. Thanks to Senior Director of Film Programs Bernardo Rondeau, a fellow Miyazaki enthusiast, for presenting all of Studio Ghibli's films in our theaters. I also thank him for his persistence in acquiring newly subtitled original-language prints for the Academy's collection. In exploring the characteristics that make Miyazaki's oeuvre so appealing and relevant, I have treasured fantastic conversations with Senior Director of Education and Public Engagement Amy Homma and her team of Public Programs Manager Eduardo Sánchez, Youth Programs Manager Julia Velasquez, and In-Gallery Programs Manager Stephanie Samera.

Together with Senior Digital Platforms Manager Mike Schiro and Associate Curator of Digital Presentations Gary Dauphin, they found exciting new ways for the public to engage with Miyazaki's work. I am also appreciative of former Director of Retail Holly Westhoff, Director of Visitor Experience Lauren Girard, Director of Board and Community Relations Mariko Yoshimura-Rank, Operations Manager Andria Mack, and the museum's operations, visitor services, and security teams.

Hayao Miyazaki is far more than an exhibition, and this catalogue will last as testimony to the project, allowing readers to dig into Miyazaki's creative work and processes. I extend my gratitude to Director of Publications Stacey Allan and the talented catalogue team she assembled, especially Deirdre O'Dwyer for her thoughtful and collaborative work as editor, and Jessica Fleischmann of Still Room Studio, whose elegant catalogue design highlights the beauty of Miyazaki's work. Thanks also to Assistant Curator Sophia Serrano, Clearance Rights Specialist Daniel Peretz, and Academy Gold Intern Lindsey Kurano for providing invaluable research support, and to Karen Jacobson for additional editing. My admiration goes to Pete Docter and Daniel Kothenschulte for their insightful contributions to this book.

Finally, my most heartfelt gratitude goes to Assistant Curator J. Raúl Guzmán. On this journey, Raúl has acted as my counterpart, companion, and friend. From the beginning, we shared a vision, and he became not only my creative partner but also a crucial critical voice. I want to thank him for his trust and faith in our work, and for bringing sensitivity, passion, rigor, and uncompromising commitment to this project as no one else could have.

JESSICA NIEBEL
Exhibitions Curator

CONTRIBUTORS

PETE DOCTER is the Academy Award–winning director of Monsters, Inc. (USA, 2001), Up (USA, 2009), Inside Out (USA, 2015), and Soul (USA, 2020). He is chief creative officer at Pixar Animation Studios, where he started in 1990 as the studio's third animator. Docter helped develop the story and characters for Toy Story (USA, 1995), Pixar's first full-length animated feature film, for which he also was supervising animator. He served as a storyboard artist on A Bug's Life (USA, 1998), wrote initial story treatments for Toy Story 2 (USA, 1999) and WALL·E (USA, 2008), and executive produced Brave (USA, 2012) and Monsters University (USA, 2013) . Docter studied character animation at California Institute of the Arts (CalArts), Santa Clarita, where he produced a variety of short films, one of which won a Student Academy Award. His interest in animation began at the age of eight, when he created his first flipbook.

DANIEL KOTHENSCHULTE is an author, curator, and lecturer on film and art history, and a lover of animation ever since he saw The Jungle Book at the age of three. As a film journalist, he is responsible for the film section in the German national daily newspaper Frankfurter Rundschau and a regular contributor to WDR Television. He has taught at various universities, including Städelschule, Frankfurt; the University of Applied Sciences and Arts, Dortmund; and the University of Television and Film, Munich. He is the author of Hollywood in the '30s and The Art of Pop Video, as well as books about Robert Redford, Fritz Lang's Metropolis, and artist Mike Kelley. In addition, he provides live piano accompaniment at screenings of silent films.

JESSICA NIEBEL is exhibitions curator at the Academy Museum of Motion Pictures. She organized internationally touring exhibitions including Anime! High Art—Pop Culture (2008), Jim Rakete: The State of Things (2011), And the Oscar Goes to . . . 85 Years of the Best Picture Academy Award (2012), and Theaters: Cinema Photography by Yves Marchand and Romain Meffre (2014) as curator at the Deutsches Filmmuseum in Frankfurt, Germany, where she was a member of the museum's award-winning theater programming committee and edited numerous exhibition catalogues. Niebel holds a master's degree in media studies and American literature from the Philipps University of Marburg, Germany, and studied media production at the University of Southern Queensland, Australia.

TOSHIO SUZUKI is producer and executive director of Studio Ghibli. Born in 1948 in Nagoya, Japan, he graduated from Keio University with a degree in literature in 1972 and joined the publishing company Tokuma Shoten Co., Ltd. After working for the weekly magazine Asahi Geino, he cofounded the monthly animation magazine Animage. While serving as co-editor, and later chief editor, of Animage, Suzuki took part in the production of films by Isao Takahata and Hayao Miyazaki, including Nausicaä of the Valley of the Wind (1984), Grave of the Fireflies (1988), and My Neighbor Totoro (1988). He participated in the founding of Studio Ghibli in 1985 and has worked there since 1989, producing almost all of Studio Ghibli's theatrical films.

ACADEMY MUSEUM OF MOTION PICTURES STAFF

Marcy Akop
Reporting and Stewardship
Specialist

Stacey Allan
Director of Publications

Shawn Anderson
Vice President of Marketing
and Communications

Rosendo Arroyo
Grounds Lead

Shraddha Aryal
Vice President of Exhibition Design
and Production

Ross Auerbach
Loans and Exhibitions Registrar

Lance Bad Heart Bull
Exhibition Art Handler

Tanya Barnes
Senior Advancement Coordinator

Doris Berger
Senior Director of Curatorial Affairs

Kianah Bobo
Security Officer

Richard Bott
Exhibition A/V Technician

Ethan Caldwell
Theater Operations Manager

Tino Carlo
Salesforce Administrator

Peter Raphael Castro
Creative Director

Brendan Connell, Jr.
Chief Operating Officer
and General Counsel

Phyllis Cottrell
Exhibition Installation Manager

Gary Dauphin
Associate Curator of Digital
Presentations

Julio De Leon Espana
Custodian

Elizabeth De Luis Venegas
Custodian

Luisa Del Cid
Senior Human Resources Specialist

Esme Douglas
Research Assistant

Omar El Sharif
Associate Director of Major Gifts

Dan Faltz
Foundation and Government
Relations Development Specialist

Adriana Fernández
Marketing and Advertising Manager

Allen Fernandez
Digital Media Manager

Mitchell Flores
Senior Corporate Partnerships
Coordinator

Citlalie Gallegos
Event Sales Manager

Mariah Gelhard
Director of Retail

Lauren Girard
Director of Visitor Experience

Daniel Gomez
Senior Communications Manager

Ricardo Gomez
Senior Security Manager

Michael Gonzalez
Preparator

Daniela Gonzalez-Pruitt
Conservation Technician

Joe Gott
Chief Preparator

Sara Greenlee
Security Officer

Reginald Guess
Security Officer

J. Raúl Guzmán
Assistant Curator

Cindy Ha
Exhibition Planning Specialist

Jenny He
Exhibitions Curator

Joseph Hernandez
Security Supervisor

Amy Homma
Senior Director of Education
and Public Engagement

Sherry Huang
Exhibition Design Coordinator

Sophie Hunter
Objects Conservator

Matthew Huynh
Desktop Support Technician

Ricardo Jacobo
Assistant Facilities Manager

Dara Jaffe
Assistant Curator

Susan Jenkins
Vice President of Exhibition Planning

Abigail Kavanaugh
Associate Director of Membership
and Annual Giving

Narjis Kazmi
Security Officer

Renee Kiefer
Associate Permanent Collections
Registrar

Peter Knezovich
Senior Operations Coordinator

Bill Kramer
Director and President

Manouchka Labouba
Research Assistant

Robert Leos
Security Officer

Amy Liu
Graphic Design Specialist

Andria Mack
Operations Manager

Omar Madkour
Exhibition Lighting Technician

George Marquez
Security Officer

Vanessa McKenzie
Exhibition Graphic Design Manager

Maggie McLandsborough
Creative Specialist

Chi Min
Desktop Support Specialist

Dawn Mori
Senior Director of Foundation
and Government Relations

Bethany Moritz
Membership Specialist

Nathalie Morris
Collections Curator

Andrew Mueller
Exhibition Fabrication Manager

Traci Mueller
Advancement Services Manager

Daniel Munoz
Operating Engineer

Sharri Nash
Security Officer

Jessica Niebel
Exhibitions Curator

Aka Obphrachanh
Senior Facilities Manager

Daniel Peretz
Clearance Rights Specialist

Gerry Perez
Security Manager

Wendy Phillips
Associate Collections Technician

Dinah Plam
Custodian

Kiva Reardon
Film Programmer

Robert Reneau
Film Program Specialist

Christopher Richmond
Senior Exhibition A/V Manager

Ladatro Robinson
Security Supervisor

Christine Joyce Rodriguez
Associate Director of Corporate
Partnerships

Christopher Roginski
Events Production Manager

Bernardo Rondeau
Senior Director of Film Programs

Edna Salonga
Security Officer

Stephanie Samera
In-Gallery Programs Manager

Eduardo Sánchez
Public Programs Manager

Ana Santiago
Assistant Curator

Mike Schiro
Senior Digital Platforms Manager

Sophia Serrano
Assistant Curator

Bridgette Smith
Senior Advancement and
External Relations Coordinator

Miguel Solorio
Leadership Annual Giving Manager

Ryan Sosa
Senior Media Production Manager

Jacqueline Stewart
Chief Artistic and Programming
Officer

Billie Strong
Security Officer

Stephanie Sykes
Director of Communications

Gregory Thomas
Security Officer

Dennis Thompson
Chief Engineer/Senior Plant
Operator

Andrew Tiedge
Assistant Security Manager

Nathaniel Timoney
Security Supervisor

Sarah Tinsley
Vice President of People and Culture
& Operations Strategy

Barbara Turman
Director of Planned Giving

Connor Uretsky
Digital Content Specialist

Cassandra Vadas
Assistant Collection Information
Registrar

Lauren Valle
Database Specialist

Leonard Vasquez
Construction Project Manager

Doris Vasquez Morales
Custodian

Julia Velasquez
Youth Programs Manager

Ken Viste
Exhibition Project Manager

Kate Weinberg
Senior Exhibition Planning
Coordinator

Andrew Werner
Vice President of Building Operations

Charlette Wilburn
Senior Human Resources Manager

Stephanie Willsey
Exhibition Project Manager

Sonja Wong Leaon
Senior Director of Registration
and Collection Management

Haley Yochum
Administrative Assistant
to the Director's Office

Mariko Yoshimura-Rank
Director of Board and
Community Relations

Matthew Youngner
Senior Director of Individual Giving

QUOTATIONS

Page 25: Miyazaki, "From Idea to Film: 2," in **Starting Point, 1979–1996**, trans. Beth Cary and Frederik L. Schodt (San Francisco: VIZ Media, 2009), 33. Originally published in **Gekkan ehon bessatsu: Animeshon** [Animation: Monthly Picture Book Special], July 1979.

Page 42: Miyazaki, "On Japan's Animation Culture," interview, in **Turning Point, 1997–2008**, trans. Beth Cary and Frederik L. Schodt (San Francisco: VIZ Media, 2014), 71. Originally published in **Yomiuri Shimbun**, August 8, 1997.

Page 68: Miyazaki, "Nostalgia for a Lost World," in **Starting Point**, 21. Originally published in **Gekkan ehon bessatsu: Animeshon**, March 1979.

Page 76: Miyazaki, "Earth's Environment as Metaphor," interview by Tetsuji Yamamoto and Jun'ichi Takahashi, in **Starting Point**, 430. Originally published in **iichiko**, nos. 33 (October 20, 1994) and 34 (January 20, 1995).

Page 80: Miyazaki, "The Porco Rosso Memos: Directorial Memoranda," April 18, 1991, in **Starting Point**, 267.

Page 120: Miyazaki, The Art of Nausicaä of the Valley of the Wind Watercolor Impressions (San Francisco: VIZ Media, 2007), 152.

Page 146: Miyazaki, "Totoro Was Not Made as a Nostalgia Piece," interview by Hiroaki Ikeda, in **Starting Point**, 359. Originally published in the roman album for **My Neighbor Totoro** (Tokyo: Tokuma Shoten, 1988).

PHOTO/FILM CREDITS

Unless otherwise noted, all images © Studio Ghibli.
Nausicaä of the Valley of the Wind © 1984 Studio Ghibli-H.
Castle in the Sky © 1986 Studio Ghibli.
My Neighbor Totoro © 1988 Studio Ghibli.
Kiki's Delivery Service © 1989 Eiko Kadono-Studio Ghibli-N.
Porco Rosso © 1992 Studio Ghibli-NN.
Princess Mononoke © 1997 Studio Ghibli-ND.
Spirited Away © 2001 Studio Ghibli-NDDTM.
Howl's Moving Castle © 2004 Studio Ghibli-NDDMT.
Ponyo © 2008 Studio Ghibli-NDHDMT.
The Wind Rises © 2013 Studio Ghibli-NDHDMTK.

Page 44: © Tezuka Productions.

Page 47: George Rinhart/Corbis Historical via Getty Images.

Page 49: © Toei Company Ltd.

Page 52: © Nippon Animation Co., Ltd.

Pages 53, 182–83: Images courtesy of TMS Entertainment Co., Ltd. Original comic books created by Monkey Punch © Monkey Punch All Rights Reserved. © TMS All Rights Reserved.

Page 62: © Toho Co., Ltd.

Pages 178–79: Studio 100 Animation.

Pages 180–81: From the Apennines to the Andes and Anne of Green Gables, courtesy of Studio 100 Animation; Sherlock Hound © RAI - TMS; Future Boy Conan © Nippon Animation Co., Ltd.

Pages 185–87: Tokuma Shoten Publishing Co., Ltd.

Page 271: Grave of the Fireflies © 1988 Akiyuki Nosaka/Shinchosha; Only Yesterday © 1991 Hotaru Okamoto-Yuko Tone-Studio Ghibli-NH.

Page 272: Pom Poko © 1994 Hatake Jimusho-Studio Ghibli-NH; Whisper of the Heart © 1995 Aoi Hiiragi/Shueisha-Studio Ghibli-NH; My Neighbors the Yamadas © 1999 Hisaichi Ishii-Hatake Jimusho-Studio Ghibli-NHD.

Page 273: The Cat Returns © 2002 Nekonote-Do-Studio Ghibli-NDHMT; Tales from Earthsea © 2006 Studio Ghibli-NDHDMT; The Secret World of Arrietty © 2010 Studio Ghibli-NDHDMTW.

Page 274: From Up on Poppy Hill © 2011 Chizuru Takahashi-Tetsuro Sayama-Studio Ghibli-NDHDMT; The Tale of The Princess Kaguya © 2013 Hatake Jimusho-Studio Ghibli-NDHDMTK; When Marnie Was There © 2014 Studio Ghibli-NDHDMTK.

Page 275: The Red Turtle © 2016 Studio Ghibli-Wild Bunch-Why Not Productions-Arte France Cinéma-CN4 Productions-Belvision-Nippon Television Network-Dentsu-Hakuhodo DYMP-Walt Disney Japan-Mitsubishi-Toho; Earwig and the Witch © 2020 NHK, NEP, Studio Ghibli.

This publication accompanies the exhibition **Hayao Miyazaki**, organized by Jessica Niebel and J. Raúl Guzmán, and presented at the Academy Museum of Motion Pictures, Los Angeles, September 30, 2021–June 5, 2022, in collaboration with Studio Ghibli, Tokyo.

Technology solutions have been generously provided by Christie. Major support comes from the Arthur and Gwen Hiller Memorial Fund.

CHRISTIE®

This exhibition has also been supported, in part, by the Los Angeles County Board of Supervisors through the Los Angeles County Department of Arts and Culture. Special thanks to the Japan Foundation for their partnership.

Published in 2021 by the Academy Museum of Motion Pictures and DelMonico Books · D.A.P.

Academy Museum of Motion Pictures
6067 Wilshire Boulevard
Los Angeles, California 90036
academymuseum.org

DelMonico Books available through
ARTBOOK | D.A.P.
75 Broad Street, Suite 630
New York, NY 10004
artbook.com
delmonicobooks.com

Academy Museum of Motion Pictures
DIRECTOR OF PUBLICATIONS: Stacey Allan
DESIGNER: Jessica Fleischmann with Jenny Haru Kim, Still Room
EDITOR: Deirdre O'Dwyer
COPY EDITOR: Philomena Mariani
PROOFREADER: Dianne Woo

DelMonico Books
PUBLISHER: Mary DelMonico
DIRECTOR OF PRODUCTION: Karen Farquhar
COLOR SEPARATIONS: Grey Balance Studio

Printed and bound in China

LIBRARY OF CONGRESS CONTROL NUMBER: 2020950574
ISBN: 978-1-942884-81-1

COVER: Hayao Miyazaki, **My Neighbor Totoro** imageboard
BACK COVER: **Spirited Away** film still (Chihiro and No Face)
FRONTISPIECE: Hayao Miyazaki, **Spirited Away** imageboard (Chihiro enters the bathhouse)